BRENDAN PRENDEVILLE studied painting at St Martin's School of Art, and Art History at the Courtauld Institute in London. He has worked as a freelance curator and lecturer, and has published articles and catalogue essays on subjects ranging from contemporary sculpture to phenomenology, and more particularly on themes relating to Realism. He teaches at Goldsmiths College, University of London.

Thames & Hudson world of art

This famous series provides the widest available range of illustrated books on art in all its aspects.

If you would like to receive a complete list of titles in print please write to:

THAMES & HUDSON
181A High Holborn
London WC1V 7QX

In the United States please write to:

THAMES & HUDSON INC.
500 Fifth Avenue
New York, New York 10110

Printed in Singapore

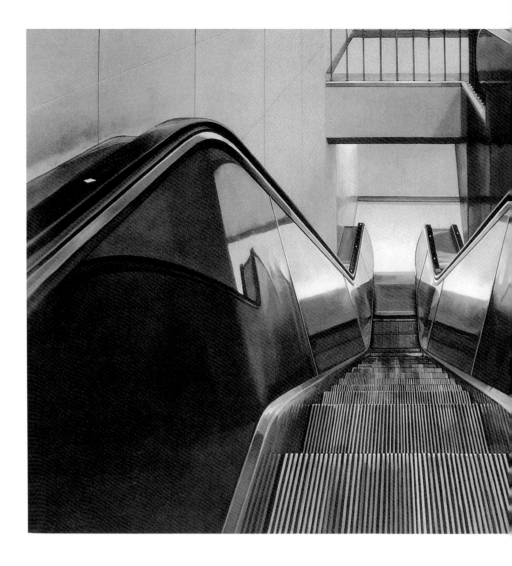

Brendan Prendeville

Realism in 20th Century Painting

192 illustrations, 92 in color

 Thames & Hudson world of art

Acknowledgments

To my mother and in memory of my father

I have benefited from too many conversations on this subject to acknowledge here, and I am greatly indebted to an abundant and diverse literature, acknowledged in the bibliography. Ian Jeffrey gave advice on some rewriting, as did Gillian Kennedy, for whose encouragement and support I am extremely grateful. Goldsmiths College granted an essential period of study leave and funded some travel, at an earlier stage.

© 2000 Thames & Hudson Ltd, London

First published in paperback in the United States of America in 2000 by Thames & Hudson Inc., 500 Fifth Avenue, New York, New York 10110

thamesandhudsonusa.com

Library of Congress Catalog Card Number 99-69883
ISBN 0-500-20336-9

Designed by Derek Birdsall
Typeset by Omnific
Printed and bound in Singapore by C.S. Graphics

Richard Estes, *Escalator*, 1970

Contents

6 **Introduction**
Realism and its Meanings

13 **Chapter 1**
The Realism of Modernism:
From the Turn of the Century to the First World War

54 **Chapter 2**
Between Wars: Realism, Modernity and Politics

108 **Chapter 3**
From War to Cold War

155 **Chapter 4**
New Realities

214 Select Bibliography
218 List of Illustrations
222 Index

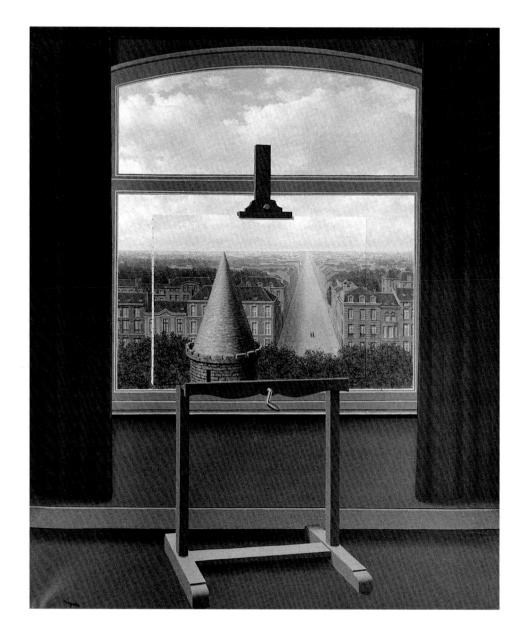

1. **René Magritte**, *Euclidean Walks*, 1955.
Magritte both employs realist perspectival illusion
and confounds its purpose. Exploiting Euclidean
geometry to offer viewers a space like one they
could step into, he simultaneously checks their
imaginary advance by creating a visual paradox.

Introduction: Realism and its Meanings

It is legitimate to doubt that the word 'realism' has a coherent meaning, given the diverse uses that have been found for it, in changing contexts and with reference to disparate work (as this book will demonstrate yet again). As with any word that has a long history of varied use, its meaning is as complex as that history. So, rather than starting – or indeed ending – with a firm definition, we will accept the shifting one given by history and usage. To an extent, this will entail considering the main categories of painting to which the term was applied during the twentieth century: Social Realism, Photorealism, and so forth. However, to go merely by labels would be to miss the wider and deeper presence of realism in twentieth-century painting; fortunately, we can recognize realist practices, tendencies and precepts without their having been marked as such. Just as we notice the traits of common ancestry in members of a family, it is partly through reference to tradition that we may recognize the family features of realism in diverse contexts.

For those of us who have been educated in a western culture, a familiarity with the tradition in question comes with our language; people frequently refer to works of art as being 'realistic', with casual confidence. Realism can in fact be thought of as defining what is most distinctive in western pictorial practice, in so far as it derives from the ancient art of Egypt and of Greece. Renaissance theory and practice renewed and effectively reinvented the realism of antiquity, whose central object was the human figure, portrayed with a lifelikeness tempered by idealization; on which basis, a familiar 'story' of western art has developed, and has come to be given a normative status: art *should* be 'realistic'. However, as we have accepted, realism lacks a simple meaning; we may go further and admit that its meaning is conflicted or contradictory, that there is more than one tradition in play. If the art of antiquity established the basis for the western concern with illusion in art – the Greek *mimesis* belongs to the family that gives us mime, mimicry – it had a countervailing aspect in its concern to pursue a beauty that was perfect and immortal (the tempering idealization). Florentine culture of the

High Renaissance, while valuing anatomical realism in depictions of the human body, counted such images as art only when they reflected what Raphael (1483–1520) called 'a certain idea' transcending experience. Equally, while the new collectors of art might look for distinctive traces of the artist's hand, they decidedly did not seek there any evidence of ordinary physical effort. Art was emphatically not a manual activity in the sense that craft was held to be. What came to be academic rules, governing both the content and the performance of art, tended to exclude as vulgar or ugly subjects or artistic practices felt to be too basely material. In this respect, the material of painting itself is of some importance, since it was the creative exploitation of oil paint, from the fifteenth century onwards, that fostered the emergence of more corporeally realist tendencies. Oil paint is a medium that is distinctive in its capacity to remain liquid throughout a long period of working; in its malleability, it lent itself well to the rendering of perishable and changeable matter, and also had scope to reflect an extremely wide range of painterly performance. Although it was readily and at times predominantly exploited for classicizing ends, oil painting responded especially well to the rendering of realities deemed inadmissible by Renaissance-derived academic theory. (In some cases – a Caravaggio, a Courbet – it was precisely the inadmissibility of these realities that came to be of expressive importance.) Varieties of realism therefore developed over the centuries after the Renaissance which, partly in continuation of certain northern traditions, dealt with 'low' themes and evoked physical materiality. In recent western history, then, there are at least two 'families' of realism, one of which was united with, and constrained by, classical ideals, while the other, broadly speaking, was not. Uniting both, however, is a common underlying presumption or imperative that we can take as being fundamental for western art since the fifteenth century, concerning a pursuit of the real.

Some twentieth-century realism draws on classical prototypes, via the post-Renaissance academic tradition and its methods and institutions: linear perspective, the academic nude, the public-scaled work (see especially chapter two). However, as has just been noted, an alternative model for realist practice was also available to painters, and this is traceable through the low-life and genre painting of the seventeenth and eighteenth centuries, and the anti-academic realism of the nineteenth. In treating mundane subjects in terms of present time, of actuality, the painters whom we now most readily regard as 'realists'

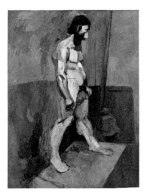

2. **Henri Matisse**, *Male Model*, 1900. Matisse (1869–1954) here interprets the central motif of academic study, the posed nude model, in terms of methods grounded in French nineteenth-century realism. His anti-academic mentors here are Cézanne and Auguste Rodin; he had recently bought works by both (the same model had posed for Rodin). Like Rodin, he violates academic principles by accentuating the model's stocky individuality; like Cézanne, he paints by juxtaposing unblended tones. The painting marks an early stage in Matisse's modernist pursuit of perceptual immediacy.

violated the ground rules of academic art and theory, focused as these were upon the transcendental and timeless. Equally importantly, as recent art-historical writing has argued, they made viewers apprehend in a new way their own orientation to the painting. Instead of presenting, in normatively Renaissance manner, a fixed view onto an unchanging world, they represented worlds akin to those their viewers knew, and in the hands of a Velázquez or a Vermeer this engendered illusionism of a complex and paradoxical kind. The portrayal by these painters and others of mirrors and frames, used as devices to intensify illusion, also disclosed the workings of illusionism itself and made the act of viewing self-conscious. Correspondingly, the kind of viewing that was invited, and encoded, came to be part of the painting's meaning: a voyeuristic glimpse, a passing glance, a reflective gaze. The complicity between painting and viewer thus came to reach a new pitch of development. French nineteenth-century realism was crucial in this, through its particular practices, through the critical discussion it stimulated and through its lasting influence on subsequent French art. Realism, in its radical address to present experience, came into association with modernity and modernism. The reality presented in Gustave Courbet (1819–77) and, later, Paul Cézanne (1839–1906) is not simply objective, but is the real as sensed and lived: in Cézanne, what holds the world together is seen to be perception itself, since the juxtaposed touches of paint represent not merely things out there in an 'external' world, but what Cézanne termed 'sensations' – everything pulses with human sensation. This is reality in terms of the intimate knowledge each of us has of it, a 'subjective' reality we have in common – 'intersubjectivity'.

An overarching theme of this book concerns the interplay between this intersubjective, inherently intimate, dimension of realism and its more impersonally public, and latently academic, side. Often, the two sides are present together in the work of individual artists, as with Cézanne himself and a later painter such as Giorgio Morandi (1890–1964). In other cases, as with the American painter Philip Evergood (1901–73) and the Germans Otto Dix (1891–1969) and George Grosz (1893–1959), we find versions of realism that expressly disavow the academic and emphasize the coarseness in their subjects, making use of narration and satire. This sardonic vein of realism itself has a long ancestry, through William Hogarth (1697–1764) and Jan Steen (1625/6–79), and its address too can at times be intimate: there is a horrible intimacy in Goya (1746–1828).

The reader might begin to wonder where realism ends. If we take the term as defining not merely a set of practices or styles, but a central principle of western art, and describe that bluntly (if problematically) in terms of an effort to represent things as they really are, then realist attitudes and expectations can indeed be seen as having been pervasive in western culture up to the present day. Both journalism and photography reflect this cultural predisposition, and the very invention of photography could be thought of partly as an outcome or by-product of realist painting tradition. Journalism and photography came into association with painting at various times from the beginning of the twentieth century onwards, or mined the same seams. We can see this in the parallels between the work of early American documentary photographers and that of the American Ashcan School painters of urban subjects; in the interplay between German *Neue Sachlichkeit* ('New Objectivity') painting of the 1920s and contemporary photography, and in the widespread adoption of documentarist methods during the interwar period (1918–39); differently again, with the Photorealists and Gerhard Richter (b. 1932). There are ways in which the spectacular realism of nineteenth-century academic painters such as Sir Lawrence Alma-Tadema (1836–1912) carries over into cinema; conversely, there are transpositions of the cinematic into painting for radical and progressive ends – for the purpose of addressing a new mass audience, newly defining itself.

While, during the twentieth century's early decades, realist painting can be seen to be bound up with modernism (Cubism has realist aspects), there are also tendencies describable as 'realist' that developed in opposition to modernism, and in many of these cases academic realism can be seen to persist or revive, if sometimes in strange guises. The fantastic and perverse traditionalism of Giorgio de Chirico (1888–1978) is a case in point. Drawing on the vein of fantasy in *fin de siècle* Salon and academic painting like that of the Swiss painter Arnold Böcklin (1827–1901), it contributed in turn to the development of metaphysical painting in Italy in the interwar period. This was the era of *Les Réalismes*, of Social and Socialist Realism in particular, when Mexican painters modernized Italian Renaissance fresco styles and painters in the Soviet Union drew on the example of the nineteenth-century academic naturalism of The Wanderers, a group of Russian artists who seceded from the Academy of Art to mount travelling exhibitions bringing art to the people. At the same time, it was the period of Surrealism, and the Surrealist

painter who was most dialectically engaged with realism, and opposed to it, was René Magritte (1898–1967), whose paintings evoked the systematized spaces – and also the strange unreality – of academic perspective manuals. (Magritte's *Euclidean Walks* (1955) subverts realism through paradox; or perhaps it brings out a paradoxicality inherent in realism.)

1

The various schools of Social and Socialist Realism adapted academic methods, often, to serve a politically realist end: the presentation of themes of real and common concern to a contemporary audience, as defined from various leftist perspectives. A realism of a different kind, though one bearing some relation to the social realisms, is found in French painting of the immediate post-Second World War period. Born of the experience of the 1930s, it used intimate means to afford recognition of what is common to all, but at the level now of experience rather than events. Once more, with Alberto Giacometti (1901–66), Francis Gruber (1912–48) and Jean Hélion (1904–87), the presence of Cézanne is felt, though without his cornucopia of colour; the object of their preoccupations is more recalcitrant, famished. Such a realism was short-lived, and it did not survive through the succeeding era of consumer abundance, although some of its concerns might be seen to persist in the work of artists as diverse as Leon Golub (b. 1922) and Lucian Freud (b. 1922).

Biennales and other large exhibitions – constituting the modern international equivalent of the nineteenth-century Salon system – gained influence through the 1970s. They encouraged heterogeneity and hybridity of practice (in contradistinction to a purist American late modernism), and fostered narrative styles (the work of Paula Rego (b. 1935) reflects this development). If they nonetheless led to a certain uniformity of address, by promoting the monumental over the intimate, this partly reflected a renewed search for public and socially relevant art. It was in the 1970s also that the art historians Linda Nochlin and T. J. Clark published influential studies of nineteenth-century realism, focusing on its political dimension, particularly as seen in the work of Courbet. In the late twentieth century, however, painting was no longer the medium of choice for a public art; installations, text- and photo-based work and video art had all now come into play. The depictive and political aspects of realism were no longer the necessary allies they had been in the nineteenth century – a fact that had already been recognized in the 1920s and 1930s, when painting retained cultural centrality. Yet the dominance of photography and 'new media' at the end of

the twentieth century strangely stimulated a renewal of interest in painterly mimesis and mimicry; by appropriating the conventions of photography the Photorealists and others effected a renewal of pictorial realism, partly following the example set by Pop art.

This might seem a strange course for painting to have taken, given the greater mimetic power of new visual technologies. Yet painting was not in competition with these new means; it was responding in its own terms to the artificial reality they created, and it had one inalienable resource at its disposal, namely its physicality, as a skin of paint on a surface. This last factor helps explain the persistence of realist depiction in a period during which the diffuse and many-stranded theme of 'the body' became influential. Freud, whose earlier paintings echo *Neue Sachlichkeit* and British Neo-Romanticism, lives on into the era of video artists such as Bill Viola (b. 1951); the painted body, in the era of the body electronic.

Having begun this Introduction by doubting whether 'realism' could be given a coherent definition, I will end by more positively asserting that the word has a manifold meaning, and that the practice of painting in the twentieth century did much to bring this about, so great was its technical diversity. Often, when painters and critics used the word, they modified it, as in 'Social Realism' and 'Photorealism', to specify particular means and ends; all twentieth-century realisms were partial or hybrid. However, my introductory remarks have also implied a broad dualism governing this manifold of meanings: realist painting may either show an intense interest in the social or present an equally strong preoccupation with the visible (to which I referred broadly by using the term 'pictorial realism'). These concerns are certainly not mutually exclusive, but they are distinct, and painters have tended often to emphasize one more than the other. Equally, the literature on realism can be roughly divided between social histories of art, on the one hand, and studies (or critiques) of pictorial illusionism, spectatorship (or 'beholding') and kindred subjects, on the other (the former not excluding the visual, nor the latter the social). This book aims to do equal historical justice to the two concerns, tracing their evolution through a diversity of practice, variously involving modernist innovation, neo-academicism, and the renewal of genre.

Chapter 1: The Realism of Modernism: From the Turn of the Century to the First World War

Painting has given rise both to radical and to conservative versions of realism, and where it has been radical, it has been modern. To be a realist, in terms of the most self-consciously modern kinds of pictorial practice in nineteenth-century France, meant addressing the present, with an emphatic immediacy: this painting, this world, here and now. In depicting 'modern life', painters developed techniques that entailed a flattening of their images, to achieve an immediacy that was in the first place visual. Flatness has subsequently come to be regarded as a defining property of 'modernism' in painting, since, as the art critic Clement Greenberg influentially claimed, it entailed for painting what obtained for modernist practice in all fields: an assertion of the medium itself, of the means particular to it. Rather than receding into an imaginary depth, the image materializes as paint on a surface. What needs to be added, however, is that there is

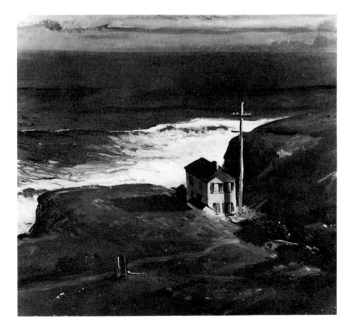

3. **George Bellows**, *Shore House*, 1911. Bellows painted this in January 1911 at Montauk (Long Island). It is a feat of painterly simplification, characteristically suggestive. The house, at once sheltered and exposed, is framed as if seen from above and at a distance. It stands between two further distances, one gable pointing seaward to the high horizon, the other shadowed by a telegraph pole, last in the line.

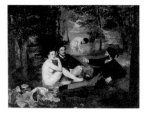

4. Edouard Manet,
Le Déjeuner sur l'herbe, 1863.
Manet's large canvas, undertaken
in pursuit of visual 'truth', was
among the works rejected from
the Salon in 1863 and shown
in a 'Salon des Refusés' at the
order of the French Emperor
Napoleon III; critics were
scandalized because – in
contrast with academic practice –
the nude, while not eroticized,
was erotic in its effect. The
composition has a classical
source, a relatively obscure
engraving after Raphael;
contemporary viewers might
have grasped Manet's allusion
to the early sixteenth-century
Concert champêtre, in the Louvre
in Paris, now attributed to Titian.

more in the painted surface than the paint: there are signs and
traces that refer us to perception and feeling, to bodily awareness,
and to social existence – including the sociality of art itself, its
disputes and debates. Edouard Manet's (1832–83) *Le Déjeuner sur*
l'herbe (1863) brought to the attention of contemporary viewers
more than the calculated shallowness of the painter's modelling.
They would have found nakedness where they expected nudity,
they would have seen a present-day setting instead of the time-
less sylvan scene hinted at by the composition. They might have
felt embarrassed before the painting, anxious as to propriety
and perhaps physically ill at ease; disconcerted perceptually, too,
by an inability to make either painted image or imaged body
predominate one over the other. They could have studied this
painted conversation with the sense of being participants, drawn
into the disputatious environment of modern art. The painting
would therefore have referred its viewers not to matters purely
external to the painting and to themselves, but to a present real-
ity, in their midst as well as in the painting – or on its surface.
Some paintings by Courbet and Manet shocked contemporary
spectators, for diverse and particular reasons, but in general
because, like the work of Charles Darwin in a different contempo-
rary context, their work afforded a vivid and disconcerting
apprehension of the materiality of existence, the argumentative
here and now.

Throughout the period discussed in this chapter (approxi-
mately 1900–14), artists in different countries took up the agenda
of French modernism, in diversely innovative ways; it was an era
of experiment and of ambitious large-scale exhibitions, a time in
which the most challenging French art of the nineteenth century
was shown internationally, alongside new work. The paintings
discussed here reflect something of the variety of contemporary
practice, in cases where realism was a significant ingredient. In
diverse ways, they alert us to the real as the modern, as all that
comprises the present, in its dimensions of subjectivity, corpore-
ality and social existence.

While the inclusion of subjectivity might seem incongruous
in this context (reality, in common usage, is always 'objective'),
a crucial aspect of the realism of modernism was its highlighting
of spectatorship, of the viewer's own responsive and subjective
presence before the painting. There was in fact a permanent ten-
sion in French realism and modernism, from Courbet and Manet
to Impressionism, between an outward attention to things as
they are and an inward reference to subjectivity, made explicit

in painters' (and critics') claims that what they painted was their 'sensation'. At the end of the nineteenth century, a group of French painters, among whom Paul Gauguin (1848–1903) was a leading figure, helped shift the critical emphasis still further towards the pole of the subjective, under the auspices of the Symbolist movement. As a consequence of the new development, entailing as it did a turning from the real to the ideal, academic practice was able to come into the modernist frame of reference. Embodying what I referred to in the Introduction as the conservative version of realism, the academic tradition in France had lost its social pre-eminence with the fall of the Second Empire in 1870. We will see in chapter two that it was to come into its own during the interwar period, when its capacity for rendering the human image in universalizing, symbolic terms answered to contemporary political demands. Earlier in the twentieth century, as I shall argue, artists explored the contradiction between the academic appeal to timeless order and the modernist address to the present. In a sense, this is what had occurred in Manet's *Déjeuner*; a shock effect that was to be repeated, in different and in varied ways, in some of the painting of the pre-First World War period that inclined to realism. In general, realist concerns, motifs and strategies gained expression through a diversity of conventions, some radically new, and this anticipated the pattern for the rest of the century: realism was to appear in hybrid guises.

From the Nineteenth Century

Through the work of Thomas Eakins (1844–1916), whose career continued into the 1900s, we can begin to trace the presence of the nineteenth century in the realisms of the twentieth. Born in Philadelphia, he trained there and in Paris, between 1866 and 1869, as a pupil of the academic realists Jean-Léon Gérôme (1824–1904) and Léon Bonnat (1833–1922). While he received a thorough academic training, one that recognizably shaped his work, his teachers did not follow the orthodox classicist line, and he himself turned realist methods to expressly modern ends. We can see his paintings as combining both of the traditions that contributed to the development of realism in Europe, academic high art and genre painting; even his boxing scenes have a monumental calm and grandeur.

Eakins belongs to the history of twentieth-century painting partly because, like Winslow Homer (1836–1910), he came to be seen as a founder of a confident and self-directed American school; American realists of the new century, from the generation of

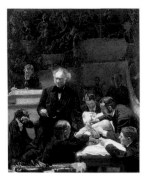

5. **Thomas Eakins**, *The Gross Clinic*, 1875. Eakins, the son of a Philadelphia drawing master, studied at the Pennsylvania Academy of Fine Arts and later in Paris, with the academic realists Gérôme and Bonnat, from 1866 to 1869. Eakins's choice of this subject, which was not a commission, and his treatment of it at monumental scale, reflects his interest in science. His interpretation, which alludes through subject, lighting and handling to Rembrandt's *Anatomy Lesson of Professor Tulp* (1632), exemplifies the confrontational character of his realism.

George Bellows (1882–1925) to that of Reginald Marsh (1898–1954), looked to him as a precursor. Eakins was an ambitious painter who showed remarkable independence in his methods and in his choice and interpretation of subjects. While the largest part of his work was portraiture, his subject paintings (sometimes themselves incorporating portraits) had the greatest public impact, and built his later reputation. His work was not generally well received during his own lifetime. His most celebrated painting, *The Gross Clinic* (1875), still has the power to disconcert that in some degree characterizes his work in general. Despite its date, it is appropriate to discuss this painting in the present context, since it highlights aspects of realism in an exceptionally vivid manner. With more than an echo of Rembrandt's *Anatomy Lesson of Professor Tulp* (1632), it shows a celebrated and innovative surgeon, Dr Samuel Gross, conducting an operation. What made the painting notorious – even though, like other works by Eakins, it was scarcely seen in public in his lifetime – was the representation of the surgeon's hand holding the scalpel, his fingers glistening with blood. The detail struck Eakins's critics as crystallizing a brutality and a wilful disregard of propriety that they found in his actions and attitudes more generally. The conservative Philadelphian élite was admittedly not hard to upset, particularly in respect of Eakins's unhesitating use of naked models in art classes for female as well as male students.

What lent the painting its particular force was precisely its violation of propriety. It was not a matter simply that the squeamish might be upset, but rather that a cardinal rule of art had been broken. The rule, as recurrently set out in academic teaching and treatises, was that art, which must be beautiful, should not incorporate an ugly subject or an unpleasing form. There can be no doubt that Eakins vehemently disagreed with this familiar precept. At the same time, it proved as useful to him as it had done to Caravaggio (1571–1610) and to Courbet, whose work in different ways broke the same rule – by allowing a deliberate and strategic upsetting of expectations. Eakins, who as a student in Paris wrote to his father that 'the big artist does not sit down like a monkey and copy a coal scuttle', knew that, for any worthwhile painter, reality had to enter painting through calculation and artifice rather than through direct imitation. The viewer is looking at a painting, a cultural object, and not at an actual scene, and so the rules and means of painting necessarily set the terms of the encounter. A sense of the real arises, in front of Eakins's painting (a life-scaled work, more than six feet in width), through

5

a calculated shock. The shock is not crude, it is precisely placed and arises within an extraordinarily complex and calculated whole. Standing before *The Gross Clinic*, the viewer's restless and anxious gaze may, for example, move back and forth between the open wound, the bloody fingers holding the scalpel and the patriarchal head of the surgeon, with its Rembrandtesque scumbled highlight – just such a distinguished head as might properly be the subject of a boardroom portrait. A dignified elder has been caught out in a cruel act; and in the same glimpse, the actuality of surgery, wounding to heal, is made vivid. Our gaze shifts from the top-lit death's head of the surgeon to the life-blood of the patient. Blood is the central fact of the painting, and Eakins is very much a painter of the central fact – one who knows that the painter's way to it is indirect.

While it testifies to the complexity of realist strategies in general, *The Gross Clinic* is of particular interest for its treatment of vision. The methods Eakins uses to engage the viewer entail making the act of seeing central both to the painting's subject matter and to its structure. Like Edgar Degas (1834–1917) and Manet, yet independently of them, Eakins here portrays a scene of theatre in which the beholders themselves are framed; the word 'theatre' itself derives etymologically from a Greek stem denoting the act of seeing. Both in general and in particular ways, the painting contradicts Lloyd Goodrich, who concluded his monograph on Eakins (1982) with the assertion that 'Eakins's art was counter to the concern with appearances that was a major trend of this period, both in impressionism and in the visual naturalism of the Sargent kind'. While Eakins was certainly far from being an Impressionist or a painter like John Singer Sargent (1856–1925), who was a highly accomplished social portraitist, the real and the apparent are quite inextricable in his work. It was indeed by virtue of his intense concern with the real that Eakins showed his preoccupation with the way things appear, a preoccupation that is if anything particularly acute and critical in his case. *The Gross Clinic* is a visual treatise on forms of attention: the surgeons intent on their work, the woman who flinches away, and the shadowy audience, which we implicitly join.

It would be nearer the mark to say that Eakins was an artist dedicated to *unvarnished* appearance. It is instructive to set his 1900 portrait of Louis N. Kenton against a typical Sargent portrait; the portrayal of Kenton is, we might almost say, anti-social, for rather than turning an elegant face to the world, this gaunt figure looks at the ground (hence its popular name, 'The

7, 6

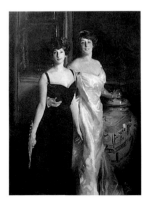

6. **John Singer Sargent,**
Ena and Betty, Daughters of Mr and Mrs Asher Wertheimer, 1901. Sargent, an American who, like Eakins, studied in Paris (under Charles Carolus-Duran), made his living as a social portraitist, principally in London, painting wealthy and aristocratic sitters as they might wish to have themselves presented.

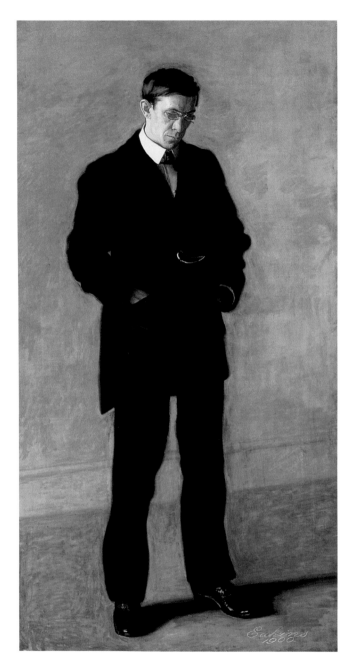

7. **Thomas Eakins**, *The Thinker*, *Portrait of Louis N. Kenton*, 1900. The sitter was related to Eakins by marriage. Unlike Sargent, Eakins spent his working life in the United States, devoting much of his time to teaching. Both this painting and Sargent's (see plate 6) reflect admiration for Velázquez, but in divergent respects: physical realism versus painterly grace.

9. **Paul Cézanne**, *Standing Female Nude*, 1898–99. Replacing tonal modelling with a 'modulation' of hues, and painting in distinct and substantial touches, Cézanne achieves a sense of volumetric mass not only in the figure but in the space surrounding it. The evident paintedness of the body confers materiality on it while preventing it from taking on an illusionistic presence. The painting relates to Cézanne's late bathers compositions of the 1890s and 1900s.

10. **William Adolphe Bouguereau**, *Birth of Venus*, 1879. The academic painter Bouguereau effaces brushwork, further enhancing illusion through the use of photographic tonality.

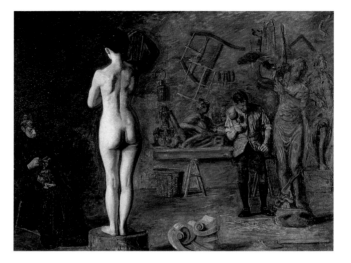

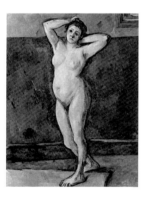

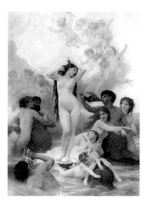

Thinker') and the paint gives a plain and ungraceful account of the way the angular body invests the lived-in suit. The painting demonstrates Eakins's concern for the concrete. He made this concern programmatically evident in *William Rush Carving his Allegorical Figure of the Schuylkill River* (1908), a later and more austere version of a subject he had first tackled in 1877. Eakins, who spent his working life in his native Philadelphia, here pays tribute to the sculptor who in 1809 carved a figure to surmount the waterworks that brought water to the city from the Schuylkill. Where a painter schooled in Impressionism would have made figure and ground relatively continuous with one another, Eakins, as if in competition with the sculptor, carves the naked model into a quasi-solid presence. As in most of his paintings, he uses a dark-ground technique and builds up paint in layers or glazes. The seeming solidity of the model is partly a function of the density of paint, relative to the thinner and looser background.

Eakins's method is quite unlike Cézanne's in *Standing Female Nude*, a late painting of 1898–99, where the background areas, painted with as dense a variegation of tones as the figure itself, tend to press forward around it. However, we can see how much these painters have in common as inheritors of earlier French realism if we compare their respective treatments of the nude with the idealized and allegorical illusionism characteristic of an academic Salon painter such as William Adolphe Bouguereau (1825–1905). In allegory, that which is immediately presented is the vehicle for a higher, more universal meaning. 'Allegory', in

etymological terms, means 'other-saying' – what is shown speaks of something other than itself. In Eakins's painting the figure whose flowing drapery Rush is carving, which carries a bittern (a marsh bird) on one shoulder, personifies or symbolizes water. The naked model in the foreground stands as nothing but herself, and the contrast allows us to appreciate this, and conveys a sense of her firm and distinct individuality. The section of tree-trunk she stands on underlines the contrast between her living flesh and the wooden sculpture, and also holds her up in luminous suspense. The other two living figures are subordinate, and lend support to the main theme. The chaperone, a black woman, is shrouded in a dark dress, against the naked model in the light; the sculptor, at work, is as awkward in form as his carving is graceful.

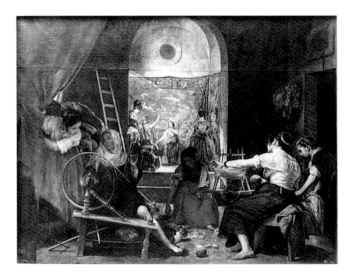

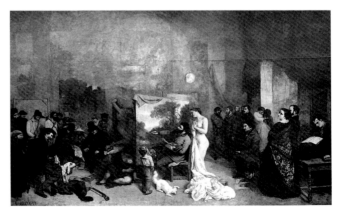

11. **Diego Velázquez,**
Fable of Arachne ('The Spinners'),
c. 1657. Velázquez juxtaposed
different orders of reality in several
of his paintings. Here, as has
been rediscovered only in
relatively recent times, the
background represents the
mythical weaving competition
between the mortal Arachne
and the Goddess Minerva. For
her presumption, Arachne is
transformed into a spider, but her
achievement had equalled that
of the goddess. In this allegory
of painting, Velázquez displays
his own skill in the foreground,
with its murmur of conversation,
its unprecedented illusion of the
spinning wheel. Additions to the
top and right of the canvas were
made by a later hand.

12. **Gustave Courbet,**
The Painter's Studio. A Real
Allegory Determining a Phase
of Seven Years in my Artistic Life,
1854–55. This is an allegory
in that the figures would never
have been brought together in
life, but are present in order to
place Courbet's practice in a
wider contemporary framework.
Personal friends and others close
to his art are assembled on the
right; on the left is a miscellany
of figures representing society at
large (including apparent political
portraits). It is 'real' in that none of
the figures is supernatural or from
the past, and landscape painting
is at the centre of this manifesto
for Courbet's declared 'realism'.

13. (overleaf) **George Bellows,**
Both Members of this Club,
1909. The subject affords Bellows
an opportunity to display painterly
vigour. 'Manliness' was regarded
as a prime virtue in the circle
of artists around Robert Henri,
matching contemporary middle-
class attitudes to sport in its
legitimate forms (the boxing
shown here was semi-legal).
Contemporary writing on Eakins
praised the 'manliness' of his art.

Eakins, for whom the naked human body was the subject
most fitting for the artist's study, painted relatively few nudes,
since he generally treated only modern and actual subjects. Even
the *Crucifixion* he painted in 1880 is realized as if in the present,
like his historical reconstruction of William Rush at work. The
boxing subjects he pioneered in American painting allowed him
to render the male nude. They also enabled him, as with *The Gross
Clinic,* to represent spectators and thus evoke the arena of vision.
Spectatorship is also a theme in *William Rush,* if less explicitly.
Brought to the very foreground, Eakins's nude stands pivotally
between the shadowy region of the painted studio and the realm
of the spectator. Imaginarily, we are brought into the studio
space. The earliest precedents for Eakins's strategy here are
afforded by sixteenth-century Venetian mannerism and by
the work of Diego Velázquez (1599–1660) – a painter Eakins
especially admired. In Velázquez's *Fable of Arachne* ('*The* 11
Spinners') (*c.* 1657), high allegory forms the background to
a realistic foreground. The allegory, a contest between a goddess
and a mortal, carries a universal meaning, while the foreground,
a workshop where women are spinning, opens into present real-
ity. Eakins goes further in *William Rush,* and makes the here and
now the sole place of universal or common meaning. The alle-
gories fade, but the actuality of the model and the labour of the
sculptor advance to be seen. The world of realism *is* this world
of appearance, of the present, of work and life. Beside the model in
the immediate foreground is a block of carved scrollwork (Rush
was a ship's carver), inscribed with Eakins's signature; he signs
his name in the place where work has been done, to show beauty
arising from work, rather than descending from above.

The Social Fabric

The main innovating impulse in North American art at the
beginning of the twentieth century was decidedly realist, and
the rising generation looked to Eakins as a precursor, in spirit if
not in terms of style. No elevated beauty is to be found in *Both* 13
Members of this Club (1909), by George Bellows (1882–1925). He
was the most successful of several artists associated with the
portraitist and art teacher Robert Henri (1865–1929), who were
struggling to gain a public for their work during the years before
the First World War. Bellows, like Rockwell Kent (1882–1971)
and Edward Hopper (1882–1967), was a pupil of Henri in New
York. Before coming to New York at the turn of the century, Henri
had been the leading light among a group of artists working

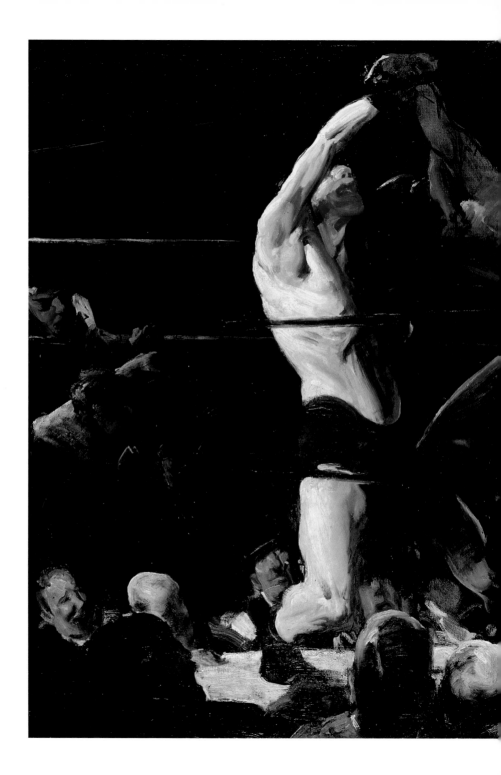

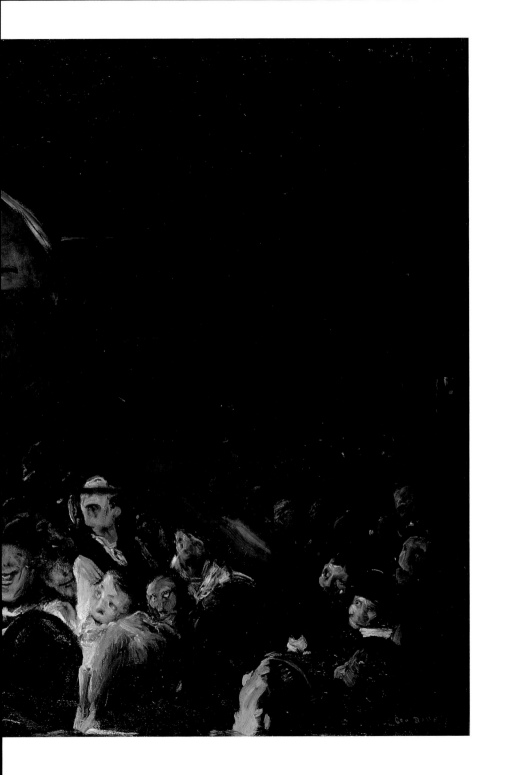

as illustrators for Philadelphia news journals. By 1904 John Sloan (1871–1951), William Glackens (1870–1938), Everett Shinn (1873–1953) and George Luks (1867–1933) were all in New York, beginning to practise as painters (in 1908 they were to comprise, with Henri, the majority of the independent exhibiting group known as 'The Eight'). The common tendencies evident in the work of some of the painters linked with Henri caused them to become known later as the Ashcan School. Within the span of very few years, Bellows produced a series of paintings that gave particularly emphatic expression to attitudes that had emerged informally within the group, in conversations, café gatherings and life classes. His are the paintings that most programmatically fulfil Henri's injunction to his students to paint the life of the modern city, implicitly that of its poor and immigrant communities. Bellows was also the painter who followed Henri's technical example with the greatest energy and confidence. In imitation of the methods of Frans Hals (1580/5–1666) and Manet, Henri painted his portraits rapidly, keeping spare canvases ready in case the work in hand lost its freshness. This was not for the purpose of nurturing a bravura manner, as in Sargent's case. For Henri and his followers, execution had to carry a sense of vigour, of the painter's energetic engagement with the subject; correspondingly, they favoured scenes they could treat so as to project a lively or forceful physicality. *Both Members of this Club* is, accordingly, a scene of violent action, and the painter's charged brush smears sweeping strokes of oily pigment, applied wet into wet, to give extremely cursive accounts of the boxers' anatomies and of spectators' faces. Bellows paints, aptly enough, with attack.

Both Members is the culminating and largest work in a series that Bellows based on visits he had made to Sharkey's, one of the semi-legal boxing clubs that flourished in private halls and the back rooms of bars after public prizefighting was made illegal in New York at the beginning of the twentieth century. While leaders of society, including President Theodore Roosevelt, promoted a cult of manliness and themselves engaged in boxing, among other sports, the 'noble art' of the gentleman's clubs was a far remove from its popular equivalent. Equally, in terms of painting, boxing as we see it here is to be distinguished from its ostensible precursors, the boxing pictures of Eakins; those were essentially static images which, in the case of *Salutat* (1898), alluded to the gladiators of Roman antiquity. Nothing is noble here.

It has been argued that Bellows affords a view of boxing that reflects comfortable middle-class judgmentalism. Indeed, he

once commented on the immorality he sensed in the fight audience, more than in the ring itself. One has only to study the leering, greenish face of a central spectator at the far side of this scene to sense what is meant, and feel invited to judge that these people are less than human. Little of the ring's surface is glimpsed, so that the crowd, emerging from the dark into the cone of light that defines the boxers, seems to surge voraciously towards them, sensing the kill. Yet Bellows's staging of spectatorship works in this case – if not in others – to undermine any feeling of distance and detachment. The rising heads in the foreground, and the low eye level, position the viewer of the painting in the midst of the crowd, so as to feel pressed upon by the same palpable blackness, and pulled by the same centripetal force.

This, of all Bellows's paintings, jumps out of its time. American twentieth-century art is often thought of as beginning in 1913, the date of the Armory Show in New York, which brought European avant-garde art to the United States, making paintings like this appear technically antiquated. Yet here Bellows invents the modern image of boxing, before the advent of ringside photographers. Boxing is already recognizable here as the sport of the underclass, the chance for escape from slum and ghetto. It is also mortally violent. The aggressive male ethos evoked here is like that of boxing in later Hollywood cinema, right up to Martin Scorsese's *Raging Bull*. As to painting, the treatment of the white boxer creates a head not to be seen again until Francis Bacon (1909–92) painted his images of George Dyer – an ex-boxer.

The title, *Both Members*, alludes to the racial aspect of the subject. One of the boxers is black, and while this heightens the pictorial drama, it also touches a topical nerve, as often with Bellows. The famous black boxer Jack Johnson, an undefeated champion, was then the object of racially driven publicity concerning the search for a 'white hope' who might defeat him. Bellows's original title, *A Nigger and a White Man*, takes up a phrase he might have heard muttered among the fight crowd. *Both Members of this Club* alludes sardonically to the fact that a black man could join a club with white men only in these peculiar circumstances. The title aligns the viewer with the liberal reformer, watching from outside. More obviously external to the scene is the viewpoint offered by Bellows's *The Cliff Dwellers* (1913). Here are the urban poor *en masse*, as an object of reformist attention. Daylight penetrates the tenement darkness from the side of the viewer, as if a door had been thrown open, to

14

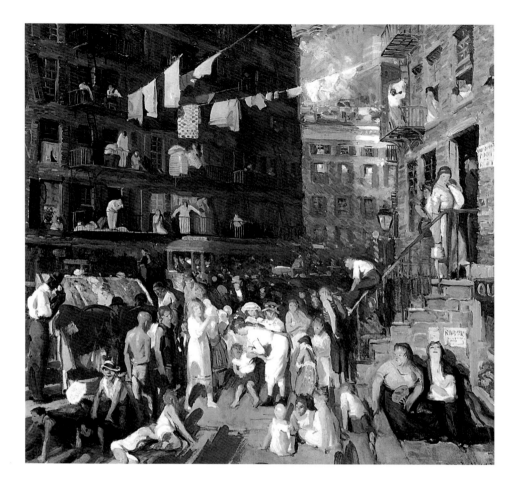

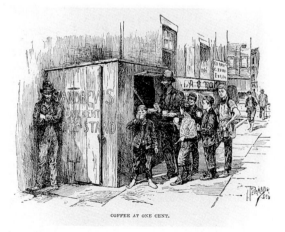

COFFEE AT ONE CENT.

15. **Jacob Riis**, *Coffee at One Cent*, from *How the Other Half Lives*, 1890. Riis used his own photographs for illustrations. Some were printed in half tone, others were reproduced from artists' copies. The Ashcan artists painted scenes similar to his (John Sloan painted a picture of a coffee stall), partly animated by the same reformist motives, partly in a pursuit of scenes that had life and character.

14. George Bellows,
The Cliff Dwellers, 1913.
Bellows's painting differs from
Riis's photographs of slum life in
his tendency to caricature and his
pursuit of vitality and individuality.
In comparing Bellows with Riis,
however, we need to bear in mind
the differences in context and
function between an easel painting
and an illustration to a published
text – a distinction Bellows himself
would certainly have understood.
Bellows's earlier view of this scene
was in fact an illustration for *The
Masses*, where it had a pointedly
political title.

16. John Sloan,
The Haymarket, 1907. Sloan's
paintings of urban subjects
sometimes show the bleak
side of life in the slums; most,
however, are vignettes, dwelling
on incident and character.

reveal overcrowding, evidence of idleness and drunkenness, with
children at large in the street. It is very much the view of urban
poverty as presented in reformist literature, most famously in
Jacob Riis's *How the Other Half Lives* (1890). The reformer comes
in with the health officer and the policeman, and reports back
to a concerned public on the immigrant 'colonies' of the city's
poorer districts. Bellows makes his figures somewhat less than
human through a kind of stick-like caricature redolent of news-
paper comic strips; the effect is still more evident in his *Forty Two
Kids* (1907). The title, *The Cliff Dwellers*, suggests a natural
colony of creatures of some kind.

In 1890, half-tone printing was at an early stage of develop-
ment, and some of the photographs Riis had taken and had
chosen as illustrations were represented by drawn copies. It was
due to the relative inadequacy of half tone that Sloan, Glackens,
Shinn and Luks were able to make a living during the 1890s as
'artist-reporters'. Subsequently, they approached their paintings
with a reporter's appetites and interests. In Sloan's case, what

15

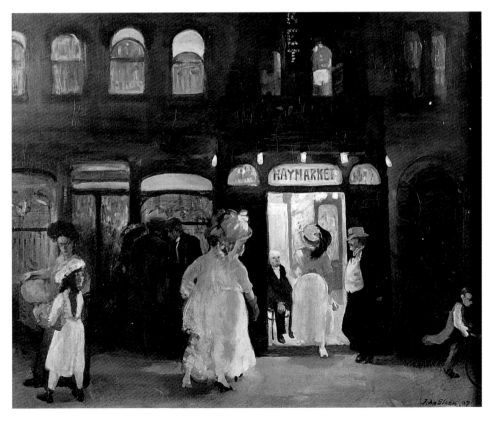

resulted was both more modest in proportions and also more sympathetic and humane than was generally the case with Bellows. As with the others, Sloan's practice as a painter drew on his journalistic habits. He made rapid sketches at the scene which he later worked up from memory into paintings (Luks ludicrously claimed he based an illustration of a man shot from a galloping horse on an 'on the spot' sketch). Sloan's city scenes, of which *The Haymarket* (1907) is typical, tend to be relatively small and intimate. The Haymarket was a dance hall and, in Sloan's words, 'an underworld hangout'. Its reputation was as bad as that of Sharkey's, and the painting shows prostitutes being let in free of charge by the doorman. A young girl looks back, under her mother's reproving gaze; a group of figures huddles conspiratorially in the shadows, and a boy plays. There is enough evidence to form a social judgment, but at the same time there is something inviting in the billowing white figures drifting towards the lit interior, while the open windows intimate the life within.

During the 1900s, artist-illustrators were being put out of business by news photography, and the Henri group's fluid, suggestive use of paint distanced their practice from photography, and in a sense outdid it by achieving effects of movement and atmosphere photography could not (although the pictorial photographers, led by Alfred Stieglitz (1864–1946) and Edward J. Steichen (1879–1973), were seeking precisely those qualities in their work at the same time). *The Haymarket* is atmospheric and alive in a non-photographic way, and so is *The Cliff Dwellers*. The latter painting, however, refers the viewer to photography in other ways, both in its content and in its method. By opening a view from outside onto the life of the poor, it directly evokes photographs like those of Riis. The connection is more evident still in a drawing that had set out a first version of the scene, which Bellows had produced for *The Masses*, a socialist magazine whose art editor was Sloan (he had joined the Socialist party in 1909). The title, *Why Don't They Go to the Country for a Vacation?*, gives the drawing a more expressly political slant than the painting, and echoes Riis's campaigning work.

In no case, however, did these painters work directly from photographs, as Eakins had sometimes done (as we now know). Eakins's involvement with photography – he collaborated with Eadweard Muybridge (1830–1904), and invented a precursor of the cinematic camera – reflected an outlook that might be termed materialist, in its attunement to the factual and the scientific. While Henri and his associates were not materialists in that

sense, they certainly addressed physical materiality, using oil paint as a means to translate between human and worldly substance. Sloan and Bellows impose on figures and settings alike the same plasticity and malleability. This they learnt not only from Henri, but also from a painter he admired, Winslow Homer, whose work thus affords a certain perspective on theirs.

Homer's paintings had nothing to do with urban experience. His late canvases were marine subjects, painted from the 1890s onwards in his studio at Prout's Neck on the Maine coast. What led Henri, despite this, to take his students to work in the area was the energy manifested in Homer's paintings of surging and foaming waves breaking on rocky shores. The paint itself mimed the action of the waves, rather than merely recording their form, and it was this painterly enactment of a world of manifold energy that excited Henri and his group. A picture such as the famous *Right* 17 *and Left* (1909) shows what his work held for them, although its most remarkable qualities remained inalienably Homer's. His marine subjects recurrently present crashing waves whose cascades of foam, in some paintings, rise up the surface of the canvas in vertical formations of agitated brushwork. Vision, paint and nature coincide in the picture-plane, in a moment of nature which is also (to paraphrase Matisse) a moment of the artist and the beholder. It is the fleeting instant at which the wave reaches its fullest existence. In *Right and Left*, the ducks appear transfixed, at the exact instant of death. At the same time as we glimpse the orange flame from the discharged gun (the title refers to its two barrels) in the grey-green distance, we realize the impossibility of our viewpoint. The physical reality of the painting, paradoxically, is brought to our attention by the illusory reality of the ducks; our gaze holds them in suspense, in their sensuous painted beauty, in the moment of their death.

None of the younger painters achieved anything like Homer's complex simplicity, and only Bellows, in his boxing paintings, approached (if more obviously) a comparable conjunction of violence with latent sexuality. Only one of Henri's pupils, Kent, devoted himself wholly to landscape and seascape. Yet Kent, who went to live in Maine, never showed Homer's preoccupation (drawn partly from Courbet) with the paradox of death in nature, with the fall and renewal of the material world. Kent's *Toilers of* 18 *the Sea* (1907) conveys, in a world of icy blues and greens, of crisp edges, of white snow against dark rock, the interinvolvement of the men with the natural world and with each other. It is the same coast as Homer's, but it is not his world of spray and storm, of lost

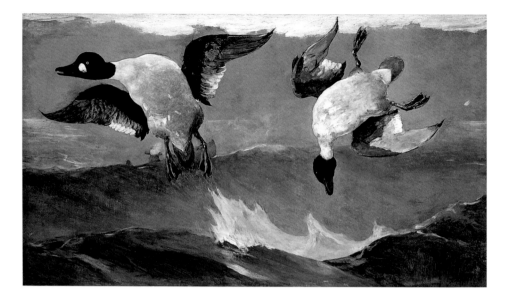

or imperilled seafarers. It is an empathetic representation of hard survival, akin to the account of a fishing community offered later by the documentarist Robert Flaherty, in his film *Man of Aran* (1934). For Kent, the social bond is crucial; Homer's sailors, by contrast, confront danger alone.

The urban painters among Henri's group took up Homer's methods in so far as they painted the city itself as a natural environment, softening its contours and rendering its tenements as cliffs for cliff dwellers. They represent the city's energies as a flux of natural force, the city's physical substance uniting with the human life it contains to comprise a common material, a social fabric. Bellows's *Blue Morning* (1909) is an urban scene which is a landscape, and in its encapsulation of the view it follows Homer's example of broad massing in the frontal plane. It is a subject Bellows tackled several times. The painting shows the vast excavation for Pennsylvania Station, with the massive new building rising incomplete in the distance; excavated beneath is an entire network of rail tunnels, and the girders of the elevated railway frame the whole scene. A subject the Italian Futurists would have interpreted with methods imitative of machinery, Bellows renders as a landscape of astonishing freshness. The painting nonetheless captures a specifically urban quality of excitement and offers an intimation of the city's vastness and aliveness – adapting Homer's methods so as to render its mortal present.

19

The Subjective and the Counterfeit

The reality of Bellows's *Blue Morning* is not simply external, for the painting does more than objectively record its subject. It conveys an atmosphere, renders a space that is not merely physical but emotional. It would be wrong to suppose that this diminishes its realism. European pictorial realism had been grounded in subjectivity from the time of its origins in the late Middle Ages. The Renaissance invention of perspective construction answered an already long-existing demand to render the world as it appeared to the individual beholder. We cannot distinguish, in painting, between (subjective) appearance and (objective) reality, for in pictorial realism the two have always been inseparable; Eakins, as we have seen, is a case in point. However, it is true that the methods fundamental to Renaissance realism, namely perspective construction and the consistent rendering of light and shade, were by themselves sufficient only to create an illusion – the induced belief that something is indeed situated externally to the viewer, in the depth behind the picture frame. The resulting effect of distance, of something seen in effigy, while highly effective for rendering still life – or angels – proved insufficient for the treatment of living subjects, such as portraits and the scenes of everyday life that came to be known as 'genre'. In fact, a convincing depth illusion, while 'realistic' in one sense, is unreal and alienating in another. In *A Favourite Custom* (1909), the academic realist Alma-Tadema constructs an illusion of spatial distance that intimates remoteness in time; the viewer apprehends a scene of intense sensuality as if lying behind the surface of the canvas, a world tantalisingly out of reach.

By contrast, in order to convey the livingness of their subjects, painters from the sixteenth century onwards developed methods that demanded the viewer's continued awareness of the painted surface. These methods, complementing illusionist techniques of disclosure, were what could be termed techniques of suggestion. Through suggestion, painters were able to convey phenomena that could not be shown, such as the vitality of a portrait subject, the emotional quality of a situation, its atmosphere. This implied a complicity with the viewer; not observation from a distance, but closeness and recognition: an illusion not of distance but of nearness.

The French Impressionists invented techniques of suggestion by means of which they addressed the present, the modern and the urban. In his 1873 painting *The Railway*, Manet brought Impressionist techniques to bear on just such a subject, one

20. **Sir Lawrence Alma-Tadema**, *A Favourite Custom*, 1909. The painting offers voyeuristic glimpses into classical antiquity: fragile and luminous, like other classicizing works of the late nineteenth-century aesthetic movement, Alma-Tadema's pictures are archaeologically exact. They reconstruct in detail the mortal life of a lost world: the painting represents life in Pompeii.

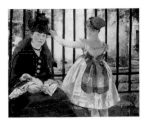

21. **Edouard Manet**, *The Railway*, 1873. The woman is Victorine Meurent, model for Manet's *Le Déjeuner sur l'herbe* and *Olympia*. The scene is a garden overlooking the lines from Saint-Lazare station in Paris. The subject is a cloud of steam, seen by the child through the black railings she grasps.

similar to that of Bellows's *Blue Morning*. Unlike Bellows, Manet does not transform the scene into the semblance of a natural landscape. On the contrary, he emphasizes its urbanity, and the blank impassiveness that is so characteristic of his paintings is consistent with that. Nothing particularly happens here. The young woman looks up from her book and the girl watches a cloud of steam. In its structure, the painting is highly suggestive of the passing urban scene. In its luminosity, it conveys an immersion in daylight. By both means, it points the viewer to a reality that is pervasive and ungraspable, yet present and immediate; it intimates that the city, which surrounds us as daylight does, is as elusive and yet as ubiquitous as light itself, materializing here in the child's dress and in the cloud of steam.

The modern city is a reality that pervades our existence. There is, accordingly, something almost abstract in Manet's attempt to represent it, as equally in his effort to paint light itself. The abstract implications of Impressionism were taken up by a succeeding generation of French painters. It is particularly in the work of Edouard Vuillard (1868–1940), Pierre Bonnard (1867–1947) and Félix Vallotton (1865–1925) that we may recognize both an inheritance from Impressionism and genre painting, and a still more decided refusal to treat reality as 'external'.

During the final decade of the nineteenth century, these painters participated as members of a group calling themselves Nabis ('prophets'), a group associated with *La Revue blanche*, one of the small avant-garde magazines that appeared during the period. The wider cultural movement to which they belonged was Symbolism; in terms of painting, the Symbolist aesthetic entailed a turn from nature to artifice, from Monet's daylight colour to Gauguin's decorative hues. This was less a radical change than a transition, as can be seen from an entry Vuillard wrote in his *Journal* in 1894, underlining the continuity between Impressionism and Symbolism (which he refers to as modernism): 'So this idea of the life that surrounds us, of our life, the source of all our thoughts and creations, this became modernism.' His words evoke Impressionist immersion. In 1876, the poet Stéphane Mallarmé, a mentor for the Symbolist generation, had remarked on the surroundingness of light in Manet: 'The natural light of day penetrating into and influencing all things, although itself invisible.' He saw this pervasive light as being analogous to participative democracy, and in his use of the motif of universal visibility envisaged a democratic art: 'today the multitude demands to see with its own eyes.' Ironically, Symbolist art

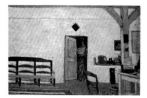

22. **Edouard Vuillard**, *Misia at Villeneuve-sur-Yonne*, 1897–99. The timber post extends from floor to ceiling, and from top to bottom of the painting, associating the perimeters of the depicted space with the canvas rectangle; Misia stands in the vertical rectangle of the doorway, just outside the space of the room, thus reflecting the presence of the viewer before the painting. The horizontality of the picture, correspondingly, suggests the shape of the visual field.

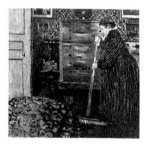

23. **Edouard Vuillard**, *La Femme qui balaie (Woman Sweeping)*, 1899–1900. Vuillard here evokes genre painting tradition, where women appear in close identification with the domestic space they inhabit and in which they work.

and literature is singularly refined and élitist, but we might nonetheless see it as rehearsing, in intimate and conspiratorial terms, a broader social mutuality.

Vuillard, Bonnard and Vallotton were indeed painters of intimate scenes, and the work of the first two came to be known under the heading of 'intimism'. Vuillard's *Misia at Villeneuve-sur-Yonne* (1897–99) offers an example of his intimist methods. It shows a close friend, Misia Natanson, looking into a room familiar to them both. In flattening the composition, Vuillard, like Gauguin and his fellow Nabis, draws out the radical implications of Impressionism. He abandons the methods of simple illusionism altogether (perspective, light and shade) and enhances the painting's power of suggestion. Colours, forms, brushstrokes, figure and setting are united in a common texture. Rendered frankly as colours and shapes on a surface (as Maurice Denis (1870–1943), theorist of the Nabis, had advocated), the genre scene, in its very privacy and reticence, intimates an emotional and imaginative space that stands outside of social convention. In other paintings, and increasingly in later years, Vuillard introduced a greater degree of depth, and in those cases the kinship with genre is still more evident. *La Femme qui balaie (Woman Sweeping)* (1899–1900) has been compared to work by Jean-Baptiste-Siméon Chardin (1699–1779), which Vuillard particularly admired. What differentiates it, however, from painting of earlier periods is the proliferation of surface pattern characteristic of Vuillard. This counters the indications of spatial depth and joins with the variegated strokes on the objects to weave figure, furniture and room into a common fabric, a pictorial embroidery. Figure and space pervade each other; matter and consciousness unite.

The room becomes an atmosphere, its features impregnated with human emotional and moral qualities, and comparable effects can be seen in paintings by Vallotton and Bonnard. In *La Chambre rouge (The Red Room)* (1898) by Vallotton, the conspiratorial feeling is as strong as in Vuillard's painting of Misia, only now there are two figures who lurk in a darkened doorway, to intimate a sexual liaison. While the objects stand in a legible depth, the colours are strident and flat, giving the ordinary domestic setting a sinister unreality. In its stark light, the figures displaced from the centre and suppressed, it is like the scene of a crime, with the woman's belongings lying like clues on the table.

The sharp separations in Vallotton convey a feeling of alienation that is characteristic of his work in general. Ostensibly,

24. **Félix Vallotton**, *La Chambre rouge (The Red Room)*, 1898. Like Vuillard in his paintings of interiors (see plates 22 and 23), Vallotton identifies the depicted scene with the painted surface, but the sense of artifice is sharper and more cynical. Vallotton's graphic art informed his painting style; his illustrations, erotic in content like this painting, appeared in major *fin de siècle* reviews.

these formal and emotional qualities distinguish his paintings from those of Bonnard. In Bonnard's *Man and Woman* (1900) the scene is indeed intimate, for the protagonists are Bonnard himself and Marthe (Maria Boursin), with whom he lived from the time he met her in 1893 until her death in 1942. Here, male and female share an ambience, a deep red interior warmly yet dimly illuminated from an unseen source; the paint, as dishevelled as the scattered bedclothes, assists the general softening. Yet a folded screen emphatically divides the canvas, separating the figures. There is an intimation of sexual and emotional dissonance, possibly drawing inspiration from stagings of Henrik Ibsen and August Strindberg at the Théâtre de l'Oeuvre, Paris, with which the Nabis were closely associated.

At the time, Bonnard was turning from Nabi patterning towards a more Monet-like and atmospheric organization of colour. Nabi practice had generally favoured the use of highly artificial colour, to suggest a spiritual world raised above mundane reality, most evidently in the religious paintings of

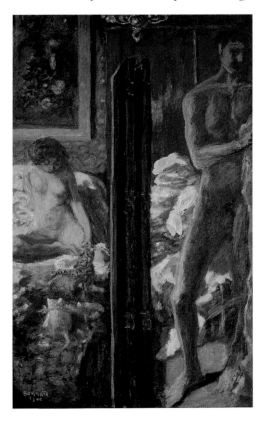

25. **Pierre Bonnard**, *Man and Woman*, 1900. In the years after 1900, Bonnard's art underwent a transition, as he ceased to be part of the avant-garde and began a personal exploration of Impressionist methods. Marthe Boursin, who was to feature so centrally in his painting, appeared now in a number of erotic works.

Denis. This practice took a more cynical turn in the paintings of Vallotton. In an extraordinary triptych, *Le Bon marché* (1898), 26 he interpreted the famous Parisian department store as a heaven of consumerism – a cynical reflection indeed of Denis's super-natural colour. He sets the bright and sharply contrasting hues of packaged goods against the generally shadowy mass of purchasers, who ascend and descend the central staircase. But these bright objects that the painting displays also turn it into another bright object for sale. Over twenty years after Vallotton painted this picture, André Gide (of the same generation as the Nabis, and an associate of *La Revue blanche*) wrote a novel describing the artistic culture that made its mingling of idealism and perversity possible. The title he chose, *The Counterfeiters* (*Les Faux-Monnayeurs*), suggests both the flirting with the illicit and the entrepreneurialism that characterized the Nabis and the Symbolists. It also aptly names a wilfully skewed reality, such as we find in Vallotton's *Le Bon marché*, whose very title – the Good Market – comes to appear sardonic.

26. **Félix Vallotton**, *Le Bon marché*, 1898. The description of compulsive commerce in Emile Zola's novel *Au Bonheur des dames* (1883), based on the Bon Marché, first of the big department stores in Paris, may have inspired the central panel. The magazine *La Revue blanche* was soon to move up market, to the area of big stores.

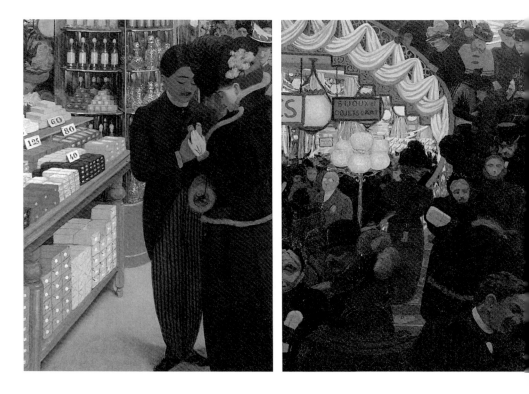

Commerce was, in hard fact, a matter of pressing concern for these artists. They banded together for practical purposes as well as on more idealistic grounds, since they followed the career path established by the Impressionists. As modernists, they had to find exhibition space outside the official framework, they needed to draw attention to their art, and they required dealers. They had accomplished all of this by 1904, when Bonnard, Vuillard and Vallotton began to exhibit in the gallery of Bernheim-Jeune, a leading art dealer.

The English painter Walter Sickert (1860–1942) showed there in the same year. Sickert, who had been working in France, was shortly to return to London, where he was to be instrumental in forming groups whose function was far more bluntly to do with selling. Both the Fitzroy Group, founded in 1906, and the Camden Town Group that grew from it in 1911 served commercial ends. There are close parallels, too, between the London and New York art worlds during this period, with respect to the publicizing and selling of modern art. The respective roles and personalities of Sickert and Henri, as teachers, organizers and

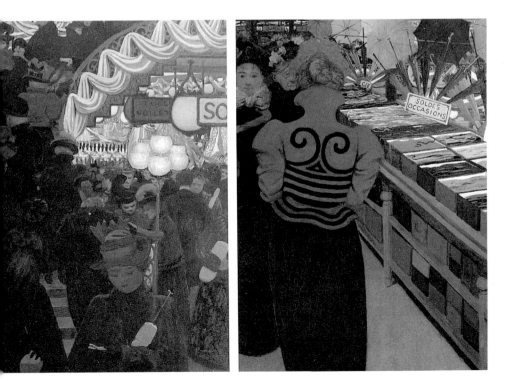

publicists, were in many ways similar. In both countries, independent exhibiting organizations had been established in the late nineteenth century to promote largely French-based innovation. The Society of American Artists stood to the long-established National Academy of Design as the New English Art Club did to the Royal Academy of Arts. In both countries, the younger organizations were themselves becoming restrictive by the 1900s. The English and American art worlds followed the French pattern, each establishing in rivalry to the official corporate structure a more diffuse pattern of activity in which exhibiting groups, private dealers and critics all interacted together.

In both London and New York, an already destabilized art world received a further shock with the arrival of still newer French art. The sensation created by the group show in which Henri and seven others ('The Eight') took part in 1908 at the Macbeth Galleries in New York was eclipsed by the famous Armory Show of 1913, with its Fauvist and Cubist exhibits. The British painter and critic Roger Fry's two 'Post-Impressionist' exhibitions, of 1910 to 1911 and 1912, caused equal disturbance

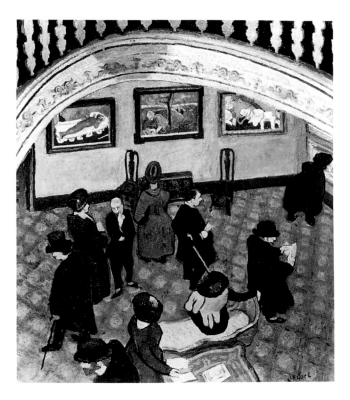

27. **Frederick Spencer Gore**, *Gauguins and Connoisseurs in the Stafford Gallery*, 1911–12. Roger Fry's exhibition 'Manet and the Post-Impressionists' at the Grafton Gallery in London from 1910 to 1911 set the precedent for this showing of Gauguin and Cézanne. Gore was a founder member of the Fitzroy Group and the Camden Town Group.

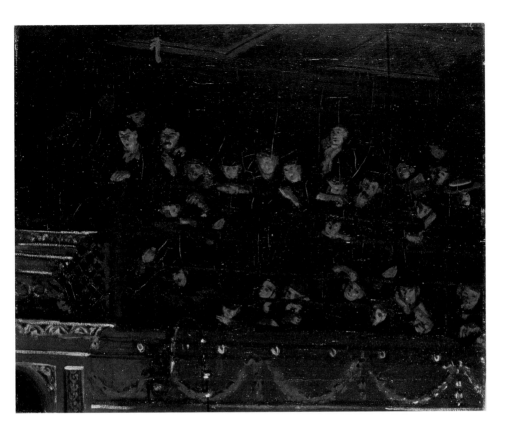

28. **Walter Sickert,** *Noctes Ambrosianae*, 1908. Theatrical deception and illusion appealed to Sickert as to Degas. Here, working-class spectators in steep seats rise up the canvas in a scattered pattern. Like the surrounding gilt, their enraptured faces reflect back the stage light.

in London. Between 1911 and 1912, Frederick Spencer Gore (1878–1914), a close associate of Sickert, painted *Gauguins and Connoisseurs in the Stafford Gallery*, depicting art-world figures catching their first glimpse of paintings by Gauguin and Cézanne. Part in tribute and part satirically, Gore adapts his style to greet the arrival of the *faux-monnayeurs* – the counterfeiters. His high viewpoint displays both viewers and viewed, and makes the gallery a microcosm of the urban scene, of its diversions, novelties and excitements. 27

English painters, like the Americans around Henri, followed French examples in presenting the city as an infinite spectacle, in which their paintings were themselves participants. When Sickert painted *Noctes Ambrosianae* (1908), showing spectators in the gallery at the Middlesex music hall, he dwelt on reactions of uninhibited delight and astonishment such as he might have wished his paintings to elicit. In framing the audience rather than the stage, he was being even more devious than his mentor Degas, whose café-concert pictures were a source of inspiration. 28

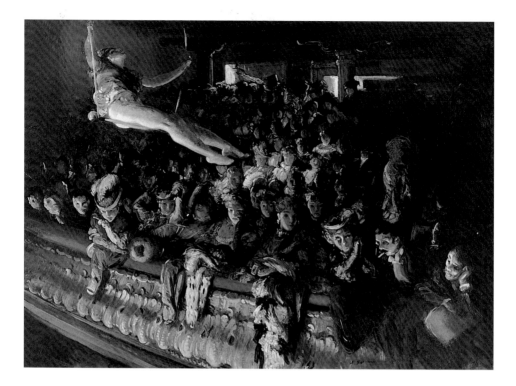

29. **Everett Shinn**,
London Hippodrome, 1902.
Shinn was the first member of
the group of Philadelphian artists
and illustrators at the core of
'The Eight' to enjoy commercial
success. This oil painting takes
up the dashing style of his
pastels; scattered light sources
illuminate the diverse responses
of individual spectators.

Quite independently, the American Shinn had used exactly the
same strategy in 1902, in his *London Hippodrome* (though Degas's
one-time pupil Mary Cassatt (1844–1926) had anticipated both
of them). Both paintings suggest more than they show. The
Sickert is more subtle if less thrilling; by ranging the faces paral-
lel to the surface, he directs the attention of the whole rectangular
formation down to the bottom left corner, where the gilded
gleam hints at what lies below – the framed scene reflected in this
frame of faces.

The faces shining dimly out of the reddish darkness are
typical of Sickert's way with light. His interior scenes of this
period fictionalize Camden Town, a working-class district of
London made notorious in 1907 by the murder of a prostitute,
whose naked body was found in her lodgings. Sickert, with an eye
for the sensational, painted several pictures related to the subject,
the most confrontational being *L'Affaire de Camden Town* (1909).
Using methods not unlike those of Vuillard, he immerses the
nude, brutally portrayed, in an atmosphere of squalour. Like
Vallotton's *La Chambre rouge*, the painting invites an attention
that mingles aestheticism with prurience. While less anti-

29
30

31

naturalistic than the Vallotton, Sickert's painting equally avoids narrational and descriptive clarity; the title does not mention murder and the viewer, left to interpret the scene, is effectively rendered a participant and denied judgmental distance. Even with less dramatic nudes, such as *La Hollandaise* (1906), there is a feeling of intrusion – assisted, as with *L'Affaire*, by the steep foreshortening of figure and bed. The woman is not merely intruded upon, however, for her presence is assertive and forceful rather than passive, as is the space with which she is identified, the whole being rendered in uningratiating impasto strokes of lilac, brown and dull green.

32

30. **Mary Cassatt**, *Woman in Black at the Opera*, 1880. Like Walter Sickert, whose career also began in the nineteenth century, Cassatt drew on Degas's treatment of theatrical subjects. Like Manet in *A Bar at the Folies Bergère* (1881–82), she associates Impressionist immersion in light with a universal social exposure to vision – but here gives her female protagonist an assertive role. The theme of watching one who watches, which conjoins seeing with being seen, had been developed by Manet in a series of café-concert paintings during the late 1870s.

31. **Walter Sickert**, *L'Affaire de Camden Town*, 1909. Sickert exhibited this painting, with its calculated glimpse of a chamber-pot, in the first exhibition of the Camden Town Group in June 1911, in order to attract publicity. There is no actual evidence of violence, Sickert typically (and provocatively) relying on the power of suggestion. The title does not mention murder, but the recent killing of a prostitute in Camden Town would have been brought to the minds of contemporary viewers.

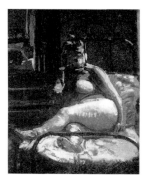

32. **Walter Sickert**,
La Hollandaise, 1906. Sickert
held that painting should deal
with 'gross material facts', but
also observed that the nude was
'in the nature of a gleam'. Here,
he paints bold volumes that are
yet insubstantial, disconnected
gleams in the dark.

The female body nonetheless remains the object of an attention that is male in the first instance, and this is also the case with Bonnard's *The Bathroom* (1908). Here, Bonnard paints Marthe's body with evident desire, modelling its contours in contre-jour silhouette and reflected light. Yet she has a self-possession that matches any possessing gaze, and she wholly appropriates the environment of colour she partakes of; held by light, she catches the light with an object she holds. However, despite the implied mutuality of the depicted space, Bonnard remained the painter in the partnership. No women were equal practitioners among these groups of artists. The Camden Town Group prevented women from exhibiting (lest wives or pupils be given favoured treatment). Among the New York painters of the 1900s, there were several who became supportive wives of better-known men. Women artists in England had a similar fate, the striking exception being Gwen John (1876–1939), who remained single and took a determinedly independent path, with support from her brother Augustus.

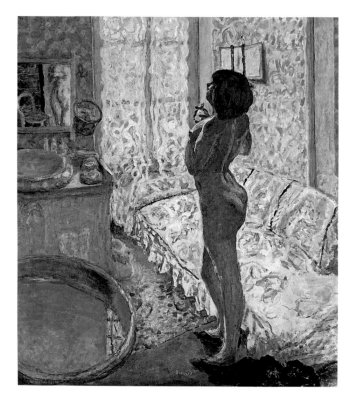

33. **Pierre Bonnard**,
The Bathroom, 1908. Light
and vision surround the naked
Marthe, since her body is seen
from in front (in the mirror) as
well as from behind. Yet she is
seen to be more than the object
of another's vision, since she
touches her own body, perhaps
to apply lotion; she is seen to feel.

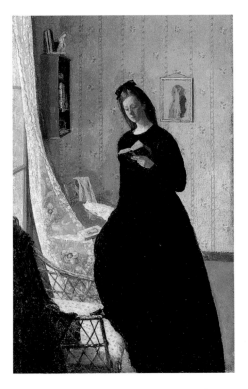

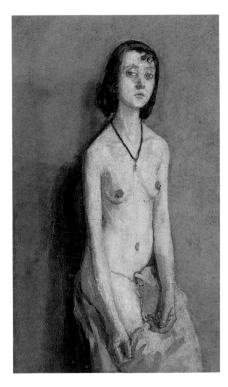

34. **Gwen John**,
Girl Reading at a Window, 1911.
John lived in Paris from 1904
onwards, sending work for
exhibition in London. A notable
painter of interiors, she would
likely have seen work by Pierre
Bonnard and Edouard Vuillard.
This painting has been compared
convincingly with the subject
of the Virgin Annunciate (John
was to convert to Catholicism
in 1913).

35. **Gwen John**,
Nude Girl, c. 1909–10. In
a companion painting, *Girl
with Bare Shoulders*, the clothed
model holds the same pose.
Here the medallion and the
presence of clothing draw
attention to her nakedness.

At the time of her self-portrait, *Girl Reading at a Window* 34
(1911), John was living in Paris, where she had for a time model-
led for Auguste Rodin (1840–1917), with whom she had had
a sexual relationship. This painting was the first she sold to the
American collector John Quinn, whose support gave her financial
independence until the time of his death in 1924. Like Sickert and
Bonnard, she identifies figure with space, though only partly
through the agency of light. Her painted self turns her upper
body to the window, partaking of the pale matt tonality that gives
the room its even, tranquil atmosphere. But the black dress stands
out sharply against the light on the right-hand side, and its long
vertical rhymes both with the window and with the verticality of
the canvas itself. The dryness of the paint, the self-containment
of the figure, and her identification with the vertical surface all
give the portrait a quality of holding its own space – almost against
the viewer. This upward flattening of the figure characterizes
John's other oil portraits too – all of women – which in later years
become hieratic images of repose. Her earlier paintings give a
strong yet unemphatic account of her sitters' individuality. *Nude* 35
Girl (c. 1909–10) is not simply a nude but a portrait (John painted

the same sitter clothed). The lean figure is tensely upright, perched rather than seated, her body turned slightly to the light-source. She is close to the wall and to the surface plane of the canvas – all three are collapsed together. There is a remoteness and perhaps a challenge in her expression. Seen too readily as a 'spiritual' painter, John here gives a very material account of a subject as elusive as the spirit: the embodiment of the self.

Corporeality

No subject of painting speaks to us more directly than the human body. Nothing is more real to us, in that it is the part of reality we know most intimately. Yet there is no subject more elusive, for the body, as depicted at all times and in every culture, appears as a paradoxical and contradictory entity, combining matter and spirit, animality and divinity, selfhood and sociality. It is something that we inhabit, and yet see outside ourselves, in the bodies of others and in our own reflections.

Realism in western painting, as it developed over recent centuries, expressed this dividedness of the body through a division in pictorial method. On the one hand, taking Greco-Roman sculptures as their prototypes, Renaissance painters gave their nude figures the traits of anatomical coherence and physical cohesiveness proper to actual bodies. Yet the illusionistic methods they used to project such figures in depth, on a flat surface, necessarily invoked the subjective viewpoint of a beholder. In the genre tradition, as we have noted, there was a comparable duality, an alliance of the actual and the virtual, since genre painting developed techniques of suggestion. Impressionism took such techniques to a radical extreme; Impressionist paintings strongly suggest our perceptual, bodily immersion in reality, by presenting us with diffuse fields of pigment that are at once illusionistically enveloping and physically immediate.

Pictorial realism thus came both to portray the body and to imply it: portraying it as an object of vision, implying it by allusion to the (subjective) visual field. This duality of inside and outside reflected a dualism in the western cultural and religious traditions that informed realist practice. Yet this is not the only duality or contradiction involved here. Precisely because the body is what we all have in common, images of it have the potential to touch on our deepest disagreements. Images of the human body can be highly controversial, in a wide range of contexts, both religious and secular, ranging from Judaic and Islamic prohibitions of image-worship to latter-day feminist critiques of

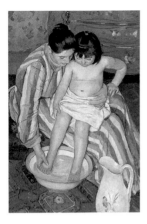

36. **Mary Cassatt**, *The Bath*, 1892. Cassatt's treatments of motherhood do not reflect personal experience, as she had no children. Friends and servants posed for her. Madonna images are inevitably recollected, but Cassatt often represents infant girls and, as in this case, attends to the prosaic aspects of child nurture; it is not even obvious here that the woman is the child's mother. Yet in its observant descriptiveness *The Bath* conveys more strongly than do many insistently maternal scenes the sense of communication between two bodies.

the imaging of gender. To paint the human body, then, has entailed a use of divided means to depict something understood culturally as divided within itself, which is furthermore the focus of profound ideological and emotional conflicts.

One of the dichotomies at work here is that between conservative and radical impulses in realism, referred to at the beginning of this chapter. It is possible to see modernist realism in terms of a recurring dialectic, or argument, between two principles; an internal dispute in art which, as it recommences, draws in the wider cultural arguments referred to above. To take an example, *The Bath* (1892) by Cassatt presents what appears at first sight to be unqualified harmony, and yet there are underlying dissonances. There is a conflict within the very structure of the painting, since it betrays a divided allegiance. In Paris, where she pursued her career, Cassatt exhibited with the artists calling themselves Independents and Impressionists. However, like Degas, to whom her work is visibly indebted, she at once participated in Impressionism and turned away from it. We can see how this painting participates in the radical turn to subjectivity, for the handling of colour, the orientation of the scene and the compression of all planes towards the picture-surface conjure a perceptual field implicitly inclusive of the beholder. The figures and even the objects communicate through this field, drawing the viewer in as well. Yet Cassatt does not deploy expression and gesture so as to engage the viewer emotionally. Instead, she attends to physical actuality; both gazes turn to the mother's hand holding the foot in the water, and the child's left arm pushes against her mother's knee for support. Accompanying this stress on the actual is an accentuation of form, and of the integrity and solidity of the child's body in particular. In her realization of the corporeal, Cassatt draws on academic traditions of life drawing and of the monumental nude, as Degas and Cézanne had done.

From Cassatt's time to our own, depictions of women and pictorial interpretations of gender and sexuality have been matters of dispute. For Griselda Pollock, an influential feminist art historian who has written incisively on Cassatt, an image such as this, in its modernity and actuality, undermines the traditional image of timeless femininity, of madonnas with infants. However, it might also be observed that, if all our prototypes of the human image are noble or divine, then realism dethrones them all, irrespective of gender. Additionally, painters' efforts to represent either male or female bodies during this period took place in a wider context of dispute regarding sexuality and relationships

36

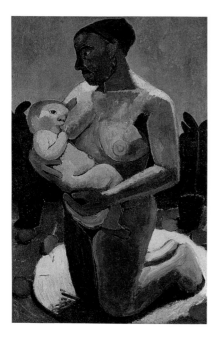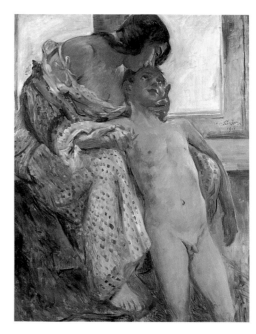

37. **Paula Modersohn-Becker,**
Kneeling Mother and Child, 1906.
Modersohn-Becker's paintings
from this period include
other naked mother and child
compositions, as well as self-
portraits. As here, the figures are
simple and monumental and tend
to fill the frame. She gave birth
to a child the following year, and
died shortly afterwards. Unlike
Mary Cassatt, who uses the
conventions of 'modern life'
painting, Modersohn-Becker
here associates motherhood
with the earth.

between men and women, both intimate and social. The argument was taken up in literature as well as in painting, by Strindberg and Ibsen as well as by Edvard Munch (1863–1944); in psychology and in the new field of psychoanalysis. Men certainly dominated the debate and were overwhelmingly predominant socially; but among artistic élites, the imbalance was slightly less, and self-examination was the rule.

It is worth comparing Cassatt's painting with two other mother and child images, *Kneeling Mother and Child* (1906) by Paula Modersohn-Becker (1876–1907) and *A Mother's Love* (1911) by Lovis Corinth (1858–1925). Both these Germans spent time in Paris and drew significantly on French painting, in ways characteristic of their respective generations. Corinth, whose work combined aspects of Symbolist and academic art, here brings Impressionism into play, using a characteristically exuberant and painterly technique. Modersohn-Becker's painting, on the other hand, reflects a use of Gauguin and Cézanne (whose work Corinth, too, admired). Both the younger and the older painter treat nudity in an assertive rather than in a merely conventional spirit. Movements in contemporary German culture promoted a cult of youth and nature, and both painters equate nakedness with naturalness, an emphasis absent from Cassatt's painting. As a member of the artists' colony at Worpswede in

37

38

38. Lovis Corinth,
A Mother's Love, 1911.
A founder-member of the
progressive Munich Secession,
an artists' association, in 1891,
Corinth was by 1911 a well-
established artist, and president
of the Berlin Secession. His wife,
Charlotte Berend, shown here
with their son, had been his
first pupil, in 1901. Here, an
association with Madonna
compositions (by Michelangelo
and Raphael) is surely intended,
and the child's pose is assertive
of his gender.

north Germany, Modersohn-Becker had participated in an artistic return to nature and to a natural simplicity whose embodiment she, like the others, found in the peasant society of the region. Whereas one of the group's founders, Fritz Mackensen (1866–1953), had painted a peasant mother and infant in deliberate echo of the madonna and child, Modersohn-Becker here contrives a primal and monumental image, in which life-giving motherhood is redolent of fertility in nature. In its deliberate removal from observed reality, the painting joins a tradition of symbolic realism that had originated in the peasant scenes of Jean-François Millet (1814–75).

Corinth's painting differs from Modersohn-Becker's in almost every respect, except that Corinth, in letting the dress slip to disclose the mother's breasts, evokes the nursing of the infant. It is as personal as the Modersohn-Becker is anonymous, for this mother and child are Corinth's much younger wife and their son. While Corinth's sculptural realization of the child is at least as strong as Cassatt's, he blends where she separates, immersing the figures in an atmosphere at once visual and emotional. As the title shows, the painting's whole impetus is subjective, and in addition to the adoring exchange between mother and son, a third – and certainly paternal – gaze is strongly implied. Patriarchal as it may be, the painting is unsettling in its eroticism.

More disturbing still is *The Blinded Samson*, which Corinth 39 painted in 1912, while recovering from the stroke he had suffered not long after completing *A Mother's Love*. In its blind thrusting, the body loses its power, to become a mere blundering physical force, its impotence signified by the manacles and loincloth which, taken together with the bloodied visage, suggest castration. Corinth's constriction of the body into a narrow space and his urgent handling serve to project an internal chaos of impotent energy.

Other painters of the time used more programmatic methods to close the body upon itself, for the purpose of suggesting its inner life, and its mortality. The body's life cycles, its suspension between life and death, vitality and sickness, were themes to which painters of the Symbolist generation returned repeatedly, among them the Norwegian Munch and the Swiss painter Ferdinand Hodler (1853–1918). When his mistress Valentine 41 Godé-Darel lay dying of cancer, Hodler drew and painted her incessantly, as if to capture what could not be brought into view, tracing from outside the ebbing of life and the encroaching isolation of death; recording the formation of the brittle mask.

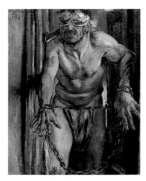

39. Lovis Corinth, *The Blinded Samson*, 1912. Corinth's sense of selfhood was bound up with his sense of masculinity; manifest in the self-portraits he painted on each birthday after 1896, his maleness is in crisis here (after the confidence of *A Mother's Love*).

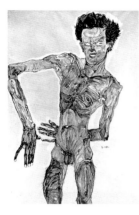

40. **Egon Schiele**, *Nude Self-Portrait, Grimacing*, 1910. Schiele's most radical works present the body in terms of extremes of pain or sexual ecstasy. He thus brings subjective feeling and objectifying vision into violent conjunction.

41. **Ferdinand Hodler**, *The Dying Valentine Godé-Darel*, 1915. A major Swiss painter who participated in the Symbolist movement at the end of the nineteenth century, Hodler is best known for his monumental paintings allegorizing the cycle of human life.

42. **Egon Schiele**, *The Family (Squatting Couple)*, 1918. Borne down by their own weight, the bodies of the man and the woman appear as inert physical mass; they are without animation and seem depressed or devoid of feeling.

Nowhere, during these years, is the life of the body more tellingly isolated, as if pinned to a board, than in the work of Egon Schiele (1890–1918). This artist owed something to Hodler in his schematic containment of his figures. In watercolour and gouache drawings he made of himself in 1910, the background lies flush with his contorted naked body. A tense and angular outline, accentuated by a surrounding rim of white gouache, gives the flattened body a hard edge, to render it as an object of intense (self-) scrutiny. But because the figure is flattened, the ground bare, the viewer's attention is invited to switch back and forth across this boundary, from inside to outside. Within, the brushing is soft and transparent, even if it models a lean and bony physique. It extends the feeling of tense discomfort, evident in the face, throughout the entire body. There is an analogy with Corinth, in the artist's re-enactment of his body in paint. This is painting as mime; indeed, Schiele used a professional mime as a model for a while. The body becomes a mask, a persona.

In its decorative rhythms and its eroticism, Schiele's work owed a debt to Gustav Klimt (1862–1918), the major figure in the Viennese art world of the 1900s, an artist on whom Schiele modelled his career, and who gave the younger artist assistance at crucial periods. However, like his contemporary Oskar Kokoschka (1886–1980), Schiele departed significantly from Klimt's practice, partly in response to a change in the critical climate. In very general terms, the change involved a new emphasis on clarity and differentiation, which in the influential polemics of the architect Adolf Loos (1870–1933) required a turn from ornament to plain articulation. Klimt's great allegorical cycles blended their tumultuous figures together, portraying human sexuality as an ingredient of universal nature. Schiele produced allegories too, but in a different spirit. His famous monumental painting *The Family (Squatting Couple)*, from the year of his death, 1918, characteristically isolates the protagonists in their individuality, even though they constitute a couple (*Squatting Couple* was Schiele's title, not *The Family*). The painting was intended to form part of an allegorical cycle for a projected mortuary chapel, in a sequence concerning 'earthly existence'. The woman (a model, not Schiele's wife Edith) looks away to the side, beneath the painter's predominant gaze. Here, as in the 1910 drawing, Schiele in the first place sees himself (*Self-Seers* was a title he used more than once for double self-portraits), and through that, others. Schiele, as it has often been argued, showed in his studies of pubescent girls, including his sister Gerti, an understanding

40

42

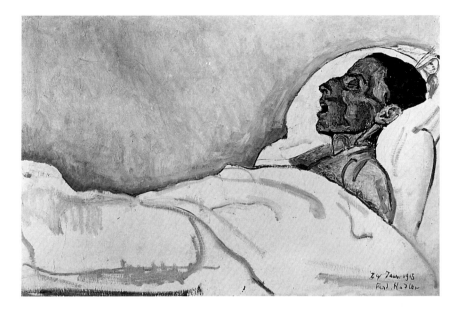

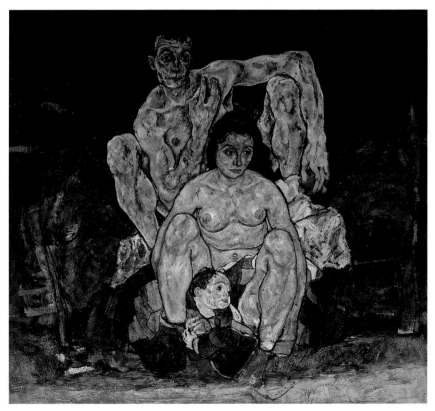

that stemmed from his own closeness to adolescence, still felt in the 1910 drawing. Fascinated with sexuality, he produced many erotic drawings, including scenes of masturbation, for the egotism of sex clearly preoccupied him. The erotic in Schiele entails not only the subjectivity of arousal, as suggested in earlier works by a hypersensitive line and agitated, transparent brushing, but also a staring objectivity and specifically an intense focus upon the female genitalia. His art is realist in its passionate appetite for the actual; his eye is aroused by what is not sublime in the naked body. Few nudes are more naked than Schiele's, exposed, their bones protruding, limbs contorted in pain or ecstasy. Love in Schiele is the opposite of Platonic; far from suggesting an escape of souls into transcendent union, his pictures describe with intensity the separateness of embodied selves, a separation that is a source both of dismay and excitement.

Cubism and Realism
We use the term 'realistic' of paintings that present an illusion of reality and indeed, as I have argued, realism in western art has been founded in illusionism. However, we also customarily speak of reality as *distinct* from illusion, and I have invoked this sense of the real in several contexts, for example in relation to sculptural properties of solidity and cohesiveness. Modersohn-Becker's figures, while not illusionistically real, have something of this quality. One factor involved here is the contrast between the tactile and visual senses, since we may be assured of the physical reality of that which we can touch. Cubism, the most radical development in the art of the period, finds a place here since it was radical precisely through transforming the Impressionist (and Symbolist) field of vision into what could be called a visual-tactile field. In this, the Cubists drew inspiration from Cézanne, even while developing methods utterly different from his.

Cubism, we might say, takes realism apart, but does so for a realist end. In *Seated Female Nude* (1910) Pablo Picasso (1881–1973) invokes the methods of pictorial realism only to deny an illusion of coherent physical reality. But in the process, he both sets in play and puts on view the pictorial conventions for rendering depth and solidity. Tonally contrasted areas of paint demarcated by straight and angled lines suggest planarity and depth without allowing the shifting planes to gather into a unified image. This means that the immediate physical reality of the painting itself prevails over the pictorial reality of the depicted body. The nude here does not stand out in space as does Eakins's

43

43. **Pablo Picasso**,
Seated Female Nude, 1910.
Between 1907 and the outbreak of the First World War in 1914, Picasso and Braque (see plate 44) invented a new artistic practice, based on the playful analysis and redeployment of the conventions of pictorial realism; this game, whose rules continually changed, was labelled 'Cubism'.

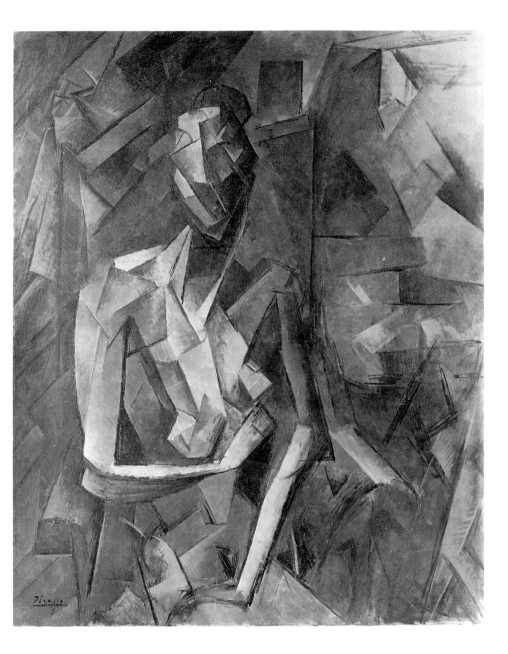

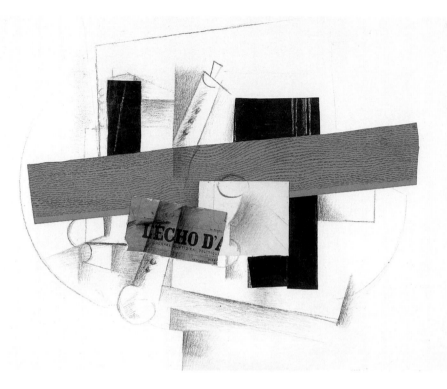

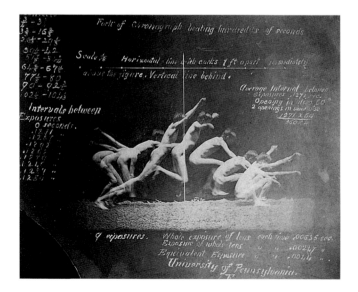

44. **Georges Braque**, *Clarinet, Glass and Newspaper on a Table*, c. 1913. The *papiers collés* represent the most inventive phase of the Braque–Picasso creative partnership. Here, paper printed as wood represents the substance of the table; the newspaper, crossing the clarinet, happens to be called *L'Echo*.

45. **Thomas Eakins**, *A Man Jumping Horizontally*, 1885. In the mid-1880s, Eakins, who was in contact with Etienne-Jules Marey and collaborated with Eadweard Muybridge, made chrono-photographs. He also designed a revolving disk camera, adapting and improving on Marey's.

in *William Rush*; nonetheless, there are resemblances, for Eakins, as was noted, brings attention to the artist's labour, and asserts the materiality of the body. On the first point, we might set the array of artist's implements on the wall in the background of Eakins's painting beside a Cubist *papier collé* of 1913, in which Georges Braque (1882–1963) plays a game with the conventions of still life and *trompe-l'oeil*, and where the very components are themselves the artist's tools. On materiality, we can note the predominance of earth colours in both the Eakins and the Picasso – colours of matter, rather than of air and light. Finally, in the famous *Nude Descending a Staircase, no. 2* (1912) by Marcel Duchamp (1887–1968), a painting whose form derives from the chronophotography that had also engaged Eakins, we see being set to work once more the antithesis between allegory and material actuality, as the nude, yet again, descends to earth, and into our argumentative midst.

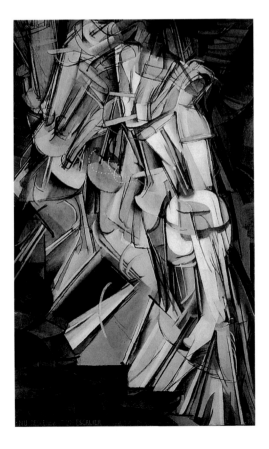

46. **Marcel Duchamp**, *Nude Descending a Staircase, no. 2*, 1912. The physiologist Etienne-Jules Marey's photographs of sequences of superimposed movements stimulated Duchamp's pictorial experiments at this time. This painting became famous after its inclusion in the 1913 Armory Show in New York.

Chapter 2: Between Wars: Realism, Modernity and Politics

47. **Pavel Filonov**, *Portrait of Stalin*, 1936. Filonov (1883–1941) who, as an avant-garde artist, was unable to practise freely under Stalinism, worked without exhibiting from 1933 until his death from starvation in the siege of Leningrad in 1941. Counting himself, despite persecution, a 'non-Party Bolshevik', he produced this hauntingly Byzantine image of the tyrant.

At no time in the twentieth century did the concept of 'realism' have more currency than during the interwar period of 1918 to 1939; yet no stable meaning for the term itself emerged from the shifting and conflictual contexts of the time. As if in recognition of this fact, the organizers of an influential exhibition on the years in question, held in 1981 at the Pompidou Centre, Paris, took as their title 'Les Réalismes'. Even the pluralistic usage 'realisms' can be misleading, however, since not all the practices in question presented themselves as expressly realist. Painters of the Italian Metaphysical School, for example, defined their art as classical; they made use of early Renaissance pictorial conventions to create contradictory worlds that were simultaneously real and unreal – a strategy that some Surrealist painters were to adopt in their turn. By contrast, the Social and Socialist Realisms that arose in the latter part of the period purposely embraced social and political actuality, and their versions of realism, however diverse stylistically, were inseparable from that commitment.

If realisms there were, their definition was constantly open to negotiation. Accordingly, the topic of realism featured centrally in the art criticism of the period, as also in literary criticism and cultural theory. Indeed, 'realism' is the term through which it is most possible to cross-refer between different art forms of the 1920s and 1930s, although this does not mean that critical categories may simply be transposed from one field to another. Only in the case of Socialist Realism, after 1935, did a universal critical principle emerge. Otherwise, on both right and left, 'realism' took on changing meanings in the flux and conflict of argument. The abiding ground of argument was political, for politics was the historical reality that pressed on painters and critics, as it did on others. The period opened in the aftermath of the cataclysmic First World War and with the shock of the Bolshevik Revolution of 1917 in Russia. Another revolution, which was brutally suppressed, took place the following November in Germany. In this atmosphere, a cultural act could imply a political choice between the polar opposites of social revolution

and nationalist consolidation: either the system was to be over-thrown or it was to be restructured, in the name of the nation.

The 'call to order' movement that gathered pace among French and Italian artists during the First World War aimed partly at a recapitulation of national cultural traditions. *Valori plastici* (Formal Values), the Italian magazine that supported the nascent Metaphysical School, was founded in 1918, a year before the formation of the Fascist party. While not all associates of *Valori plastici* or even of the Novecento (Twentieth Century) Group founded in 1922 by Margherita Sarfatti (Mussolini's mistress) were Fascists or Fascist sympathizers, some definitely were, among them Carlo Carrà (1881–1966) and Mario Sironi (1885–1961). The régime certainly laid claim to the forms and emblems of Italian – and ancient Roman – tradition, although it did not institute an official policy for art. In fact, it is not always possible to establish simple alignments between style and ideology in the period. French advocates of a return to classicism were in some cases outright traditionalists, in others – as with the 'Purists' Charles-Edouard Jeanneret (Le Corbusier) (1887–1965) and Amédée Ozenfant (1886–1966) – promoters of a universaliz-ing modernism. Styles changed their meanings in different con-texts, and the motifs of nationalism and of social revolution interacted diversely in different settings. Soviet Socialist Realism, for instance, had nationalistic aspects.

Two general features are constant, among the range of practices to be discussed here. One is an insistence on technique, ranging from the reaffirmation of traditional methods, to the redefinition of art as 'production'. The other is that painters of the period dwelt acutely on the boundary between art and life – the central preoccupation of realism, renewed in the political tensions of the time. Bearing politics in mind, it is worth adding that the subject of the city, recurrent in realism at all periods, arose with new urgency and in varying shades of unease: the city as dreamt, feared, endured, renewed and destroyed.

Suspended Reality: Transcendentalism and Critique

More than one historian has remarked how frequently visual art of the interwar years evokes the themes of Sigmund Freud's essay on 'The Uncanny', published in 1919. The sense of an uncanny or dream-like reality, as if moulded by anxiety or desire, pervades the painting of the 1920s and 1930s. This is most conspicuously true of work associated with the French and Italian 'call to order' and with German 'new objectivity'. *Unheimlich*, the

48. **Roger de la Fresnaye**, *Portrait of Jean-Louis Gampert*, 1920. Calls for a return to French classical traditions in art, voiced during the First World War by Jean Cocteau and André Lhote, and foreshadowed in Derain's practice, found a response in work produced in the 1920s by former Cubists, including de la Fresnaye. Like Picasso's portraits of the 1920s, this painting takes the work of the great French nineteenth-century neo-classicist Ingres as a model, while such Cubism as remains contributes to the formal discipline. The turn from anarchic pre-war Cubism to the French 'Grand Tradition' implied a shift from individualism to an art of order, grounded in national culture.

German word that translates into English as 'uncanny', is itself at the centre of Freud's reflections; its opposite is *heimlich*, 'familiar' ('homely'), and Freud points out that the distinctive quality of the uncanny is that of something strange-yet-familiar, a thing we somehow know, yet are not 'at home' with. We might say that the 'reality' in question in much interwar painting is the 'heimlich' which has become an object of uncertainty, 'unheimlich'. The reasons why this came to be so are complex, but one contributing factor was the *rappel à l'ordre* (call to order) which originated in French modernism before the First World War. Painters returned to earlier traditions for models of order, through which to counteract the anarchy of Cubism. It was Cubism itself, paradoxically, that prompted the return, for order was latent in its anarchy. Additionally, its realism was conspicuously artificial, and pictorial realism had begun, in the Renaissance, through the artificial contriving of illusion – carried out in the studio and not *en plein air*.

The outstanding painter of the 'call to order' movement – even though he distanced himself from its theorists – was André Derain (1880–1954). By 1913, when he painted *Saturday*, Derain had long relinquished the style of his Fauvist years, to develop a practice that steered a course between Cubism and Cézanne. The posthumous influence of Cézanne on French artists, together with the publication in 1912 of the classicizing *Theories* of one of his principal interpreters, Maurice Denis, prepared ground for the 'call to order' in painting that Derain did much to initiate in practice. *Saturday* comes from the crucial period of 1912 to 1913 when Derain, concentrating largely on still-life subjects, used Cézanne as a means to reorient Cubism towards earlier tradition. Simultaneously, he used Cubism to select what he wanted from Cézanne, namely those qualities of formal coherence and 'solidity' that impressed others of his generation and established the terms in which Cézanne was to come to be seen. The Cubo-Cézannian synthesis is particularly evident here in the fruitbowl and sheet at the front of the table. Derain's is the Cézanne of objects, not of 'sensation' and Impressionist flux. His intention was to create an order (a 'rhythm') that was internal to painting and that drew on tradition. This order was to be timeless, untroubled by perceptual instabilities. Although the figures in the painting act, there is no naturalistic sense of movement; gestures and actions are geometricized, presented as signs on the surface rather than movements in depth. Planes are tilted upwards, as in a Cubist painting; but unlike Braque or Picasso,

48

49

Derain does not cause objects, figures and ambient space to inter-penetrate. Each element is self-contained, in a solemn composure epitomized by the arched hands of the woman on the right. By these various means, Derain brings a familiar habitation close to us, at monumental scale, while yet holding it back, estranged, within the confines of art.

Derain, whose reputation was to diminish drastically after the Second World War – partly due to accusations of collabora-tion with the Nazis – became a central and influential figure in art during the 1920s. André Breton and the other poets who founded Surrealism were drawn to his work, partly through recognizing a shared inheritance from Symbolism. The Italians Carrà and de Chirico responded strongly to Derain's painting when they were in Paris before the First World War. The poet Guillaume Apollinaire, a supporter of both de Chirico and Derain, wrote the catalogue essay for Derain's exhibition of 1916, an essay which, in its emphasis on antiquity and French tradition, enunciated the themes of the 'call to order'.

49. **André Derain**, *Saturday*, 1913. As in a Cubist painting, the light and dark tones that define volume are left unblended, and lie on the surface as conventional signs. Stylistically suggestive of pre-Renaissance art, the painting evokes a perennial domestic calm.

Derain's *Harlequin and Pierrot* (1924), commissioned by his 50
new dealer Paul Guillaume, marks the epoch of Derain's fame
and commercial success. It is also definitively of its time, even
fashionable, treating a theme – the *Commedia dell'arte* – shared by
Picasso and used in his designs for the ballet *Pulcinella* in 1920.
Derain himself was now designing for the theatre, and *Harlequin
and Pierrot* appears as a stage scene, before a painted backdrop.
The figures are strongly modelled, but in a top lighting which
renders the faces as shadowy masks. In their mingling of the solid
and the insubstantial, they resemble Picasso's contemporary
neo-classical figures and, still more, the inhabitants of the
German painter Max Beckmann's (1884–1950) painted theatre.
Derain's painting presents its stage illusion on a theatrical scale,
setting its figures in a shallow space whose limits only just con-
tain them. Vivid and imminent, they are yet unliving, as tantaliz-
ingly near and far as stage performers. Dancing weightlessly,
pressed to the surface like the still life below them, in geometric
formation within a perfect square, the pair mime to the
silent music of stringless instruments. Art, though confined to
mimicry, intimates a higher order, an unheard music.

De Chirico was equally preoccupied with the antithesis of appearance and reality and, like Derain, meditated on symbolic geometry. Paul Guillaume, who was to be Derain's dealer, gave de Chirico the 1922 exhibition in Paris that established his reputation; it was André Breton who wrote the catalogue preface. The mysterious perspectives and long shadows of de Chirico's prewar canvases were to provide a model for Surrealist painting. When, late in life, Magritte recalled having been moved to tears by a reproduction of de Chirico's *Song of Love* (1914), because it let 51 him 'see thought', he evoked the 1920s yearning for a compelling pictorial reality remote from the realm of the senses.

De Chirico had arrived at this way of painting 'thought' after academic training in Athens and then Munich, where he drew inspiration from the symbolist realism of Arnold Böcklin (1827–1901) and Max Klinger (1857–1920). The direct influence these artists had on his work lessened during his time in Paris, from 1911 to 1914, when he painted imaginary Renaissance piazzas,

51. **Giorgio de Chirico**, *Song of Love*, 1914. In the rubber glove, de Chirico chooses a plainly utilitarian object, and paints it in *trompe-l'oeil* style, as 'really there'. Yet he also undermines the illusion, with his customary black outline and shadow (a shadow without sunlight) – so that the ordinary glove is on the verge of becoming something indeterminate.

rendering the spaces enigmatic through an intimation of objects out of view. *Song of Love* retains their tantalizing quality, in the alternating spaces of the arcade and the train partly hidden by the wall. The closing of the near ground, however, was a relatively new development, and it yields a shallow object–space equivalent to that of Derain. It is a world without movement; a sense of 'without', of something crucially absent, pervades the painting. A cast head of Apollo, a rubber glove and a sphere stand in enigmatic juxtaposition. Offered insistently to the eye, with strong cast shadows, a *trompe-l'oeil* nail, and biting colour, they each attract the gaze in turn, like maddeningly unavoidable objects of thought. For de Chirico, Apollo would have had a direct association with the German philosopher Nietzsche, whose book *The Birth of Tragedy* (1872) influentially contrasted Apollonian order with Dionysian disruptive energy. Nietzsche's Apollo represents the consoling illusion of order in art, evoking Arthur Schopenhauer's distinction between will and idea (*Vorstellung*), which de Chirico also knew well. The rubber glove might recall a quite different glove, also familiar to de Chirico, that features in a sequence of etchings by Klinger; dropped by an attractive woman, it becomes a vehicle for the artist's fantasy. As in Freud's theory of dreams, an object displaces a desire. The objects that appear in *Song of Love* are seen to be incomplete, or empty: a cast in place of a head, a glove instead of a hand.

Moulding is the common denominator between glove and head in the de Chirico. Both objects, additionally, are kinds of effigy. A year later, effigies in the form of mannequins were to appear in de Chirico's canvases. These figures were to distinguish what became known as metaphysical painting, a term that arose through the forming of a group of artists, the Scuola Metafisica (Metaphysical School). It was the war that brought together the founders of the group, Italian artists who had volunteered for military service. Carrà, who had also been in Paris, met de Chirico in a military infirmary. A former Futurist, Carrà had written articles in the journal *Il Voce* which mingled Futurist rhetoric with references to pre-Renaissance Italian artists, Giotto and Uccello – incongruously, since Futurism famously proposed destruction of museums, but consistent in the orientation to cultural nationalism. De Chirico's paintings showed Carrà a means to reconcile antiquity and modernism. The paintings he produced in 1917, typified by *The Metaphysical Muse,* are heavily dependent on de Chirico, save that space and tonality are coherent whereas in de Chirico they are disjunctive. Both Carrà and Morandi, the

52

other principal exponent of metaphysical painting, adapted de Chirico's iconography to more purely formal ends. Morandi's metaphysical paintings are invented still lifes, projections in ideal space of non-existent objects, painted with hallucinatory precision. Produced in 1918 and 1919, they belong to a relatively brief moment in art. As a style, metaphysical painting did not survive long after the founding of the magazine that publicized it, *Valori plastici* (1918–22).

The magazine, together with associated exhibitions, helped stage the transition from metaphysical art to a new classicism (which the Novecento Group was later to claim for Fascist cultural politics). This took diverse forms. De Chirico, declaring himself in 1919 a 'classical painter', became absorbed by technique and painted self-portraits and still lifes which accentuate

52. **Carlo Carrà**,
The Metaphysical Muse, 1917.
One of the defining features of metaphysical painting was the depiction of lay figures or mannequins, initiated by Giorgio de Chirico. Carrà's version seems as if cast from a mould: with racquet and ball pressed to the skirt, it suggests mobility yet embodies stasis.

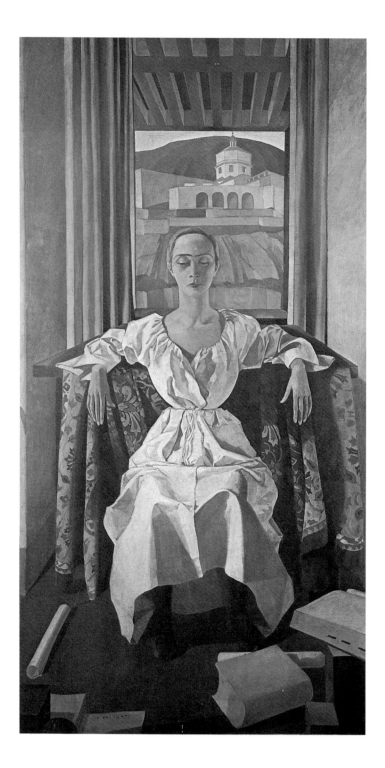

53. Felice Casorati, *Silvana Cenni*, 1922. Over two metres high, probably originally wider, this studio scene contains a lifeless figure to whom the title gives a fictional name. She is an empty persona, like one of Luigi Pirandello's 'six characters', in the pose of a Piero della Francesca Madonna (*Six Characters in Search of an Author*, first produced in Italy in 1921, explores the paradox of theatrical illusion). The medium, tempera, recalls Quattrocento art.

living and sensuous qualities, while constraining them within the frame of artifice. The paintings hold a balance between living matter and dead form, the liquid and the arid. The effigy stands in place of the living, as it equally does in the paintings of Felice Casorati (1883–1963), who began to make a reputation at this time. *Silvana Cenni* (1922), his best-known painting, revisits Piero della Francesca (1410/20–92) by way of Cézanne; the figure arises from the complex perspective of objects on the floor and is herself arranged as an object, her hands hanging limply, her head rigidly upright. The painting has the air of a metaphysical Morandi, especially in the arrangement of objects.

Morandi himself had by now opened up the narrow field that he was to explore so intensively for the rest of his life, as we can see from a wonderful still life of 1921 in the Ludwig Museum,

53

55

54. Dod Procter, *Morning*, 1926. This figure, by the British painter Dod Procter (1892–1972), has an affinity with Casorati's reclining nudes, hers differing from his mainly through a sense of weight. There is a sensuous empathy with the model, an erotic intimacy. Several interwar exhibitors at the Royal Academy of Arts in London, including Procter, Meredith Frampton and Stanley Spencer, developed versions of modernist-classical realism.

55. Giorgio Morandi, *Still Life*, 1921. Morandi, one of several painters of the period who responded creatively to Cézanne's still lifes, painted objects at once palpable and elusive; here, a pitcher shaded on one side loses definition on the other, held between volumetric depth and painted surface.

Cologne. The Cézanne exhibition of 1920 in Venice is often cited as an influence for both Casorati and Morandi, but it is important to note how drastically Morandi reduces the range of Cézanne, with colours as with objects. He replaces Cézanne's shifting and scintillating space with a compressed band of mainly earthen hues, lying parallel to the gaze. This still life comprises moulded, pre-formed objects of art, and the brush softly models the mostly clay-like pigments. Whereas nineteenth-century French realism opened radically towards nature, here is a realism emphatically of the studio. Even Morandi's landscapes assume still-life formation. With some exceptions, nothing natural appears in Morandi's still lifes, and the colours, bleached or baked, have the dryness of his objects. Yet the paint, in impasto, softens the objects back to a moist state. To take a complementary example, Salvador Dalí (1904–89), in a still life of 1926, paints bread in a hard style but to liquefying effect. Both paintings present malleable objects, modelled as if in response to emotion or desire; we apprehend the uncanny substance of a dream.

Dalí's painting is one version of a kind of realism particular to this period: one which, in Cubist-inspired exploitation of *trompe-l'oeil*, accentuates the paradox of illusion. Objects formed to attract the touch are offered as if at reaching distance, only to

56. **Salvador Dalí**, *Basket of Bread*, 1926. At the time he painted this still life, Dalí was painting in a range of modernist styles, with an eye on developments in France and Italy. In its hyper-realism, the painting anticipates his future Surrealist practice.

57. **Rudolf Schlichter**, *Studio Roof*, 1920. Schlichter, a member of leftist art groups in Germany throughout the 1920s, here adapts the devices of metaphysical painting for social-critical ends; also in evidence is his taste for sexual fetishism.

elude our imaginary grasp (Morandi's pitcher dissolves). Figures approach the footlights only to show a bewitching hollowness. Realism of this kind exceeded experience. Alternatively, it addressed an experience of estrangement that was specifically modern. This was the case with a group of German artists who, at the beginning of the 1920s, adopted the idioms of Italian metaphysical art while rejecting its principles. In *Studio Roof*, a watercolour of 1920 by Rudolf Schlichter (1890–1955), the mannequins and doll-like figures seen against the blank façades do not, as with Carrà and de Chirico, evoke the past or the enigmatically imaginary. Their strangeness is of the present. The floorboarded studio-without-walls at once echoes and contradicts Carrà's hermetic spaces, for it opens onto the city and admits a disturbing contemporary population. Although this is a fantasy, it intimates no 'spiritual' interior life, asserting instead a materialist transparency. Its humanoid inhabitants are dummies or robots, and an anatomical model displays human internal organs. Whereas de Chirico had used Renaissance perspective to suggest enigmatic concealment, Schlichter employs it in a context of unsettling disclosure.

57

Schlichter's spaces are not abstract or timeless but political – of the *polis*, the city, collective life. His automata are denizens of an urban and dehumanized present. The political dimension is made more explicit by George Grosz (1893–1959) in his *Grey Day*, also pseudo-metaphysical, of the following year. In 1921, *Valori plastici* organized a touring exhibition in Germany, but Grosz and Schlichter would already have seen reproductions of meta-physical painting in the magazine itself. In an article written in 1920, 'On my new paintings', Grosz wrote that his pursuit of a 'deliberately realistic picture of the world [by means of] ... a clear simple style' brought him 'involuntarily close to Carrà'. The paintings were scenes of robotic figures, and *Grey Day* echoes them. Here, like Schlichter, he both imitates the hermetic space of metaphysical painting and pointedly drains it of mystery. The cross-eyed foreground figure, with his kaiser's moustache, duelling scars and imperial lapel ribbon, is an image of self-satisfaction. The uncompleted wall seals him in his own region, while admitting to our view the reality he refuses to recognize. The world of destitution breaks in, as if to awaken him, just as it disrupts the conventions of metaphysical painting.

58

Grosz himself lived the contradiction that he painted. A watercolour and collage of the previous year mocks and also celebrates his own entry into the bourgeois institution of mar-riage. In the same year, he held his first solo show with a private dealer. As a committed Communist, a member of the November Group of artists who embraced the revolutionary aims of the 1918 Spartacist uprising in Germany, Grosz had put his creative ability at the service of the revolution; this was not with the intention of producing 'art', for as a member of the Berlin Dadaist group, he took an anti-art position, affirmed vehemently in publi-cations of 1920. He was to reaffirm this view in a manifesto, 'The Arts in Danger', that he wrote jointly with his fellow-communist Wieland Herzfelde (1896–1988) in 1925: 'our only mistake was to have engaged with so-called "art".' Easel-painting, besides constituting art, was poor as a means for political combat, and Grosz was certainly more evidently effective as a graphic artist, publishing with Herzfelde's left-wing publishing house Malik Verlag. Like other Dadaists, including Herzfelde's brother John Heartfield (1891–1968) and Hannah Höch (1889–1978), he made use of photomontage, de-individualizing the creative process and exploiting the unpainterly precision of the machine-made image.

58. **George Grosz**, *Grey Day*, 1921. One of a small number of paintings Grosz produced at a time when his output was largely graphic work intended for reproduction; it was exhibited in the 1925 'New Objectivity' *Neue Sachlichkeit* exhibition in Mannheim as 'Official for the Relief of War Wounded'. It is not known who changed the title.

Höch's *The Beautiful Girl* (1919–20) intersplices the human with the mechanical, in deliberate dissonance with the sentimental title. Grosz, in the same spirit, saw his work as a form of production, continuous with other modern technical practices, and engaged in the work of revolution.

In aligning their practice with machine production, these artists worked in ways that paralleled the Russian Constructivists, and a much-reproduced photograph of the 1920 Berlin Dada Fair shows Grosz with a placard proclaiming support for 'Tatlin's new machine-art' in reference to the work of the Russian Constructivist Vladimir Tatlin (1885–1953). As Communists and internationalists, Grosz and his associates necessarily took Soviet practice as a model. The Germans, however, were engaged not in 'collective construction', but in opposition, and they were also caught up in the workings of that which they opposed. Participants in the international avant-garde, political activists, they also accepted the embrace of dealers and curators. Grosz's *Grey Day* was included in the famous synoptic exhibition of 'New Objectivity' (*Neue Sachlichkeit*) in art, mounted by Gustav Hartlaub at the Mannheim Kunsthalle in 1925, in which the curator brought together a group he termed 'verists' with others he called 'classicists'. The former were leftists who addressed social themes and included Grosz, Schlichter, Dix and others. The 'classicists' followed Italian metaphysical art. Grosz's artistic militancy thereby contributed to the instituting of a style.

The social reality of Weimar Germany was as riven with conflict as Grosz's art. Led by Hitler, the Nazis, whose electoral victory resulted in the Weimar Republic's destruction in 1933, condemned its 'extreme particularism' and substituted for its quarrelsome politics and culture an 'organic' corporate state, as unified as a human body, and guided by the *Führerprinzip* (the leadership principle). In part, this was the victory of provincial Germany over modern urban society. The creation of a modern German industrial state had been late and rapid, and the effects were all the more sharply felt. It was Germany that produced, in Georg Simmel and Walter Benjamin, outstanding analysts of the psychology of urban experience. The modern city, as Benjamin writes of it in the 1930s, presents a perpetually unfamiliar view. Not a world we can greet with recognition, it breaks in on our awareness, in its strangeness and disconnectedness, as so many shocks (against which Grosz's bourgeois insulates himself). For Benjamin, this perceptual condition suited cinema (a sequence of shocks to the retina) and photomontage, but not painting.

59. **Hannah Höch**, *The Beautiful Girl*, 1919–20.
The invasion of the human by the mechanical, of
the subjective by the objective, is here a leftist strategy,
meant to disconcert a bourgeois, private, sense of the
human. Höch signs with an impersonal HH.

60. **Christian Schad**, *Self-Portrait with Model*, 1927.
Schad, a former Dadaist and experimenter in
photography, spent the early 1920s in Rome
and Naples, returning to Germany when the neo-
traditionalist style he had developed answered
to current fashion. His eroticized treatment of
bohemian life indeed appears fashion-conscious.

Constrained by its 'unique presence in time and space', and inheriting the 'aura' of the cult object, painting belonged to a pre-modern era when a familiar world returned our gaze. As we have seen, however, painters too interpreted urban experience, and the gazes returned by 1920s realisms were interrogative rather than familiar.

Self-Portrait with Model (1927), for example, by Christian 60 Schad (1894–1982), invites an attention as impersonal and fragmenting as the camera's, against an urban roofscape, crossing early Renaissance realism with the prurience of modern photography. He presents himself in effigy and, in a different way, the same is true of *Self-Portrait with Tuxedo* (1927) by Beckmann, 61 whose ethos is equally urban. Beckmann evolved a kind of dream-realism in the interwar period which broadly answered to *Neue Sachlichkeit* without fitting either of its categories – 'verists' and 'classicists'. The closest parallels are with de Chirico and Derain who, like him, were fascinated by the esoteric. His most famous paintings are the triptychs, theatres of arcane imagination. This self-portrait, though lacking any symbolism, is as uncanny as the triptychs. The modelling is strangely heightened, so that the face becomes a mask, divided like the shirt-front. The impassive figure stands as a metaphysical synthesis of opposing principles, darkness and light, while conveying, cigarette in hand, an urbane elegance. Filling the frame in a shallow space, volumetric yet flattened, it looks back from a more-than-real world.

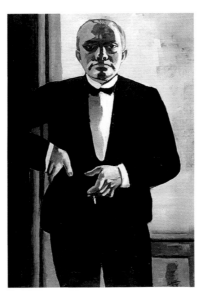

61. **Max Beckmann**, *Self-Portrait with Tuxedo*, 1927. The shadow takes on a more emphatic presence than its realist role of modelling volume requires. Whereas, with Schad a skin-deep selfhood lies open to sharp objective scrutiny, in Beckmann the self's elusiveness is figured by a shadow.

The multi-stage theatrical productions of Erwin Piscator (1893–1966) have been cited in relation both to Beckmann's triptychs and the famous *Metropolis* (*Großstadt*) triptych of 1928 by Dix. A Dadaist in the immediate postwar period, Dix had been on the left, though he had not been an activist like Grosz. By this date he, like Beckmann and Grosz, had established a career. However, he retained a commitment to modernist experimentation, and in the disabled veterans at right and left we see echoes of his abrasive Dadaist collage-paintings. While participating in the avant-garde, he had also continued an academic training, and here he paints on panel in oil and tempera in technical imitation of German Renaissance art. As with Grosz, then, Dix's practice embodies conflict, and this painting presents a fractured reality. The discordant colours and angular forms of the central scene make a visual equivalent for the machine-rhythms of jazz; gold leaf on the elaborately patterned cloth, answering to gleaming saxophones, ironically evokes a tripartite Renaissance altarpiece. At either side, disabled veterans appear, alongside the grotesque inhabitants of the dream-like nocturnal world. Dix's realism is dialectical: reality is that which jars against our expectation of beauty, from the exotic transvestite to the disfigured war victim. The real is the inadmissible.

If we set his painting beside *The Street* – also a disturbing work – by the French painter Balthus (b. 1908), we find ourselves moving between two utterly different visions of the city, and the difference partly reflects a disparity in context, as between Weimar German culture and the equal complexity of interwar France. Painted in 1933, *The Street* is not evidently concerned with modernity, despite its urban setting and robotic figures.

62. **Otto Dix**, *Metropolis*, 1928. Dix was inspired by James Joyce's novel *Ulysses*, in his complex scenography, and parodistic use of high traditional form for unexalted modern content. Painting in oil and tempera with gold leaf on wood, Dix, with consummate skill, mimics a German Renaissance altarpiece.

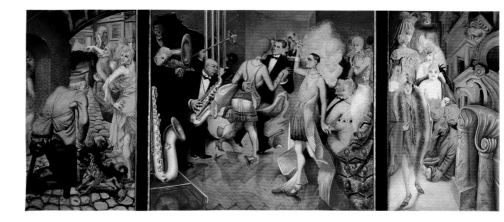

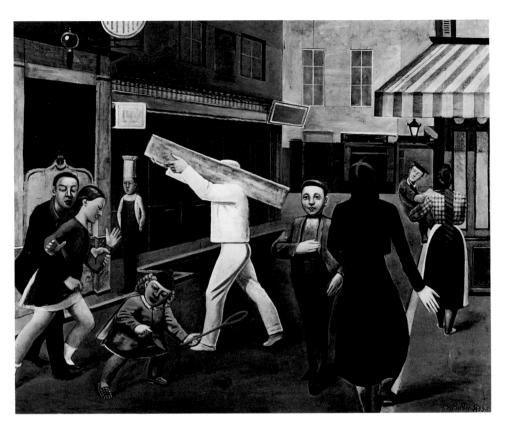

63. **Balthus**, *The Street*, 1933.
In 1929, Balthus had painted a
first version of *The Street* which
shows a bourgeois father leading
two children, instead of the scene
of assault. Here, our gaze is taken
to various blank destinations, then
back to the violent incident, where
the prevailing condition of trance
is broken. Originally, the boy's
hand was between the girl's legs;
in 1956 Balthus altered this at
the request of the then owner,
James Thrall Soby, in order that
the painting might be exhibited
at the Museum of Modern Art
in New York.

Whereas one of the strongest realist imperatives in German painting was that it address the present, realism in France tended more decidedly to arise from a new investment in tradition. As we have seen, this was the case with Derain, and it remained true into the 1930s, when realism became the predominant theme of French artistic culture. At no point in the interwar period did French painters take the urban culture of capitalism as their direct subject, as certain Weimar painters so insidiously did. Instead, what became paramount was a universalizing humanism: a 'return to man' in an age of mechanism, to be achieved partly by recourse to earlier traditions. Balthus, if certainly a highly idiosyncratic painter, could only have developed his singular art in this context. His work was to a high degree responsive to a specifically French demand, and his first exhibition, in the year after *The Street* was painted, drew supportive reviews from André Lhote and Antonin Artaud.

Balthus contrives a sense of the uncanny by complex means. Like Casorati, he conceives his figures as static volumes in the chessboard-space of perspective construction. Although the figures move, their actions are geometric and give a clockwork-like impression. The painting alludes, with ironic effect, to the Piero della Francesca frescoes (1452–66) at Arezzo, Italy, that the self-taught Balthus had copied in 1926 and 1927. The large scale of the painting – to become consistent with Balthus – evokes the monumentality of fresco. In an article of 1936, Artaud, referring to Balthus's Quattrocento sources, situates the art of that period (1400–1500) between the 'sacred' painting that preceded it and the 'epidermal' naturalism of the High Renaissance. This in-between status is associable with Balthus's lifelong fascination with female adolescence and in *The Street*, as elsewhere, it is the adolescent girl, here the object of an assault, whose presence disrupts the gauche and static calm to which she also belongs. Like the Surrealists, Balthus venerates and mystifies female sexuality. Indeed, this painting and his illustrations for *Wuthering Heights* by Emily Brontë were reproduced in the Surrealist magazine *Minotaure*.

In its surreality and singularity, *The Street* was modern enough to attract the attention of a major American collector. Cultural and economic relationships between the United States and Europe were highly significant throughout the period, the Wall Street crash of 1929 marking a kind of caesura. In the two-way exchange across the Atlantic, particularly during the 1920s, the United States exported its cinema, its popular music, and images of its own modernity – while Europe exported the fashions and practices of new art. The Armory Show in New York provoked in American artists a desire to catch up with Europe, if only in order to attract the attention of American collectors and curators. One painter whose work reflects this imperative, while also bearing upon American industrial modernity, is Charles Sheeler (1883–1965). His work is associable with Precisionism, a hard-edged style developed by Americans including Charles Demuth (1883–1935) and Gerald Murphy (1888–1964), which used the techniques of European geometric abstraction to interpret modern industrial culture. Like another affiliate of Precisionism, Georgia O'Keeffe (1887–1986), Sheeler drew on photography, albeit in the service of an ostensibly more material vision.

64. **Georgia O'Keeffe**, *Radiator Building, Night, New York*, 1927. O'Keeffe began to paint images of New York in 1925 when she moved into an apartment high up in the new Sheraton Hotel on Lexington Avenue, with her husband the photographer and art entrepreneur Alfred Stieglitz. Her daylight subjects are horizontal views across the East River to the smoke-hazed industrial district opposite. They are monochromatic, with a misty and quasi-photographic tonality, unlike the vertical skyscraper canvases: here ground and matter disappear, mass being suggested only by silhouette and scattered lights, the radiations of the Radiator Building.

64

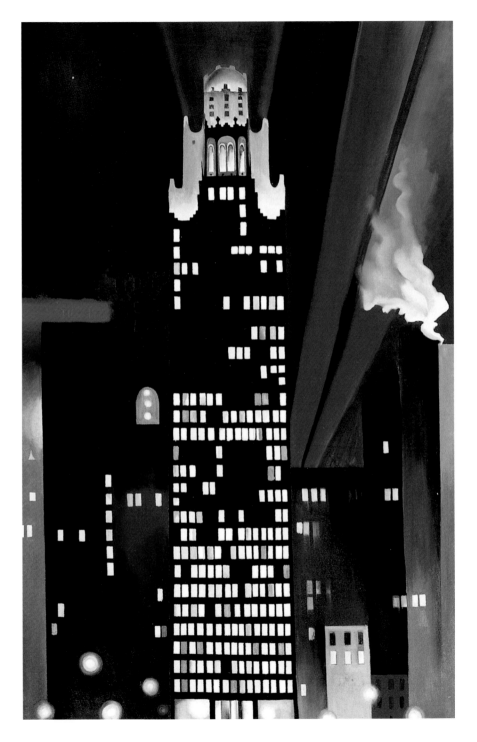

City Interior (1935) shows part of the Ford automobile plant at 65
River Rouge near Detroit, which Sheeler, who earned his living
as a commercial photographer, had been commissioned to photo-
graph in 1927. His images were used in Ford publicity and were
published internationally. In the early 1930s he made a series
of paintings from some unpublished reference photographs.
Whereas earlier works in the series simplify and flatten areas 66
in converting the monochromatic originals into paintings, *City
Interior* retains the visual intricacy of a photograph, partly by
virtue of the given view, with its complex pipework. The painting
therefore affords a divided perception: we recognize the traits of
photography, but retain expectations proper to painting. By tradi-
tion and by virtue of its properties as a physical object, a painting
is, more fundamentally than a photograph, something we stand
before to look at. In rendering his photograph as a painting,
Sheeler confers on the original image a monumental immobility.

65. **Charles Sheeler**, *City Interior*, 1935. The painting is a late addition to the series of paintings based on Sheeler's photographs at the Ford automobile plant at River Rouge near Detroit, including *Classic Landscape* (1931) and *River Rouge Plant* (1932) and is more photographic in convention than either. Unlike either Rivera or Deineka (see plates 86 and 89), Sheeler pictures a technology desolately separate from the human sphere – as if seen from its own perspective.

Equally, by letting the conventions of photography show through, he brings to our attention the mechanical nature of photographic 'vision', so that we might associate its impersonality (and that of the factory) with the beauty (and enduringness) of high art. In 1920, in a very different spirit, he and his fellow-photographer Paul Strand (1890–1976) had made an experimental film, *Manhatta*, which viewed New York in terms not simply of its architecture, but of the flux and energy of its inhabitants. Here, however, the 'city' is a self-sufficient apparatus, whose interior is void.

The diverse realisms that evolved in the aftermath of Cubism in Europe and the United States comprise three broad tendencies, sometimes interconnected in the work of a single artist: transcendentalist, critical and utopian (so far, we have encountered the first two of these). All three entail distance or detachment, even when the city and social life constitute the subject. This is

66. **Charles Sheeler**, *River Rouge Plant*, 1932. In most of his paintings of the Ford plant near Detroit, Sheeler simplifies the form of the industrial architecture and sets the buildings at a distance, imposing a classic calm emphasized here by the expanse of water. Abstract order materializes in the numbers on the riveted plate at the right.

67. **Edward Hopper**, *New York Movie*, 1939. It often took Hopper a long time to find a subject for a new painting. Through slow and critical pondering, he took a narrow set of methods to remarkable ends. His wife, Jo, also a painter, a pupil of Robert Henri, modelled for his female figures. Their embattled relationship haunts Hopper's work.

68. **Edward Hopper**, *Approaching a City*, 1946. Nothing approaches. Hopper, who lived and worked in New York, viewed the city remotely; here, from an uninhabited space, unseen from the street.

what principally distinguishes these realisms from those of the nineteenth century, which accentuated immediacy and an involvement in the living present. It was through interpreting city scenes in precisely those terms that the Ashcan painters displayed their nineteenth-century affiliations. Conversely, it was by strategically modifying nineteenth-century techniques that Edward Hopper, one of George Bellows's fellow-students in the 1900s, evolved an urban vision quite different from that of the Ashcan painters, in the interwar period. More anomalous as an artist than his critical classification as an 'American Scene' painter implies, Hopper painted notably unconvivial scenes of urban life. Sometimes viewed as a critic of urban alienation, Hopper is more likely to have been by his own intention a painter of imaginary situations. He and his wife Jo were keen theatre-goers, and Hopper's paintings resemble stage scenes or film stills, sometimes without action; he painted theatre interiors, and a cinema auditorium, the famous *New York Movie* (1939).

67

Hopper's paintings, with their discrete hues and strong cast shadows, depart from the nineteenth-century realist principle of painterly, atmospheric unification. Hence the marked contrast between Bellows's *Blue Morning* (1909) and Hopper's *Approaching a City*. Although the latter was painted in 1946, it accords in general character with Hopper's work of the 1920s and 1930s, and in its emptiness it illustrates what is generally the case: rather than imagining situations, his paintings offer spaces for imagination. Hopper suspends time, which is the medium of action, real or imaginary. The tracks, a sign for speed, emphasize the absence of motion. In Bellows's painting, vision coincides with action; in Hopper, immobility is the condition of visibility, as in *New York Movie*, where isolated viewers face an eerie screen. Hopper's cinema is a place out of life, its screen the emblem of a higher, imaginary order of reality, beyond the human and social sphere. In his isolating and fragmenting vision, Hopper achieves an effect akin to that of a tracking movie camera whose frame impassively unites its contents – an effect that is particularly appropriate here. The view divides, between the fragment of screen and the voluptuously modelled usherette who stands at the entrance to this place of waking sleep. The upholstered cinema is, like other Hopper locations, an in-between place, one we are familiar with yet not at home in.

19
68

Human Reality – the Personal and the Political

The English painter Stanley Spencer (1891–1959) is as hard to place, historically, as Hopper. As an artist who synthesized earlier tradition with modernist formalism, he had affinities with the Continental painters recently discussed. Yet his fervent concern with human intimacy and interdependence links him to those painters in the period who took as their subject the struggle for life, in conditions of war, poverty and persecution. In its visionary aspect, his art is the non-political counterpart of Philip Evergood's, to be discussed later.

Like many other painters of the time, Spencer had experienced warfare at first hand. He alone, however, approached the subject of war reverently and with no portrayal of violence, in his paintings for the Burghclere Memorial Chapel, Hampshire. Four of his nine scenes show the Macedonian campaign of the First World War, in which he had served, presenting it almost as a boys' vacation. Four smaller panels depict life in the hospital where he worked, and here, too, he brings out the soldiers' youthfulness. Through a swelling distortion of form, he marvellously conveys involvement in the physical world, so that even putting jam on bread appears ecstatic. The scenes are all outside combat, and the culminating image is one of resurrection; indeed, Spencer's thoroughly bodily notion of resurrection runs through all the images. These are subjective, sensing bodies which, swollen like balloons, are always touching or feeling the physical things that bulge towards them, in mutual bliss. Here is the same erotic world that Spencer painted in his images of lovers, and it arose from a personal sexual-religious vision.

Spencer's paintings are informed by a faith in the alliance of flesh and spirit. That faith, while idiosyncratic, drew on broad

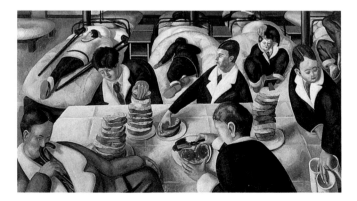

69. Stanley Spencer,
Tea in the Hospital Ward, 1932. Spencer was commissioned by Mr J. L. Behrend to paint a commemorative chapel built as a memorial to Mrs Behrend's brother who had been killed in the Macedonian campaign of the First World War. Spencer worked on the series from 1926 to 1932; this is one of the four lower scenes on the side walls, based on Spencer's hospital service.

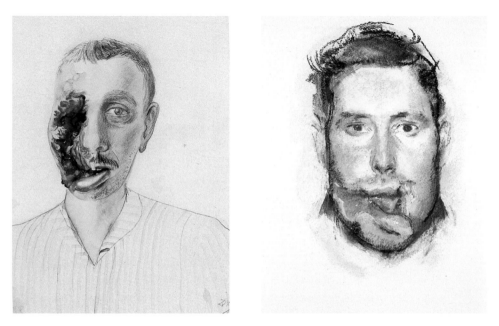

70. **Otto Dix**, *War Wounded*, 1922. Dix served in the German army throughout the First World War, and produced stark images of the horror of warfare. This was drawn from one of the war photographs that Ernst Friedrich exhibited in 1924, the ten-year anniversary of the outbreak of war, in his Antiwar Museum in Berlin, alongside Dix's remarkable series of etchings, *Der Krieg*, and Käthe Kollwitz's woodcut series, *Krieg* (see plate 73).

71. **Henry Tonks**, *Study of Facial Wounds*, 1916–17. Tonks, a qualified surgeon and painter, Professor at the Slade School of Fine Art in London, assisted the plastic surgeon Sir Harold Gillies, drawing diagrams and pastels to record the faces of the dreadfully wounded soldiers. Tonks discouraged public showing of the drawings, whose function he regarded as purely clinical.

western cultural traditions. However, the cultural traditions in question tend to link spirituality with beauty and wholeness of form (a principle that Spencer's art questioned or defied). Ex-soldiers disfigured by warfare suffered social rejection after the First World War, as if their disfigurement made their humanity unrecognizable. In the early 1920s, Dix made watercolour draw- 70 ings of the war wounded from photographs, in one of which the individual looks back at the viewer with only the half of his face that can do so. Unlike the British surgeon and artist Henry Tonks (1862–1937), whose sensitive pastels of 1916 and 1917 describe 71 facial injuries for medical records, Dix seeks deliberately to con-front the viewer and to pose a dilemma. He renders the half of the face to which we might attribute subjectivity with a sensitive softness of shading; the other half is nauseatingly formless, not readily assimilable to our sense of the human, as shaped by art and culture.

The viewer's visual dilemma touches on an ethical one, con-cerning that which conditions the way we accord or withhold human recognition. Interestingly, Spencer, in whose visionary paintings everything greets everything else through a universal physiognomic expressiveness, experimented with the opposite possibility as well. In nude double portraits he painted of himself 72 and his second wife their two bodies, cramped together, are

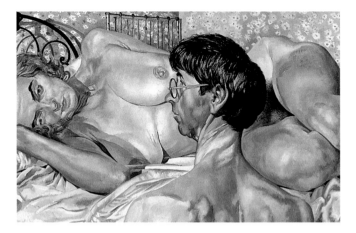

72. **Stanley Spencer**, *Self-Portrait with Patricia Preece*, 1936. Spencer painted a series of portraits of Patricia Preece between 1935 and their marriage in 1937, following his divorce from Hilda Carline. Both bodies, including his own, are viewed in a markedly objective and external way: he shows himself from behind, as if seen by another.

absolutely separate. The sharp edges, the hard light, the disconnected gazes and – in one of the portraits – the juxtaposition of a piece of raw meat and human flesh, are factors tending to abolish all reciprocity of feeling. (It was in fact an unreciprocated love.) Both Spencer and Dix manipulate the conventions of realism so as to investigate the alliance between flesh and selfhood, and evoke the unstable processes of recognition. Dix, as a remarkable portraitist, veered towards caricature in presenting the faces of his sitters as social masks: the flesh hardens into a socially acquired form, a persona.

The politics of the period put an intense focus on the matter of human recognition, for the shared, collective principles on which such recognition depended were, in diverse contexts, drastically redefined or put to the test. In Germany after 1933, and subsequently in Italy and then in countries under German occupation, Jews and other groups were stigmatized as outcasts and expelled from their erstwhile civic and national communities. Felix Nussbaum (1904–44), in hiding in Brussels, painted himself with *Judenstern* (the Star of David) and *Judenpaß* (an identity card) in hard *Neue Sachlichkeit* style. His place of birth, Osnabrück, has been erased from the card, and the French and Flemish for 'Jew' have been stamped over the space for 'nationality'. The face that looks back holds no expectation, only apprehension. The star he bears makes a stigma of what had been a mark of the sacred, of that which demands recognition.

If human recognition depended on politics, then it could not be taken for granted. The Social Realism that became the predominant tendency in art in the United States in the 1930s

73. **Käthe Kollwitz**, *The Mothers* from the series *War*, 1922–23. This woodcut is from Kollwitz's series of seven prints, *Krieg* (*War*). Kollwitz's greatest prints were the emotionally forceful etchings she published in the early 1900s. Her younger son was killed in the First World War, and among the more militant of her later images is a poster, *Never Again War* (1924). Woodcut, which she had recently adopted, here aptly expresses block-like containment.

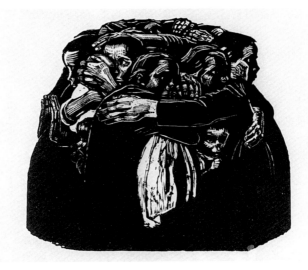

74. **Felix Nussbaum**, *Self-Portrait with* Judenpaß, *c*. 1943. Living in Brussels after release from internment in 1940, Nussbaum had, with his wife Felka Platek, eluded police raids in 1942 by changing addresses. Captured in 1944, the two were put on the last transport to the concentration camp at Auschwitz. Here Nussbaum, in hiding, shows yellow star and identity card, marked 'Juif-Jood'.

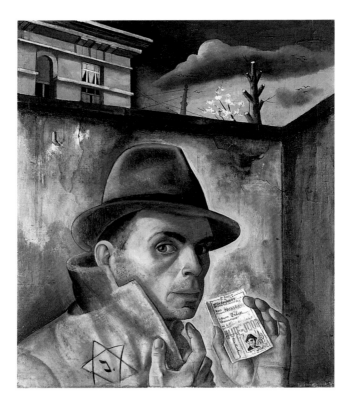

centred precisely on the question of recognition, and on the nature of the bond that guaranteed it. It was the collapse of capitalism, followed by an era of interventionist national government under Roosevelt (elected in 1932), that provided the conditions in which Social Realism flourished. Most concretely, the state provided support for artists under its public works legislation. Through the Federal Art Project (FAP) of the Works Progress Administration (WPA), the most inclusive of the schemes, which ran from 1935 to 1943, painters gained commissions for murals and received payment to work in their own studios. Artists who would otherwise have been unemployed acquired a social role. At the same time, work on government projects put artists in touch with each other, as did the several artists' organizations that developed during the period. 'Social Realism' is the term that has come to be used since then to describe a diversity of practices whose common denominator was a critical or humanitarian advocacy of social change. Only some of the painting showed a Marxist awareness of class struggle. Indeed, artists of the more politically conscious left such as Louis Lozowick (1892–1973) pointed to the absence of revolutionary intent, and the stereotypical subject matter. Social Realism in general reflected the populist ethos of the New Deal. It was also very much of the Popular Front era (the declaration of a popular front against Fascism in 1935 by the Comintern – the Third International, established in 1919 in Russia to work for Communist revolutions – effected a temporary suspension of sectarian conflict on the left, until the 1939 Nazi–Soviet pact).

Both Social Realism and the concurrent practices known as Regionalism were essentially genre painting, variously and eclectically informed by tradition (sometimes academic). They focused on the shaping rituals of social life and also portrayed social types, the adoption or imposition of roles. *American Gothic* (1930), the best-known painting by the Regionalist painter Grant Wood (1891–1942), depicts nineteenth-century midwestern farmers in front of a house whose gothic style they share; they are formed by the world they have built. In the case of the New York Social Realists Reginald Marsh, Isabel Bishop (1902–88) and Raphael Soyer (1898–1987), all of whom painted the working and unemployed population of the 14th Street area, social identity is rather more a matter of perception. In the city's spaces, as these painters present them, following Ashcan School precedent, groups define themselves in the eyes of others. As in nineteenth-century French art, the city is a place of seeing and

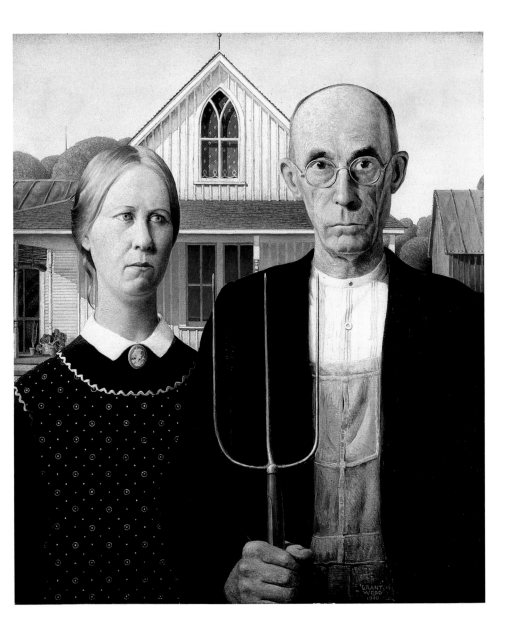

75. **Grant Wood**, *American Gothic*, 1930.
In a lucid style reminiscent of Flemish art,
Wood defines as 'gothic' the principle
uniting figures and building. Casting his
models (his sister and his dentist) as
nineteenth-century Iowan farmers, and
giving them an air of narrow and naive
reserve, he fabricates an ancestral portrait.

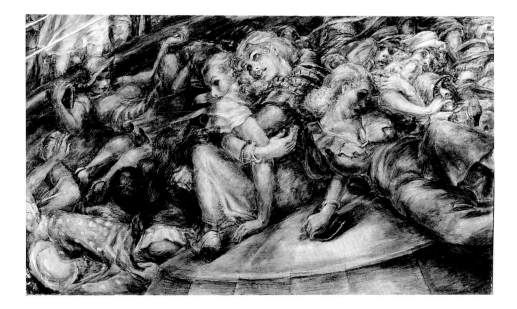

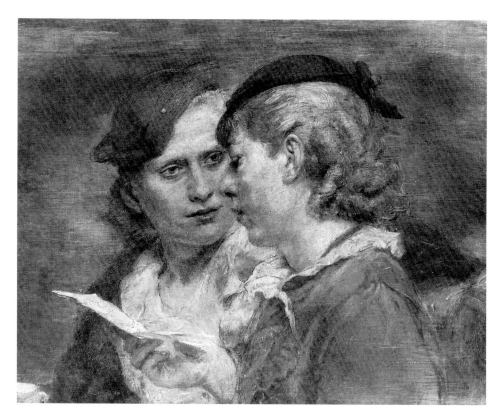

76. Reginald Marsh, *The Bowl*, 1933. Differing from Bishop (see plate 77) in his approach to the subject of shop- and office-workers at leisure, Marsh shows his growing preoccupation with figure drawing, using hatchings of thin tempera wash to define the anatomies of tumbling bodies – which invite a prurient interest.

77. Isabel Bishop, *Two Girls*, 1935. Influenced by Ashcan School painting, like Soyer (see plate 78) and Marsh (see plate 76), through study at the Art Students' League in New York, Bishop painted sympathetic studies of female city workers in their free time. Her finely descriptive paintings, as atmospheric as Soyer's, convey her models' individuality and suggest the world with which they are intimate.

78. Raphael Soyer, *How Long Since You Wrote To Mother?*, *c*. 1934. Born in Russia, Raphael Soyer immigrated to the United States with his parents and his brothers Moses (1898–1974) and Isaac (1902–81). All the brothers were painters and worked in similar ways during the 1930s, painting scenes of the unemployed and destitute.

being seen, of social differences and distances expressed through perception. Marsh clearly treats his subjects voyeuristically – their world is not his. Bishop and Soyer, by contrast, construct their scenes so as to situate the viewer close to the unemployed men or female city workers they depict. Yet, in the work of both, closeness has the effect of emphasizing distance, since the depicted worlds hem their subjects in; pleasantly, in Bishop's case, harshly with Soyer – who brings a more political eye to bear.

The work of Philip Evergood, a friend of the 14th Street painters, showed a still deeper social involvement. It is notable that of the painters associated with Social Realism those whose work was most sharply political were not realists in the naturalistic sense; Evergood himself, Jacob Lawrence (b. 1917) and Ben Shahn (1898–1969) were each quite independent of the Ashcan tradition, unlike Bishop, Marsh and the Soyer brothers (Raphael's brothers were also artists). None, furthermore, partook of the 1930s interest in reviving earlier technical and academic practices. In a published statement, Evergood referred to himself as a 'social artist', and the social and participative aspect of his work was what he especially emphasized. He associated Marsh's form of realism with 'social observation', commenting that the Bowery bums in Marsh's paintings were merely abject and conveyed only pathos, whereas his own had evidently 'not accepted their lot'. Interviewed later in life, he spoke of 'fighting in paint – the same way that John Reed fought in prose.' Evergood was very much an activist. Although he refused an invitation to join the John Reed Club (a Communist group founded in 1929), he was a leading spirit in several other artists' organizations, including the American Artists' Congress.

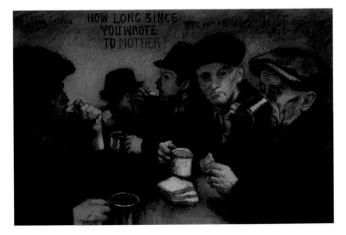

87

The art historian and critic Meyer Schapiro, speaking in a debate held by the Congress in 1936, criticized 'the passivity of the modern artist with regard to the human world'. This was not a rebuke that would have applied to Evergood who, in the same year, joined a demonstration at the WPA headquarters in New York to protest against cutbacks in funding, and was severely beaten up by police. A year later, and in response to a police action against strikers in Chicago, he painted *American Tragedy*. This painting, with its frieze-like arrangement and laconically emblematic background, is structured like a classical relief, without using antique figure conventions. It is rendered in an awkward and angular style which nonetheless strongly conveys the physicality of the engagement, in which all participants appear as individuals – the uniformed police less than the others. Evergood powerfully suggests physical violence and confusion, yet also, in the central figures, articulates resistance. The hat on the ground, which, as Evergood said, magnifies the violence, also freezes it at the point where the action turns defiantly back, as a striker effectively arrests a cop, in a face-to-face demand for human – or class – recognition.

79. **Philip Evergood**, *American Tragedy*, 1937. For this painting, Evergood used magazine photographs of the Memorial Day Massacre in Chicago, when ten strikers were killed, and a hundred wounded, as police broke up a meeting. He also drew on personal experience.

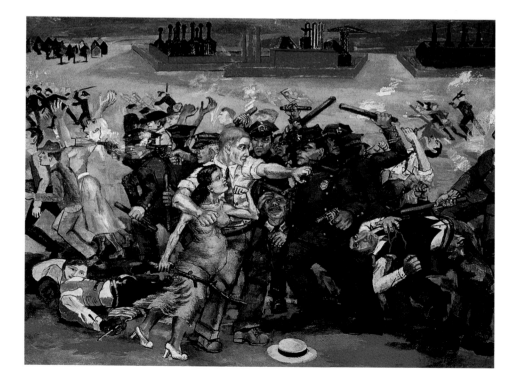

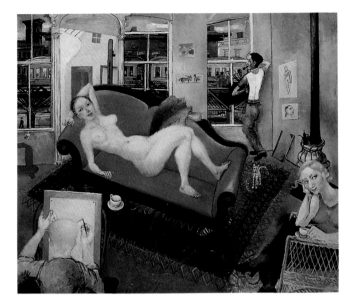

80. **Philip Evergood**, *Nude by the El*, 1934. The Elevated Railway, seen through the window, is a recurrent feature of paintings of New York life. Placing a mirror between two windows, Evergood portrays art as an inviting world-in-itself, which yet opens onto the space of the city.

Although Evergood also worked as a muralist, he clearly found easel painting a viable medium for social art. Arguably, he reveals it as a singularly effective medium, one that can engage the individual viewer in a critical way. His paintings, with their rebarbative colour and awkward form, have a compelling quality even though they resist easy assimilation. They also are full of physical energy. George Dennison, an art critic reviewing Evergood's 1960 solo exhibition at the Whitney Museum of American Art, New York, wrote of his capacity to reduce or return abstractions such as money and class to the erotic and physical. He saw the paintings as imbuing reality with the hyper-clarity and complexity of dreams. It is indeed true that Evergood's preferences in art – for Hogarth, Goya, Dix, Beckmann – mix the critical with the fantastic. His paintings imagine a different space within the actual and oppressive spaces of the urban present. His most utopian painting, in these terms, is *Nude by the El* (1934). Art, here, opens a dream-space of its own giving onto mundane urban reality. 80

To some degree, all Social Realist painting held this transfigurative promise. The painter Edward Laning (b. 1906) wrote later of the benign yet accidental transformation whereby New York had become, in the New Deal era, 'the Great Good Place', and the United States a promised land. Redemptive idealism of this kind inspired contemporary documentary photography, particularly

that of Walker Evans for his and James Agee's study of impoverished tenant farmers in 1936 (their book, *Let Us Now Praise Famous Men*, was published in 1941). The painter Ben Shahn (1898–1969) was drawn into documentary photography through contact with Evans, and in turn used city scenes as a basis for his paintings. Like Evans, he projects his figures against, as much as into, their environing spaces; he uses a graphic formalization when translating photographs into paintings such as *Handball* (1939). Shahn, like many of the 1930s painters, came to the United States as a child of immigrant parents, and he approaches the city's spaces with sensitivity to the isolation of individuals, their moments of drifting, curiosity, animatedness. In *Handball*, he re-enacts the intently spontaneous ballet of the game, framing it between idle spectators.

The city's space itself is, in the immigrant's perception, uncommitted or unstable. In *Handball*, there is both desolation and possibility. There is also territoriality. The city's spaces are open, then suddenly and unpredictably closed and fearful. Mark Rothko (1903–70), an outright opponent of Social Realism who nonetheless painted urban scenes in the 1930s, found in them the

81. **Ben Shahn**, *Handball*, 1939. The son of immigrant Jewish parents, like many New York painters of the period, including the Soyer brothers and Mark Rothko, Shahn attracted public attention with his gouache series, *The Passion of Sacco and Vanzetti*, 1931–32, concerning two Italian anarchists executed after a faulty trial.

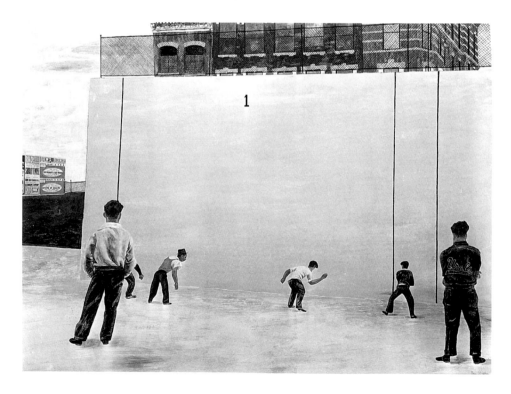

82. **Mark Rothko**, *Entrance to a Subway*, 1938. Rothko conveys the inhuman character of the subway. Unlike most of the Social Realists, he effaces narrative. Yet he simultaneously draws on another aspect of the genre tradition: its evocation of atmospheric, subjective space.

83. **Jacob Lawrence**, *Race Riots were Numerous. White workers were hostile toward the migrants who had been hired to break strikes*. Panel 50 from *The Migration* series, 1940–41. Lawrence had grown up in Harlem, New York, during the period of the Harlem Renaissance, but his own work shows no trace of the Jazz Age. He steadfastly focuses on the life, not the image, of the African-American. *The Migration*, one of his first narrative series, comprises sixty paintings.

spatial-emotional themes that were later to gain extraordinary expression in his abstract paintings. In *Entrance to a Subway* (1938), one of a number of subway paintings, he effaces all narrative, yet in doing so stages the inner drama of entering a space; all the figures are at the periphery of this place of transience and self-loss, gridwork of drab-ethereal hues.

The city is a place of inner migration, yet one that confines its immigrants. The subway's impartial offer of unimpeded mobility is deceptive. Jacob Lawrence, who came to New York with his parents as a child, later gained a mobility that he knew to be unavailable to most inhabitants of Harlem, through his practice as an artist, beginning in the last years of the FAP. In series of tempera paintings on 'The Migration of the Negro' from south to north during the First World War, he traced a history of hope and disillusion, of a journey to a worse oppression. A New York that contained Harlem was not the 'Great Good Place' and the cities of the north no land of promise. In his highly formalized and incisive style – inspired by the Mexican painter José Clemente Orozco (1883–1949) – Lawrence traced other narratives that bore on African-American experience, including the Haitian revolution under Toussaint L'Ouverture. Lawrence's realism was political and historical; like Evergood, he cited Honoré Daumier (1808–79) and Goya. Though untouched by academic tradition, his was a kind of history painting. He counted himself among those whose history and experience he painted, and confronted the fact that they could secure freedom from a prolonged slavery only through struggle. In his painting of race riots, the city closes in as threateningly as it did also on Nussbaum, in the same years.

As we have seen, 'Social Realism' is a category that brackets socially conscious genre painting such as Raphael Soyer's with work such as Jacob Lawrence's which, while being sharply political, is not stylistically realist. With certain important exceptions, the most decisively political art of the 1930s departed significantly from nineteenth-century models of realist representation. The outstanding exception was painting produced in the Soviet Union which drew on the nineteenth-century tradition of the *Peredvizhniki,* the Wanderers, an organization founded in the nineteenth century which took art to the people in travelling exhibitions, seeking to make art serve a social purpose, and which was to provide the basis for Socialist Realism. Although certain of the principles underlying Socialist Realist art – that art should serve a social end and be meaningful for a wide public – were common currency on the left, only Socialist Realism revived the spirit, and in some degree the methods, of nineteenth-century realist art. Left-wing opponents of Socialist Realism, in the west as well as in the Soviet Union, argued for a more experimental and technically modern enactment of what they too saw as realist aims. In 1938 the German Marxist poet and dramatist Bertolt Brecht wrote in response to Georg Lukács, a critical precursor of Socialist Realism, that literature which is to be 'fully engaged with reality' needed to keep pace with the rapid development of reality itself.

In the west, after the Wall Street crash of 1929, Marxism became a strong influence in cultural debate; but all on the left took 'realism' to imply a reality that was historical and social, and not simply sensuous and natural. Some, such as Brecht, held that the complex processes of the real world could not necessarily be epitomized within a naturalistically coherent framework. Whatever its technique, however, a political art needed to refer its viewers to the processes of historical change, in order to enable them to engage with historical events, rather than being merely caught up in them.

An address to history was precisely what Alvin Johnson, Director of the New School for Social Research in New York, demanded of the painters Thomas Hart Benton (1889–1975) and Orozco when he commissioned them to paint murals for the School in 1930. They were to paint contemporary subjects 'of such importance that no history written a hundred years from now could fail to devote a chapter to it'. Mural painting was the medium of choice for so resonant an enterprise, and in Orozco,

Johnson had chosen one of the Mexican painters commissioned by José Vasconcelos to paint murals for the Mexican government in the 1920s. Mural paintings were, by definition, both large and public, and throughout the 1930s both Mexican and North American painters used them not simply to reach a wide audience but to foster a sense of collective historical identity and purpose.

Benton and Orozco were allocated rooms on different floors of the new, modernist building. Benton had already completed a monumental sequence of paintings on his own initiative, an epic on American history begun in 1919, 'to present a people's history in contrast to the conventional histories which generally spotlighted great men.' This populist and democratic outlook, which was to inform Benton's work as a whole, is fully evident in the ten New School panels, collectively entitled *America Today*. There are three main themes: productive power, the American regions and big city life. Benton neither denigrates the city nor idealizes the

84

84. **Thomas Hart Benton**, *City Building*, from *America Today*, 1930. This monumental canvas was part of a series made for the New School for Social Research, New York. Like the other panels, it shows a montage of scenes, separated by a curved wooden moulding. Benton, who had worked in Hollywood, mimics the cinematic montage of moving images.

regions (for instance, *Deep South* includes a chain gang). The point is worth making since, during the 1930s, Benton became the leading representative, with Grant Wood and John Steuart Curry (1897–1946), of the Regionalist movement, which has come to be seen as regressive and reactionary. This is not entirely fair. Although Benton, partly through his own fault, was attacked as a Fascist and racialist by leftists in the 1930s, he was neither of these things. Coming from a family long steeped in populist politics, he carried the attitudes of the progressive era forward into the period of the New Deal. Although Roosevelt was yet to be elected, the ideals and optimism associated with the early New Deal years are strikingly anticipated in Benton's panels. *City Building* emphasizes human productive power, foregrounding the workers themselves who, black and white together, are remaking America.

Benton gives the paintings a rhythmic energy learnt from early essays in formal abstraction. He endows not only figures but machinery and buildings with animated presence. The workers' impersonal physiques articulate a sinuous power, with an effect at once monumental and grotesque (elsewhere, his work tends towards caricature and satire). The meaning of the paintings, as consistently in Benton's work, concerns the determination of political and economic life by the people themselves, as envisaged in republican and reformist, rather than revolutionary terms. As such, it answered to the ethos of the New School, which was a progressive institution. Orozco's frescoes, unlike Benton's, do refer to revolutions – but in India, Mexico and Russia, 'the non-industrial periphery', as Johnson's description puts it. Lenin and Stalin appear, but only as leaders in the Soviet Union, paralleled with Gandhi and Felipe Carillo Puerto, the assassinated reformist governor of Yucatán.

The three leading Mexican muralists, Orozco, Diego Rivera (1886–1957) and David Alfaro Siqueiros (1896–1975), were more radical than Benton in both artistic and political terms, but the paintings of all four betray similar problems. While the mural was indeed, as Siqueiros insisted, essentially a more public form than easel painting, the way in which it defined and addressed its public remained problematic. The immediate public for the New School murals were the School's members and associates, whose progressive outlook the murals reflected. The situation was more complex in the case of murals painted in Mexican public institutions in the 1920s. Offered, in principle, to the illiterate as well as the educated, the paintings, with their synthesizing of European

and indigenous cultures, presented images of national coherence and identity. There was an inevitable gap between such imagery and reality, since the nominally revolutionary government was very far from achieving an equitable social order. To put indigenous people, the Native Americans, into the picture was not to put them on an equal footing in reality (Orozco's Felipe Carillo Puerto section records a rare and local case of achievement on the ground). Not only in Mexico, but in the New Deal United States too, it has been argued, government-funded muralists risked becoming image-makers in the advertising sense.

Rivera, for one, was certainly aware of playing a double game. In an article published in the *Modern Quarterly* in 1932, he characterized the state patrons of the Mexican murals as 'a fraction of the bourgeoisie that had need of demagogy as a weapon in maintaining itself in power'. (Rivera, expelled from the Mexican Communist Party in 1929 and anxious for readmission, here adopts the correct political tone.) He went on to claim that he and others had nonetheless created a genuinely revolutionary art. However, it could be argued that Rivera's most impressive work was one where he was most politically compromised and least overtly 'revolutionary'. In 1932 he was commissioned to paint murals for the garden court of the Detroit Institute of Arts, and

85. **José Clemente Orozco,** *Felipe Carillo Puerto (of Yucatán),* 1931. Untypically placid in form, Orozco's New School fresco cycle reflects the concerns of his friend Alma Reed's progressive salon, the 'Ashram', associated with the School. Carillo, whom Reed was to have married, is linked here with Yucatán's indigenous people and Mayan historic culture (the pyramid).

85

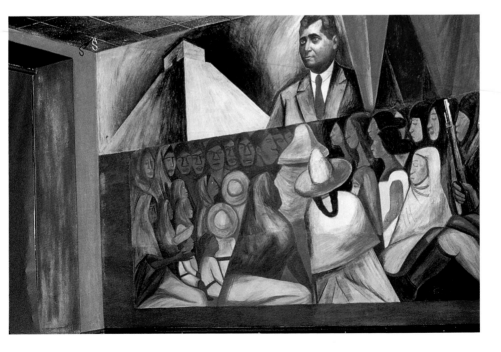

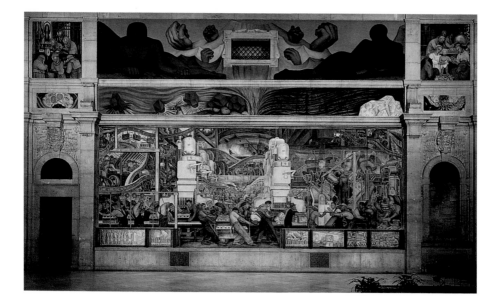

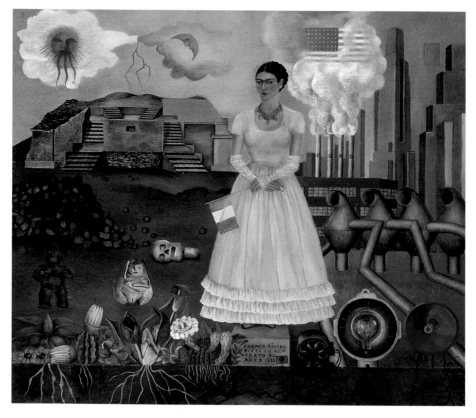

chose to take the new Ford River Rouge automobile plant as his central subject; the principal patron was Edsel Ford, Henry Ford's son and an art enthusiast with a keen awareness of the power of advertising.

Rivera was partly motivated by a delight in machinery. He spent long periods drawing in the Rouge, and a striking feature of the murals is the brilliant synoptic rendering of manufacturing processes, in the main north and south wall scenes. At first sight, one would hardly guess at the actual conditions that workers endured. The Rouge's most productive years coincided with the Depression in the 1930s, when the workforce was much reduced. Sheeler's desolate images give a better sense of that reality than Rivera's bustling scenes. In March 1932, a march of the unemployed on the Ford Dearborn plant was brutally broken up by police, with four marchers killed. Rivera's paintings offer no overt criticism and certainly do not refer to strike breaking; but there are satirical touches in subordinate panels, and the grim calisthenics of the workers allude to the relentless pace of work, and the summary dismissal of 'time-stealers' (Ford workers were forbidden to join unions, and endured a severe work regime).

Unlike Benton's labourers, or the heroic figures in the Soviet art that Rivera knew and disliked (he visited the Soviet Union in 1927), his workers are individuals. He included portraits of his own assistants. Rivera was well funded for the project, and the high quality of his fresco work, with its clarity of colour, has often been remarked upon. He aimed at transforming the image of work into beauty, and used golden-section divisions as an aid in rendering machine processes as a nature-like rhythm. The upper panels represent the mineral resources and races of the continent, others portray positive and negative uses of science. He thus subordinates machinery to the larger theme of the productive interaction between humans and nature, and puts individuals into the foreground. (The ostensible goal of the process, the completed Ford V-8, appears only as a small detail on the south wall.) It is therefore not hard to see, in Rivera's coerced workers, potential cooperators.

Mural paintings have a propensity to overwhelm their viewers, their purpose being to amplify vision, tackle large themes. Rivera, who had studied Giotto, succeeded in Detroit at least in striking a balance between the individual and the cosmic. Siqueiros's methods were far more akin to Baroque art, where a powerful illusion exerts a coercive power. In the painting he and collaborators made for the upper stair well of the Electrical

86. **Diego Rivera**, *Detroit Industry*, north wall, 1933. 'The work moves and the men stay still'; Rivera gives his car workers more importance than Ford's axiom implies, while suggesting the rhythm of movement. The main north panel shows the new V-8 engine in production; the south wall depicts manufacture of the body.

87. **Frida Kahlo**, *Self-Portrait on the Border Between Mexico and the United States*, 1932. Kahlo (1910–54), married to Rivera in 1929, accompanied him to Detroit, where she suffered a miscarriage. Her Detroit paintings offer a striking counterpoint to his. She painted at small scale on metal, in imitation of Mexican *retablos* (religious ex-votos, recording misfortune), implicitly linking her personal life to wider human and social reality. Here, she contrasts the inhuman and smoke-polluted place where she stands, dressed for a night out, with the place she yearns for.

Workers' Union building in Mexico City, spray-gunned images, some derived from photographs, create a cinematic effect. Siqueiros's team made studies showing an 'average' of the sequence of visitors' eye-movements, and co-ordinated the images accordingly; so that, in relation to the mobile viewer, the mural presents a moving image.

There are analogies between Siqueiros's practice here and work produced in the Soviet Union, from its first years onwards. There, too, artists and political leaders seized on cinema as both a means and a model for politicizing art. Lenin, famously, regarded cinema as the most important art form; it appealed to the 'naive realism' he thought essential for reaching the largely uneducated Russian masses. This opinion of Lenin's, which contributed towards the development of Socialist Realism, finds confirmation in Clement Greenberg's contention that the art most likely to appeal to an ignorant Russian peasant would be one that manifested 'no discontinuity between art and life'. In his famous 1939 essay 'Avant-Garde and Kitsch', Greenberg equated the state-sponsored art of Germany, Italy and the Soviet Union with popular, commercial art and literature: *kitsch*. All, equally, were products of industrialization, means of appeasing and controlling the industrial masses.

88. David Alfaro Siqueiros, *Portrait of the Bourgeoisie*, 1939–40. The illustrations show the view from the top of the staircase, looking down to the corner of the left and central walls, and up to the ceiling. On the left, a parrot-demagogue incites a crowd; at centre, imperialists, capitalists and the machinery of war; on the right wall (not shown here) a revolutionary dives downward; above, pylons and the Electrical Workers' Union flag. When Siqueiros fled following an attempt on Trotsky's life, the Union ordered certain changes, and altered the title (originally, *Portrait of Fascism*).

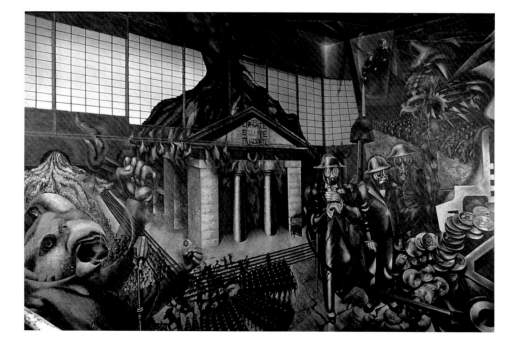

Greenberg's essay retains its cogency, and certain historians still follow him in using the category 'totalitarian art'. Some scholarship of recent years, however, tends to favour a more differentiated account. Socialist Realism evolved in a context very different from that of Nazi Germany, and developed over a longer period. Nor does Greenberg's antithesis between avant-garde and mass art hold completely in the case of the Soviet Union, since Socialist Realism actually inherited and incorporated some of the traits of Futurism and Constructivism. Stalin's reported definition of the artist as 'the engineer of human souls' unwittingly echoed the rhetoric of the Constructivists and Productivists of the 1920s (except that the tone is far more romantic than theirs).

The theme of the association between art and engineering pervaded avant-garde theory and practice during the 1920s; as we have seen, German critical realists such as Grosz drew on the example of 'Tatlin's machine-art'. A certain realism was inherent in the machine aesthetic; when, in 1913, Duchamp, Fernand Léger (1881–1955) and Constantin Brancusi (1876–1957) looked in admiration at aircraft propellers in the Salon d'Aviation in Paris, they consciously took as artistic that which was not art but an object, a real thing. In practice, each would have drawn

different lessons from this experience, but an emphasis on the immediate materiality of the work of art was inherently entailed.

'Materialism' became a significant term in artistic debate in Russia after the 1917 revolution, both because of its place in Marxist philosophy and through its application to art. The avant-garde, which identified with the revolution, proposed a revolutionary materialist practice. The 'Programme of the Productivist Group' of 1920, for example, envisaged a radical replacement of art with 'materialistic constructive work', which would 'transplant' hitherto abstract experimentalism into 'the real'.

Political leaders, Lenin foremost, soon took issue with this radicalism, and when in 1922 a group of academic artists proposed a 'revolutionary' version of figurative realism, drawing on nineteenth-century tradition, it gained the immediate support of the ruling élite. AKhRR (Association of Artists of Revolutionary Russia) grew out of the Wanderers. Though hidebound and conservative by the time of the revolution, its original impetus had come from the radical social thinker Chernishevsky, whose ideas on art Lenin admired. The new organization, which held huge themed exhibitions and formed links with key institutions such as the Red Army, was the prototype for Socialist Realism. The latter, however, was not publicly proclaimed as the guiding principle of Soviet art until 1934, and up to 1928 diverse practices coexisted and competed, including those of the 'left' avant-garde. The liberalizing New Economic Policy (NEP), established in 1921, favoured this pluralism, and so Constructivist and Productivist ideas continued to have an influence.

The foremost painter of this period was Aleksandr Deineka (1899–1969), whose work combined the formalist 'materialism' of the avant-garde with a degree of figuration sufficient to make it – in the words of a 1925 Party resolution – 'intelligible to the millions'. In *Female Textile Workers* (1927), Deineka uses perspective to construct a legible pictorial depth, yet simultaneously renders figures and objects as flat shapes on the surface. Everything appears to float, an effect epitomized in the suspended spindle, which brings art, illusion and technology together in the spirit of the Productivists' 'materialistic constructive work'. Deineka was a member of OSt (Society of Easel Painters), which constituted the artistic left's alternative to AKhRR. Both organizations, however, responded to the demand for 'realism' that predominated in Soviet culture after 1921, voiced for example by Trotsky who, writing in 1923, evoked a realism expressive of 'this life, our three dimensions'. Anatoly Lunacharsky, the Commissar for People's

89

Education, and thus in charge of art, also called for a renewed realism and, like Trotsky, was an early supporter of AKhRR.

'Realism' was at once the most prominent term in art criticism, and one of the vaguest, and such variants as 'heroic realism' (AKhRR) and 'synthetic realism' (OSt) were scarcely clearer. What realism meant in practice depended partly on artists' interpretation of certain consistent general criteria, including Lenin's demand that art should educate the masses and serve the Party's goals (it should show *partiinost*, Party-mindedness). Further, there should be a guiding idea (*ideinost*), a principle reflected, for example, in AKhRR's choice of themes for its exhibitions, such as the one in 1926 on the diverse nationalities of the Soviet Union (in 1930, Stalin was to define Soviet culture as 'socialist in its content and national in form').

With Stalin's inexorable rise to absolute power (his rival Trotsky was exiled in 1929), and with the end of the NEP in

89. **Aleksandr Deineka**, *Female Textile Workers*, 1927. Deineka, eighteen in the year of the Bolshevik Revolution, studied art in the new system dominated by the avant-garde in Moscow. He was one of a group of young graduates who developed formalist types of realism in the 1920s, drawing on the example of Constructivism and Supramatism.

1928, everything, including art, came under stronger central control. Art organizations were abolished in 1932, to be replaced by a single Artists' Union (a Moscow Union was established initially). Academic training was reinstated. Soviet culture came to be characterized by the development of high technical expertise within conservative areas of practice – the ballet, the classical symphony orchestra, the large narrative painting or *kartina* – which were largely nineteenth century in origin. Although Socialist Realism was given its official status in 1934, it was not described in any detail. As with other areas of bureaucratically controlled Soviet life, it was defined through the tension between individual creativity and official criticism and censorship, in changing historical circumstances.

New Moscow by Yuri Pimenov (1903–77) and *A Collective* **90, 91** *Farm Festival* by Arkadi Plastov (1893–1972) are mutually contrasting works from 1937, well into the Socialist Realist era. What they have in common is a high degree of descriptive painterly naturalism; in Plastov's case, a tendency to lyrical impressionism, for which his later work was to be criticized. Both painters render illusionistically coherent spaces in a way that draws the viewer into the depicted scene. Pimenov, a former OSt member, retains a modernist sense of formal construction, appropriate for the subject. Both images are optimistic and are meant to be emotionally and sensuously engaging. Also evident is an emphasis on the individual and (in Plastov) the portrayal of emotion; the anonymous human-machine figure of the 1920s (as in Deineka's *Female Textile Workers*) was now seen as 'Fascistic'. In the Plastov, we see the vast and detailed narrative that was especially to distinguish Socialist Realism. It combines extraordinary verve in colour and characterization with a crowning contribution to the Stalin cult. In this sunlit world, the suffering and deaths of the period of collectivization are unimaginable.

1937, the year when these paintings were produced, was also the year of the Paris International Exhibition, where the Soviet and German pavilions confronted each other, in cultural anticipation of war. This was the year, too, in which Nazi cultural policy took definitive form. The painter Adolf Ziegler (1892–1959) was authorized to confiscate 'degenerate' art in public collections and organize an exhibition, the infamous show of 'Entartete Kunst'. At the same time, the new House of German Art opened in Munich, to present the first in a series of exhibitions of 'Great German Art'. Painting played a relatively minor, if significant, part in Nazi state culture, which made play chiefly with theatre

90. **Yuri Pimenov**, *New Moscow*, 1937. Pimenov belonged to the post-revolutionary generation of artists and studied, alongside Aleksandr Deineka, at the Moscow VKhuTeMas (State Artistic and Technical Studios). He was also a member of OSt. His early work drew inspiration from German *Neue Sachlichkeit* painting.

91. **Arkadi Plastov**, *A Collective Farm Festival*, 1937. The slogan at the top of this huge painting reads 'Living has got better, living has got merrier!' An exuberant painter of peasant scenes, Plastov here also furthers the Stalin cult, as did much other Socialist Realist painting, not least in official portraits by Aleksandr Gerasimov (1881–1963) and others.

and spectacle. In his speech at the opening ceremony, Hitler contrasted the 'crippled' figures of the 'stone age' artists (Expressionists and other 'degenerates') with the perfection of antiquity. True German artists were to create images of national health and well-being. As seemingly bland a painting as Ziegler's *Female Nude* (*c.* 1937) puts Nazi racial theory on show, presenting a stereotypical 'Nordic' type, whose dancing shoes affirm her healthy athleticism.

92

One of the several ways in which Nazi and Soviet official cultures reflected each other was through their respective rhetorical emphases on 'the people'. *Narod* and *Volk* were not identical concepts, for the latter had an expressly racial connotation; in Stalin's Soviet Union, art came to serve the *Narod* rather than the proletariat. This was the era of 'the people' in the democracies too, under the New Deal in the United States, and with the French and Spanish Popular Front governments. No painter was

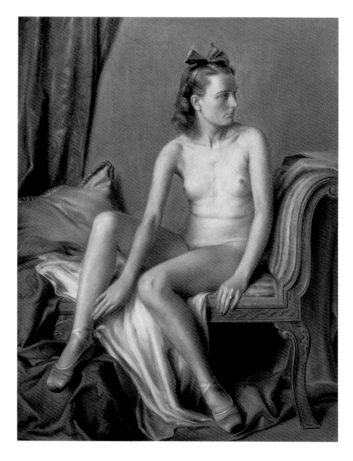

92. **Adolf Ziegler**, *Female Nude*, *c.* 1937. Ziegler's classicism reflects one aspect of Nazi taste in painting; the other was a preference for peasant genre scenes in the nineteenth-century German tradition of Wilhelm Leibl and Hans Thoma. In 1942, Adolf Feulner, a German museum director, celebrated the return in art 'to a simple world and to humanity', to 'calm, realism [and] earthiness'. Ziegler fell from favour in the same year, and was imprisoned for a time in 1943.

93. **Fernand Léger**, *Adam and Eve*, 1935–39. A tattooed Adam, like a sideshow performer with a tame serpent, returns with Eve to an earthly paradise. Flowers, limbs and abstract forms float and interweave. Léger's 'new realism' is a relaxed and demotic modern classicism.

more suited to respond to the Popular Front spirit than Léger, who painted a vast mural for the Palace of Discovery in the 1937 exhibition in Paris, and collaborated with Charlotte Perriand (1903–99) on another, for the Agriculture Pavilion. Léger, who had been to see the New School murals in 1931, had been planning and working on mural projects throughout the decade. He was committed to the mural as a form of popular art, but not in the terms of Socialist Realism. Instead, he proposed a 'new realism', which should combine modernist technique with social commitment. His is the least programmatic, the least explicitly political of all the socially oriented 'realisms' of the period. Like his murals, his monumental canvases of those years figure a benign public space. His Adam and Eve are yet further versions 93 of the 1930s new humanity, crossing classicism and modernism with an imagery evocative of popular culture, of circus and acrobats. Following the 1936 Matignon agreement (signed between employers' representatives, trade unions and the government at the Prime Minister's office in the Hôtel Matignon), the new Popular Front government introduced measures including a forty-hour week that brought more leisure into working-class life, and paintings like this reflect the spirit of that time.

94. **Serafima Ryangina**, *Higher and Higher*, 1934. While the painting concerns technological progress, it differs from the earlier work of Deineka (see plate 89) by creating glamorous and romantic heroes with whom the viewer is invited to identify.

95. **Pablo Picasso**, *Guernica*, 1937. Picasso began this vast painting soon after the German Condor Batallion bombed the Basque town of Guernica, on 26 April 1937, during the Spanish Civil War, and it was installed in the Spanish government pavilion at the Paris International Exhibition in June.

Broadly speaking, public and state-sponsored art in Europe and the Soviet Union differed from its equivalent in the United States and Mexico in having comparatively less detailed didactic content, and in placing a particular emphasis on physical well-being. Leni Riefenstahl's film of the 1936 Berlin Olympics, while inspired by Nazi ideology, also corresponds to a general tendency in publicly oriented art of the period to use the body as a means for the communication of ideology. In the case of Socialist Realism, as recent scholarship has emphasized, it is the bodily response of the spectator that is crucial. The large Socialist Realist canvases of the 1930s are typically painted with a bravura which, with the proper uplifting content, works to draw the viewer into a state of exhilarated identification. Frequently, as in *Higher and Higher* (1934), by Serafima Ryangina (1891–1955), there is a poster-like immediacy and urgency. Soviet cinema develops similarly in the 1930s and 1940s, turning from montage to the narrative excitement of a film such as Sergei Eisenstein's *Alexander Nevsky*. As the system became more authoritarian, it seems, cultural forms became softer, imbued with emotion and sentiment. Socialist Realism of the 1930s conveys less a meaning than a mood.

94

What was under way, however, beyond the golden harvests and heroes of labour, was mobilization. Amid the radiant imagery of the 1937 exhibition stood one dark and fractured exception, Picasso's *Guernica*. It is the only public work of art in the period that evokes the monumental history painting of the past, and the only one whose content is negative: not the golden city, but the ruin of hope, it recruits for no dream, yet proclaims an unambiguous allegiance.

95

Realism as Allegory

A strong current of anti-naturalism runs through the realisms of the interwar period. There is a common move away from the emphasis on 'sensation' that had arisen in nineteenth-century French realism, and from the Impressionists' pursuit of shifting and unstable effects of light. Most of the painters discussed in this chapter give clear definition to objects and figures, sometimes in a return to earlier tradition and 'order', sometimes (or additionally) in response to technological modernity.

Among the exceptions to these generalizations, the most conspicuous is Socialist Realism. Although Socialist Realist theory anathematized naturalism (as well as 'formalism'), Socialist Realist painting was often markedly naturalistic. However, these Soviet paintings engaged their viewers not only sensuously, but in a more indirect way, at the level of social content. The viewer's participation in the illusion is interrupted (though not in any critical way) by a recognition of allegory; the painting means more than it shows, and its meaning must be read across its surface, like a slogan. In general, all the realisms of the period are allegorical in character. Their highly wrought and artificial surfaces direct the viewer's attention to narratives of social involvement, or to the traces of universal order – or to both simultaneously. As a political allegory, *Guernica* participated in this era of realism, yet in a singular way, for its imagery evokes a subjective world of psychosexual fantasy. The bull, whose violent sexual power Picasso elsewhere integrates with other principles and forces, here stands in dumb and threatening isolation. The creative 'household of impulse' that W. H. Auden writes of in his poem 'In Memory of Sigmund Freud' has fallen apart – 'Sad is Eros, builder of cities / And mourning anarchic Aphrodite.' Like Picasso's painting, Auden's poem, written on Freud's death in September 1939, expressed not only grief but foreboding.

Chapter 3: From War to Cold War

During the 1940s and 1950s and especially in the immediate postwar years, realism was predominantly a European affair. It was in Europe that the realist tendencies which had emerged during the 1930s came to take on a new life. Although Socialist Realism continued its evolution in the Soviet Union, it ceased to have any connection with practice elsewhere and so became hermetic, at least until conditions changed after Stalin's death in 1953. The rising generation of Soviet artists had been trained wholly within the art educational system established during the 1930s, which reinstated academic training; as late as the mid-1960s, the French Communist painter André Fougeron (b. 1913), visiting the Soviet Union for an exhibition, found himself surprised by the extent of Russian painters' ignorance of twentieth-century modernism. In the United States, on the other hand, Social Realism not only lost its dominance during the 1940s, but went into virtual eclipse with the emergence of Abstract Expressionism.

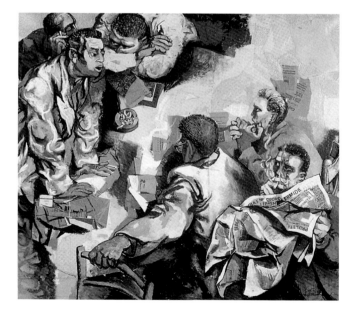

96. Renato Guttuso,
The Discussion, 1959–60.
Guttuso here paints from his own experience as a politician. Through combining collage and illusionism, by compressing pictorial space and in using a large canvas, he seeks to engage the viewer in an almost bodily way. His actualization of a heated discussion bears comparison with the vivacious group and crowd scenes of Italian neo-realist cinema.

In France, Britain and Italy, where realism remained in contention with other forms of practice, it did so only partially under directly political auspices. Whereas for some French artists, including Léger, the term 'realism' signified a political commitment, for Hélion and others realist forms of practice entailed a more general – if intense – concern with common human experience. The Second World War was of major importance for both these realist tendencies. It brought about the end of Fascism (except in Spain and Portugal) and thus of anti-Fascism as a unifying principle on the left, and it paved the way for the Cold War. Western Communists, including Picasso and Léger, who joined the French Communist Party in 1944 and 1945 respectively, found themselves enlisted in Cold War cultural politics from 1947 onwards. The other and wider influence of the war arose from the deep impact it had on civilian populations, due to bombing, privation, occupation and, above all, the concentration camps. The war was a collective experience, undergone or witnessed by millions in Eastern Asia and in Europe, and many survivors unavoidably remained haunted by it. This was the context in which the 'argument about realism' that had so engaged artists in the 1930s came to be taken up again, especially in France and in Britain.

While wartime experience spurred some French painters to affirm political commitment through their work, it also, and more widely, prompted a new engagement with the fabric of a world unexpectedly regained. This existentialist theme (Jean-Paul Sartre was a predominant cultural influence) is easily caricatured. Yet the received notion of 'existentialist angst', while seemingly warranted by the leanness and angularity in a Gruber or a Giacometti, overlooks what we might equally call existentialist *joie de vivre*, an appetite for the real, born of hunger. Admittedly, there was a distinctly bogus side to the French art of the period, most apparent in the stylized anguish of Bernard Buffet's (1928–99) spiky paintings. Plainly genuine, however, was the pictorial evidence of Boris Taslitzky (b. 1911) and Zoran Music (b. 1909), both of whom had survived internment in concentration camps, and drew what they had seen. In France, which had endured occupation, witnessing and bearing witness was a recurrent motif in postwar culture; the word *témoin* (witness) appeared in the titles for exhibiting groups: *Peintres témoins de leur temps*, *L'Homme témoin*.

Many factors unite the three pictorial cultures of Western Europe that chiefly concern us here. Apart from the experience of

the war, and a preoccupation with the real (and with the processes of perception), there was the influence of a general political turn to the left. Britain had a Labour government until 1951, Communist ministers were for a time in the French President Charles de Gaulle's cabinet, and both the French and the Italian Communist parties were extremely large. The painting of common experience flourished within a culture of collectivism.

Political Passions
In October 1940 Marshal Pétain, establishing at Vichy the government of the part of France left unoccupied by the Germans (until 1942), proclaimed that France was 'entering the path of collaboration' and that collaboration had to be sincere. After the liberation Pétain was executed, like a few other active collaborators, but the *épuration* did not extend very far or last particularly long, for in some degree almost everyone had collaborated with the Germans. Among the small number of active resisters, Communists predominated. Their political prestige and influence was at its highest in the immediate postwar years, a strong recovery after the low point of the Hitler–Stalin pact. Their influence extended to cultural and artistic life, in which they had been deeply involved since the 1930s. The poets Paul Eluard and Louis Aragon organized underground publishing during the war, and their fellow-Communists Edouard Pignon (1905–93) and Fougeron published a set of subversive lithographs, the *Album vaincre*. The Party gained recruits as the war ended, the most prestigious being Picasso, highly respected for having remained in Paris during the Occupation; the Communist daily *L'Humanité* announced in 1944 that he had joined 'the Party of the Resistance'. De Gaulle, keen to promote the myth of national resistance, and recognizing the Party's high standing, included Communists in his government.

The myth of resistance effaced memories of Pétain's 'path of collaboration'. Everyone who looks at photographs of the summary street punishments that took place immediately after liberation can read the mixture of guilty emotions on the faces of bystanders. These are scenes of scapegoating. Fougeron, on behalf of the Communists' National Art Front (whose President was Picasso), called for the prosecution of collaborating artists who had 'gravely compromised the good name of French art'. Those he had in mind included the artists who went in 1941 on an organized trip to Germany, attended by photographers at every turn. Some among them, for instance, Maurice de

Vlaminck (1876–1958), were certainly ideologically motivated, but others, including Derain, were principally naive and not much more or less guilty of collaboration than those who had continued to exhibit and publish in conditions of censorship. The art trade in wartime Paris boomed (some Jewish-owned galleries were taken over at negligible cost). Simone de Beauvoir produced her own radio programme.

The experience of the collective collaboration that had followed defeat needed to be expunged, the feelings arising from it had to be vented. A painting that attracted particular attention in the first big public exhibition after Paris had been freed, the 1944 Salon d'Automne, was *Job* by Gruber, which was conspicuously not an image of liberation. At a moment when there was talk of triumphant resistance, here was a picture of abject defeat. Gruber puts a naked, ageing man in an impoverished urban setting, giving figure and surroundings the same sinewy obduracy. The green boards of the broken fence echo the man's bony despondent angularity. The painting portrays a resigned and bitter submission. Here is a man in a corner to which he has retreated, and which reflects back his own despair. The scene might almost illustrate the account of 'passive sadness' which Sartre had published in his 1939 *Sketch for a Theory of the Emotions*: 'lacking both the ability and the will to carry out the projects I formerly entertained, I behave in such a manner that the universe requires nothing more of me.' The despairing individual makes the universe 'bleak and undifferentiated' and finds a paradoxical refuge – 'a bleak wall, a little darkness to screen us from that bleak immensity.'

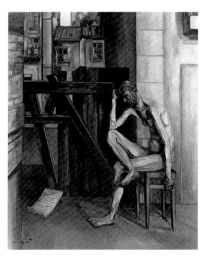

97. **Francis Gruber**, *Job*, 1944. A literal translation of the French inscription of the verse from Job written on the sheet of paper is 'Now once more my pleading is rebellious / Yet my hand suppresses my sobs.' (cf. Job, 23, 2) It comes at a mid-point in the Biblical text, where Job laments the depth of his abandonment.

Job's world, as shown here, is not an objective reality but a projection or corollary of his despair. We might speculate on how the painting might have served its viewers, in helping them objectify, and so expel, wartime experience of submission. Memories of the Occupation were soon to be covered over, but in the war's immediate aftermath there was some willingness to face up to what had happened, beyond occupied France as well as within it. A large exhibition of 'crimes hitleriens' took place in Paris in 1945, and a mock-up of a concentration camp was built in the same year. In the 'Art et Résistance' exhibition of 1946, Picasso exhibited his *Charnel House, Monument for Spaniards who Died for France*, a painting whose jumbled mass of bodies would have evoked the photographs of piled-up corpses published after the liberation of the camps.

The image of death clings to many of those French paintings of the period that most overtly address collective experience. Political hope, the aspiration to communality, grew out of feelings of loss and fear. Fear is isolating and the Communist Party, especially, afforded community. Picasso, explaining his decision to become a member, evoked his sense of isolation as a foreigner and spoke of having joined a family. Indeed, those expelled from the Party in the subsequent period of re-Stalinization confessed feelings of loss. To be a Communist was, above all, to belong, to share in a common destiny. Gruber, who painted a famous landscape of defeat in 1942, his *Hommage à Callot*, and whose paintings are generally redolent of isolation, joined the Party after the liberation, having been a sympathizer in the 1930s. *Job* evokes the moment when he and so many others chose to join.

It is in Léger's late paintings that we can find the most positive assertion of the familial, communitarian spirit that pervaded not only Communist rhetoric, but left-centred politics generally. Like Gruber a participant in Communist-organized cultural events during the 1930s, Léger joined the party from the United States, where he had spent the war years, so as to return to France a Communist, ready to participate in the rebuilding of society. He wrote on his return that it was necessary to be near the people if one was, as an artist, to communicate with them; this long-standing aspiration now found its most appropriate channel, for to be in the party of the working class was to be joined to the people, *ipso facto*. Léger's postwar paintings carry forward the ideals of the Popular Front, but with a new confidence. His modernizing classicism becomes more humanized and supple (*La Grande Julie*, painted in New York in 1945, held a presage of this).

98. **Fernand Léger**, *Les Loisirs, Hommage à Louis David*, 1948–49. Painted in celebration of the 1948 bicentenary of the birth of Jacques-Louis David, the history painter and Jacobin, *Les Loisirs* is also the summation of a series of images of cyclists; all feature groups in formal yet amicable pose, as in an old plate-camera image.

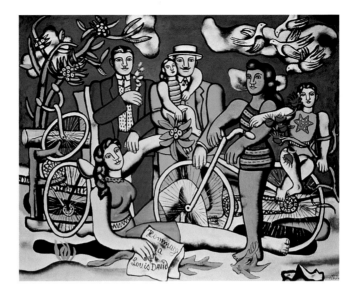

In contrast to the *Plongeurs* (immersed swimmers) of his New York years, the new subjects have firm ground beneath them.

In 1949 the Paris Museum of Modern Art mounted a Léger retrospective, which included his first major postwar work, *Les Loisirs, Hommage à Louis David* (1948–49). '*Les loisirs*' means 'leisure', but the holiday scene depicted here figures a world beyond labour rather than time away from it. In no obvious respect does this *hommage* evoke actual paintings by David; what the inscription celebrates is David's contribution as an artist to revolutionary politics, whose only end is human fulfilment. The 'new realism' Léger proclaimed in the 1930s here works for the end it also portrays, interlinking bodies, bicycles and flowers on the demotic armature of a 1900s photograph of a family outing. Bearing in mind what was happening in the Soviet Union and Eastern Europe, it is possible to see Léger's imagery as delusively easy; the novelist Milan Kundera, who takes such a view, has written of the painter's friend Eluard reciting lyrically in Prague after refusing to speak for victims of show trials. However, there is not only ease in Léger, as we shall see; for the moment, it is worth recalling that it was during service as a soldier in the First World War that he had gained his formative experience of communal life.

Although not all Parisian artists and intellectuals were Communists, the issue of Communism was prominent in intellectual debate, both up to and after the commencement of the Cold

War. Intellectual culture was predominantly leftist, and up to 1947 there was a relatively open and fluid debate between different positions. In 1947 the Cold War began, and the consequence for art was that – as in other fields – it became necessary to choose sides. In September Zhdanov, the leading ideologue of Socialist Realism in the 1930s, made a speech at Cominform (the Communist Information Bureau, established in 1947 to coordinate the policies of ruling European Communist Parties) on the world's division into two opposed camps; he was subsequently to issue vehement denunciations of 'formalism' in art. The French Communist Party, whose representatives had left de Gaulle's government by the end of the year, fell into line. Louis Aragon, who had already reaffirmed in 1946 that the Party had an aesthetic, and that it was called realism (i.e., Socialist Realism), wrote a glowing obituary for Zhdanov on his death in 1948. Laurent Casanova, a leading Party ideologue, stressed the need for unconditional support for Party decisions, in culture as elsewhere – 'the Party is not a party of discussions'. The Popular Front was finally consigned to the past. Those who sought a third way between the two blocs, including André Malraux and the group around Sartre, were soon disabused. Erstwhile allies of the Party such as Sartre faced a dilemma, and what sharpened it was the emergence of strong evidence concerning Soviet work camps and east European show trials. A choice was unavoidable; ultimately, Sartre chose the Communist side as the only hope for the working class, a decision that separated him from his close allies Albert Camus and Maurice Merleau-Ponty.

One of the closest adherents of the Party line among painters was Fougeron. Respected as a *résistant*, and for his courage in exhibiting a painting implicitly critical of Vichy propaganda in 1943, Fougeron received a prize in 1946 which enabled him to travel to Italy the following year. There is a significant difference between the painting he exhibited on his return, *Italian Women*, which was well received, and *Parisian Women at the Market*, which drew a divided response at the Salon d'Automne of 1948. Whereas the earlier painting was Picasso-like, and rather in the spirit of his friend the painter Renato Guttuso (1911–87), the later one was assertively realist, its figures starkly frontal and rendered in strong tonal contrast evocative of seventeenth-century Caravaggesque genre painting. It was a pointedly uningratiating proletarian scene. Fougeron had conceived it in response to the new Party line, particularly as expressed by Casanova at the PCF (French Communist Party) Congress, and

Party members including Casanova visited the painter's studio as he worked on it. When it was shown, only the Communist press approved; elsewhere it was vehemently disliked.

After 1948, the year in which *Parisian Women* was shown, the Salon d'Automne regularly had a section of Social Realists, the best known of whom were Fougeron himself and Taslitzky. Fougeron's painting was a manifesto, a contribution to the revived quarrel about realism. *The Judges*, painted three years later, is still more decidedly confrontational. One in a series of works produced in response to a union invitation to tour mining districts of northern France, the painting arranges its figures in frontal echelon, as in *Parisian Women*. Fougeron uses methods akin to those Grosz and Dix had employed in the 1920s. His painting is polemical and critical, staging a reversal of roles whereby those who have been the victims of power form a tribunal, facing the public with brutal evidence of what is done in its name. The painting might equally well serve as a poster; indeed, an earlier canvas in this style, *Homage to André Houillier* (1949), was painted in memory of a man beaten to death by police while putting up anti-war posters designed by Fougeron himself. Police brutality and political censorship reflected the tense political atmosphere of the time, a period during which a newspaper published the findings of a questionnaire on the topic 'what would you do if the Reds invaded?'

99

99. **André Fougeron**, *The Judges*, 1950. A female sorter and three miners show their injuries; with them is an orphan. Fougeron's message is as emphatic as the hard and sculpted style, which replaced the Picassoism he maintained until 1947.

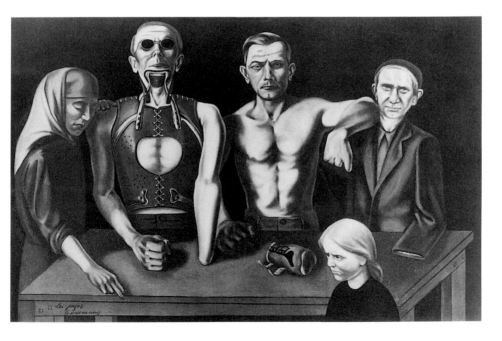

The accusatory mien of Fougeron's *The Judges* reflects on art as well as politics: the hard gazes are designed also to bear down on 'formalism'. Far later, Fougeron was still to assert that all painting was either mere decoration, or it was *témoignage* – testimony, evidence. Such a demarcation would certainly not have suited Léger, who privately expressed despair at Communist cultural policy. Both Léger and Picasso remained silent on this subject, while wholeheartedly supporting the Communist cause. Picasso was assiduous in attending Soviet-inspired peace congresses, whose symbol, the 'Dove of Peace', derived from one of his lithographs. Regularly denounced by the Soviet art establishment, Picasso drew criticism from French Communists (at the instigation of Fougeron) when *Les Lettres françaises* published a too-youthful and insufficiently avuncular drawing he made of Stalin, on the latter's death in 1953. Aragon was obliged to apologize for publishing it.

Léger would surely have claimed that 'decoration' was an aspect of his 'testimony'. Decorative projects indeed comprised a large part of his late work; in them, strong-hued mosaic inter-acted with ceramic relief panels. Fougeron, in the statement referred to, did qualify his distinction by adding that all art 'signifies', and Léger's decorations signify the promise held out by revolutionary politics. Yet his formal language could also be discordant, as it is in *Les Constructeurs*, exhibited in 1951 and received, it appears, as a response to Fougeron's mining region series, which included *The Judges*.

100

In spite of its decorative qualities, *Les Constructeurs* is not a harmonious painting, for Léger establishes a dissonance between the workers and the flatly painted girders. In this it is unlike *Les Loisirs*, whose figures are at ease in their surroundings, with bicycles to hand; the bicycle, one of the few machines Léger depicted, has the virtue in his paintings of visually expressing a direct amplification of the body's power, a companionable extension of its limbs. *Les Constructeurs* is Léger's culminating treatment of the relationship between the human and the mechanical, present as a theme in his work since the First World War, a relationship that here takes an ambivalent form.

The painting also resumes Léger's equally long-standing theme of male working-class comradeship; the group of four men holding a girder constitutes an image of interdependence. These are not Soviet-style heroic workers. Léger said that his idea for the painting came from seeing men working high up on electricity pylons: 'Lost in the rigid, hard, hostile surroundings

100. **Fernand Léger**, *Les Constructeurs*, 1950. This is the definitive version of a series of works on this subject, comprising drawings, watercolours and oil paintings. Léger's fascination with the beauty of machinery and machined metal, and his sense of affinity with the working class, here find expression not in an association between humans and metallic geometry (as in the 1920s), but in a mutual contrast. Léger said that his feeling of solidarity with the working class began with his First World War military service. His sentiment then, however, had been republican and nationalist: 'I discovered the French nation', he said in 1920.

the men appeared tiny.' His vision was thus the exact converse of Ryangina's in *Higher and Higher*. Unlike her film-star workers, Léger's are unglamorized. He uses tonal modelling to render not heroic anatomies but an ungainly physical toughness. This is manual labour, and the central motif emphasizes the work of hands, for whose arduous grasping actions there are many drawn studies. Yet if they are not heroes, neither are they victims like Fougeron's figures, for here it is precisely not a question of incapacity. In a by-product of the *Constructeurs* series, a picture-poem of workers' hands in memory of Vladimir Vladimirovich Mayakovsky (1893–1930), Léger both praises the character of the hands and looks to their emancipation. Although the structure the *constructeurs* build imprisons them, it also draws them into an association that constitutes their true strength; their hands, which 'resemble their tools', signify their common practical involvement but not their chosen destiny. (In *Les Loisirs*, conversely, the bicycles 'resemble' the human body.)

The difference between western Communists such as Léger and Soviet artists was that the latter operated in a system where the worker was officially in power. Fougeron's *The Judges* would have been inconceivable as a Soviet painting, even though Soviet workers certainly suffered no less than did their French counterparts. Plastov's *Threshing Corn on a Collective Farm* was painted in 1949, deep into the era of Stalinist cultural repression known as the *Zhdanovschina*, after its chief proponent. To our eyes, it might seem a wholly orthodox piece of Socialist Realism: a vast thematic canvas portraying patriotic labour in idyllic sunlight.

101

101. **Arkadi Plastov**, *Threshing Corn on a Collective Farm*, 1949. A lyrical yet physically realistic rendering of Soviet landscape was a strong feature of Socialist Realism. Plastov's cinematographic treatment suggests how much the early cinema of the Russian film director Tarkovsky drew from the Socialist Realist aesthetic.

102. **Aleksandr Laktionov,**
A Letter from the Front, 1947.
In this famous painting of the high
Stalinist era, Laktionov analyses
light with time-stopping intensity.
Partiinost is less important than
the appearance of an arm through
a sunlit blouse. Pushed this far,
academicism becomes surreal.

Yet, from a Socialist Realist standpoint, even this could be criti-
cized: Plastov establishes no psychological interaction between
the characters, develops no positive narrative and also shows no
modern machinery; furthermore, there is evidence of sweat and
exertion, and the central episode of slaking thirst is quite
unheroic. The painting also lacks the seamless high finish of a
more academic work like Aleksandr Laktionov's (1910–72)
A Letter from the Front (1947). Nonetheless, Plastov is a genuine 102
Socialist Realist, if not a compliant hack like Aleksandr Gerasimov
(1881–1963). Typically, the scene is felt immediately by the
viewer, as if it were reality itself, in a way that can only compare
with cinema. What is artful here is not only Plastov's colour, but
his orchestration of simultaneous, disconnected actions.

103. **Geli M. Korzhev,**
Raising the Banner, 1957–60.
This forms the central panel of the
triptych *Communists*; the vertical
flanking panels show a sculptor
in soldier's uniform modelling
a bust of Homer, and an army
bandsman on a battlefield playing
the Internationale.

While vehemently opposed to western 'formalism' (the Museum of Modern Western Art in Moscow was closed in 1948), official Soviet culture of the Cold War years evolved along formal and highly codified lines of its own. In visual art, the *kartina*, the large subject picture, was and remained the central vehicle of expression through changes of regime. It was an institution that had no equivalent in the west. When a painting such as Geli M. Korzhev's (b. 1925) *Raising the Banner* (1957–60) was shown in London, it appeared as a work from another world. Yet Korzhev's painting reflected a liberalization of Socialist Realism around the time of the famous secret session of the Twentieth Soviet Party Congress in 1956, at which Khruschev denounced Stalin. The veteran Communist critic Georg Lukàcs wrote his book *The Meaning of Contemporary Realism* immediately after the Twentieth Congress, breaking his silence on the 'dogmatic sectarianism' in cultural policies of the Stalinist era. Korzhev and other artists of the 'severe style' (Matthew Cullerne Bown's translation of a Soviet critical label) exploited the new release from dogma.

103

Like the other 'severe style' painters, Korzhev uses 'formalist' means to present a synthetic, simplified and concentrated account of his subject. These painters looked to Deineka, and also to Picasso, Guttuso and others, in their modernization of Socialist Realism beyond academicism. Korzhev's painting, the central part of a triptych called *Communists*, is untypical of the style in its density of detail; other painters used a more modernistic schematization of colour (critics sought to reconcile formalism and realism, and made reference to Brecht). However, Korzhev's tonal stippling and scumbling is less descriptive than emotive, supplying the equivalent of cinematic 'grain'. Indeed, the laconic style of this image owes much to cinema, the kneeling worker being framed as if by a movie camera. This is a strong male figure, but it is not the stereotypical Soviet hero, and the scene and its outcome are wholly enigmatic, the context unclear – although the experience of war is central to the triptych as a whole. The effects of the 'Great Patriotic War' were lastingly felt in the Soviet Union, which lost 20 million of its population. Korzhev's most notable works, painted in the 1960s, are vast and starkly economical portraits of individuals bearing the physical or mental scars of war.

A major cultural achievement of the Khruschev era was the demolition of the superhero image. For a brief period wider reform appeared a possibility, but Khruschev was hemmed in by

104. **Renato Guttuso,**
Flight from Etna, 1938–39. Painted
and exhibited under the Mussolini
régime, the painting covertly alludes
to Picasso's *Guernica* (see plate 95),
in the central horse and the bull's
head at the left. The fallen chair,
peasant furniture, invokes van Gogh;
Guttuso's friend the writer Alberto
Moravia spoke of his 'Mediterranean
expressionism'.

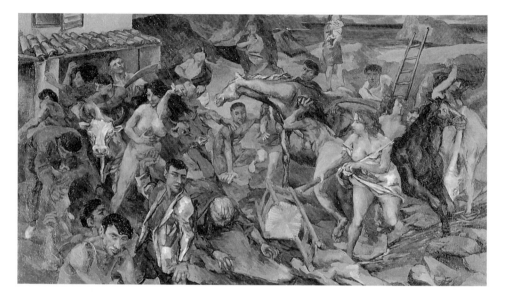

the Cold War; 1956 was the year both of his Stalin speech and of the Soviet invasion of Hungary (Lukàcs, a member of Imre Nagy's government, was under threat). The Khruschev thaw ended with the 1962 Cuban missile crisis, which diminished Khruschev's political authority, and to a degree the Soviet cultural world closed upon itself again.

Only Communist artists travelled readily from the west across the divide that dominated postwar politics, among the most important being Guttuso. He joined the Italian Communist party in 1940, having been an associate of intellectual and artistic anti-Fascist groups during the late 1930s. From 1951, he was a member of the Party's Central Committee. In the postwar years, he became the most internationally known among the younger Communist painters, exhibiting widely in the Soviet bloc countries, and also in London and New York; curiously, he had no solo exhibitions in France.

With *Flight from Etna* (1938–39), he presented himself as 104 a painter of public-scale work. Like Picasso's *Guernica*, which 95 inspired it, the painting is a scene of checked flight. Picasso was a deep influence on Guttuso; a study of Picasso's violent *Crucifixion* of 1930 preceded his own controversial interpretation of the subject, exhibited with the Etna painting in 1940. Guttuso was himself a Sicilian, though not from a rural community like the people shown here, and his painting was informed both by experience and by Sicilian literary tradition; the novelist Leonardo Sciascia, a fellow-Sicilian, was a supporter of his work. In this painting and others Guttuso, like his friend the poet and film-maker Pier Paolo Pasolini in some of his films, or like another friend, the painter and novelist Carlo Levi, evokes the elemental in peasant or working-class life. The volcanic eruption of Etna effectively communicates its violence to the people and animals, whose actions tear confusedly in all directions. The forms themselves are torn and shredded, an abiding feature of Guttuso's style. The effect, taken together with the naked flesh and the predominantly earthy hues, is to identify the bodies with the earth itself, its matter and its forces. This painting of panic evokes the ancient sense of that word, the Greek *panikos*, belonging to Pan.

Guttuso resembles Pasolini and Levi in that his art goes in search of a primordial energetics of human association; his painting has everything to do with life-giving passions and appetites – hence the dark forcefulness of his series of wartime drawings, *Gott mit Uns*. His spiky and cluttered still lifes, bristling with baskets, cages and implements – manipulable things – enact

105. **Giuseppe Pelliza da Volpedo**, *The Fourth Estate*, 1901. In this famous early twentieth-century Italian essay in 'social painting', Pelliza (1868–1907) represented peasants as Raphaelesque philosophers, advancing in debate – an utterly different visual metaphor of socialist politics than Guttuso's images of struggle and conflict (see plates 96 and 104).

intense involvement in the material world. His is a hedonistic politics, or a politics of hedonism. Straightforwardly political subjects are in fact fairly rare in his work; far more characteristic are the exuberant beach scene of 1955–56, *The Beach*, or the intensely descriptive account of the Palermo market, *La Vucciria* (1974).

106

The Discussion (1959–60) at least takes us into the world of politics of a traditional kind, the all-male smoke-filled room. Guttuso depicts himself speaking. What his painting conveys is the pent involvement of debate; this is a realism of bodily states: the smoke exhaled, the grasping hands, the head burying itself. A collage of newspaper and magazine scraps with a cigarette packet gives tangible actuality and immediacy. The furiously crumpled paper held by the smoking man is an emblem of political passion. Guttuso, engaged in an actual debate in London in 1955 on the theme 'Realism versus Abstraction', defined 'Realism today' as essentially concerned with the present, 'strictly connected with modern reality and culture'. It meant involvement. *The Discussion* relates to a number of paintings in which Guttuso uses montage techniques to bring together contrasting aspects of present (and past) reality – into the same space, as if in debate. Teenagers dance in front of a Mondrian, in *Boogie-Woogie* (1953); in the 1976 *Caffè Greco*, de Chirico, d'Annunzio, Buffalo Bill and a Japanese tourist all take coffee. Guttuso's use of montage is far more interesting than that of his friend Fougeron in the latter's vast *Atlantic Civilisation* (1953), but both painters adapted politically conscious realism to take account of the contemporary. In the 1960s Guttuso was included in survey exhibitions of neo-realism and Pop art. A comment by Richard Wollheim, an early British supporter of Guttuso, helps explain the relevance of his work for a diversity of post-war realist contexts: Guttuso, Wollheim observed, had learnt from Cubism that 'the realism of a picture can be enhanced by emphasizing the reality of the painting'.

96

107

The Painting of Being

Interviewed in a Communist paper in 1945, Gruber affirmed that 'great painting is history painting', meaning, art with a public purpose. Lukács had placed comparable emphasis on the 'historical novel' in his Marxist exposition of the interdependence between realism, history and politics; to the realist, in Lukács's account, man is pre-eminently 'a social animal'. Lukács wrote dismissively in 1957 of what he called 'the dogma of the *condition humaine*'. His allusion was to Malraux, but his wider target was the movement in French postwar culture broadly known as

106. **Renato Guttuso,** *The Beach*, 1955–56. In 1956, John Berger wrote that Guttuso had been able here to 'make a scene of pleasure heroic'. The painter had a strong following among critics and painters in Britain in the mid-1950s.

107. **André Fougeron,** *Atlantic Civilisation*, 1953. Painted contemporaneously with the equally monumental *French Peasants Defending their Land* (from USAF air bases), this painting juxtaposes emblems of American domination with references to the war in Indochina. Aragon attacked it as anti-realist in its lack of perspective and disconnectedness. In Fougeron's view, it was precisely realism that entailed the montaging together of disparate entities. Political reality, in its complexity, could not be represented in naturalistically coherent terms.

existentialism, which he saw as focusing upon the isolated individual, to the exclusion of society. However, the intellectuals associated with this movement – principally Sartre, de Beauvoir and Camus – were fully alive to politics. By enquiring as they did into human affective life, they did not thereby necessarily disregard social and political reality. The realm of the emotions, even isolating ones, is social; it is, to adopt a term Sartre used, 'intersubjective'. Whether or not Gruber regarded his *Job* as a history painting, his painting belongs to a region of common experience. What the individual feels is not confined to that individual.

By 1945, in fact, Gruber's paintings of historical allegory were behind him, and the works of his remaining years manifest an effort to – as he put it in 1948 – 'rediscover the world through solitude'. The phrase might equally hold for certain other artists of the time, some close to Gruber. However, there was not an 'existentialist art'; indeed, one or two of the artists who are relevant here were in fact indifferent or even hostile to Sartrean existentialism. It is rather that, during the postwar decade, a number of French artists began to work along lines that had relevance for existentialism – and in Giacometti's case this was certainly recognized. Of central importance was a pattern of friendships and associations, established before the war, linking Gruber and Giacometti, Hélion and Balthus. Gruber had been connected with Social Realism; Hélion and Giacometti had turned from abstraction and Surrealism respectively towards a new concern with depicting the human figure; all, including Balthus, came to be preoccupied with what could be termed intersubjective reality (the influence of Surrealism was a factor) and, in differing degrees, with working from the model. As a parallel development, the 1940s saw a renewal of theoretical interest in perception and the representation of visible reality. Merleau-Ponty's *Phenomenology of Perception* was published in 1945; Sartre, also reflecting on perceptual themes, wrote essays on Giacometti in 1948 and 1954. Malraux published *Le Musée imaginaire*, the first volume of his *Psychology of Art*, in 1947, addressing the question of the cultural impact that photographic reproduction has on our understanding of art. His publisher Albert Skira, who was to become renowned for the exceptionally high quality of his art books, also, in 1955, published Georges Bataille's reflections on the Lascaux cave paintings – primary depictions of visible reality.

It was Skira who prompted Giacometti to write what became the text published by him in his magazine *Labyrinthe* in 1946, in which the artist described a traumatic and formative experience,

108. **Francis Gruber**, *Nude in a Red Waistcoat*, 1944. Gruber's lean style, modelled partly on the work of the seventeenth-century artist Jacques Callot, cuts back almost to the bone, to nakedness and bareness. This reduction to the essential is at once melancholy and affirmative – an equivalent for Sartre's famous paradox (soon to become a cliché) that the destitution and confinement of wartime Paris afforded an intense freedom.

involving perception. He recalled seeing the heads of living people as if they were isolated against a void, as objects simultaneously living and dead. 'I let out a cry of terror, as if I had just crossed a threshold, as if I were entering a world never seen before.' Giacometti's text artfully interweaves motifs of crossing between waking and sleeping, imagination and actuality, past and present; the vision of 'heads in the void' suggests the experience of seeing things as if for the first time, catching sight of the world in formation, as it crosses the threshold of awareness.

Something in this is reminiscent of Sartre, of his prewar novel *Nausea*, and Giacometti, avid for intellectual conversation, had become a friend of Sartre's at the time. However, the image also specifically evokes Giacometti's own recent work, in its sculptural and pictorial pursuit of the human image to the brink of disappearance. Both the reported hallucination and the works themselves suggest the inauguration of appearance, the first sight of being. The common factor linking Giacometti not only

with Sartre but with other writers and artists of the time was a reawakened concern with a principle central to pictorial realism, namely that the image must be invested with life by the viewer. The 'existential' implication is that we make the pictorial world we see. Sartre compared Giacometti to a magician, that is, an illusionist, who creates the conditions whereby the spectators themselves make things appear. There is nothing up his sleeve; his pictorial methods are those of long-established perspectival illusionism, rendered singular only by being made conspicuous, for example in his 1950 painting of his mother. By characteristically leaving a border around the spatial image, Giacometti keeps it before our attention as a mesh of painted lines on the surface, even as we read the space in depth. In its linearity, the painting retains the diagrammatic character of perspective construction, thus disclosing the basis of the illusion. What further inhibits our perception of depth is the fact that none of the fine lines can be construed as the definite boundary of an object, since too many lines in different hues quiver around a possible edge, or, in the case of the figure, wind around its surface. Nothing firm is found; the lines, so evidently traces of action, denote seeking rather than finding. Therefore, even when the image stands forth in depth, it never attains solidity. The figure itself, additionally, rather than acquiring independent life on a perspectival stage, constitutes the very nexus of the perspective, like a spider at the heart of its

109

109. **Alberto Giacometti**, *The Artist's Mother*, 1950. Giacometti was extremely devoted to his mother and revisited the family home often (he spent most of the war years there). The artist's most regular sitters were people close to him – for instance, his wife and his brother Diego.

web. Giacometti's mother sits in frontal pose and absolutely still at the centre of this system of Chinese boxes. Her head, set appreciably further back than the rest of her body, rises absolutely erect, at or near to the distance point – and looks back. The object of the search we find ourselves drawn into is the only object that returns our gaze, as if reflecting it from the bottom of a well. She is the artefact of perspective and the gaze she returns is our own; we bring her to life by finding her and losing her in Giacometti's pictorial divagations.

What coalesces and comes apart is not simply an image but a mesh of affective and cultural relationships, a world. In many of his paintings, Giacometti situates his subjects in the neutral setting of his studio, but here the space is particular to the person. In her pioneering book *The Second Sex* (1949), de Beauvoir defined cultural archetypes of womanhood, including 'the Roman *domina*', seated in the atrium as the 'lady of the house': 'Today the house has lost its patriarchal splendour; for the majority of men it is only a place to live in, no longer freighted with the memory of dead generations', but women still seek 'a true house'. Giacometti, notoriously rootless in Paris, to the frustration of his wife Annette, cherished the patriarchal/maternal home. In his art, he revisited the emotional complexes into whose cultural origins de Beauvoir inquired; the question for both of them (as for Sartre) concerned the way in which the world of our attachments, desires and fears is constituted.

Hélion, who had known Giacometti since the 1930s and, like him, turned to realism (initially at great professional cost, in both their cases), engaged in his paintings with both the cultural and the sensuous constitution of the human world. 'Reality', as he had defined it in 1934, when still an abstract painter, 'is between the mind and the exterior', an ambivalent space that his paintings negotiate. His canvases of the 1940s are frequently street scenes; the word 'quotidian' recurs repeatedly in his notes at the time, and men reading newspapers populate his paintings, whose titles refer often to *journal* and *journalier* – the daily, the everyday. Schematic and sign-like, these paintings do not, like Giacometti's, direct us to the act of perception, but instead make reference simultaneously to sensuous things and to the concepts whereby we establish our relationship to those things. In his notes, Hélion writes of the 'mythic' construction of the everyday, the social and cultural archetypes that shape it. He isolates quotidian gestures, habits, items of clothing. *Nude with Loaves* (1952), while it presents not a street scene but a domestic

110. **Alberto Giacometti**, *Annette*, 1954. Here head and torso lie in the same plane, as generally in Giacometti's nude studies. The studio setting is only vaguely suggested. Using a fine brush, the artist gauges relative distances from the eye, and traces rhythmic symmetries in the figure rising on the canvas. He negotiates between the horizontal axis of the gaze and the body's verticality. The model is Giacometti's wife Annette, whom he depicted in another painting in exactly the same pose as his mother in the 1950 portrait at Stampa.

111

111. **Jean Hélion**, *Nude with
Loaves*, 1952. Accentuating folds
and edges, Hélion renders bodies
and things as simultaneously
sign and substance. He prevents
the painting from resolving
itself wholly either into three-
dimensional illusion or into a
signifying surface; although there
is depth and modelling, the
arrangement is too manifestly
artificial to comprise a 'scene'.

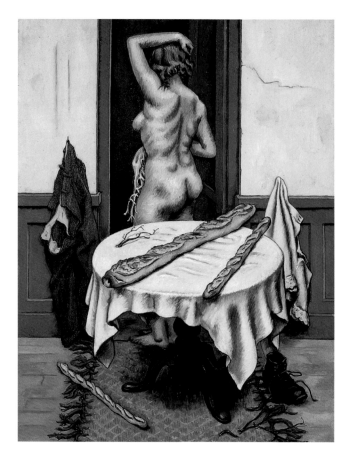

112. **Jean Hélion**, *Vanitas with
Dead Leaf*, 1957–58. From
a sketchbook note, January
1957: 'The skull: seashell;
human object; object-stone,
relative of flint and limestone.
A single specimen. Which
still resembles a person. The
object that survives, long still;
reassuring. Ovoid, full and hollow.
Open and closed. Contrasting
in its unity. Oriental. Tending to
yellow like a dead leaf and a flint.
To roll like a pebble...the skull is
hollow and sonorous like a violin.'

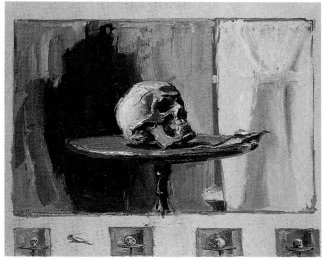

interior, is typical in its symmetry and schematism. It is conceived as a system of meanings. A man's and a woman's clothing flank the central female nude, and on the round *guéridon* lie French loaves, cultural items that here allude simultaneously to male and female genitalia.

In a 1950 article, 'Reason and Reality', Hélion wrote that he had turned in 1939 from abstraction towards realism in the belief that he could not 'paint eight hours a day in one manner, then live in another'. He wanted to put his painting alongside the 'figures and objects that haunt my dreams and pervade my life'. The practice that he evolved, rendering the everyday as a system of signs, brought him close to the poet Francis Ponge, in whose writing words and things mutually confront or discover each other; words become opaque, thing-like. In his *Vanitas with Dead Leaf* 112 (1957–58) Hélion focuses on a single object, as Ponge sometimes did. His broad and liquid brushstrokes strongly suggest (or re-enact) the skull's materiality and plasticity, without submerging their own identity; like Giacometti, Hélion isolates the painted area, so that we attend to the signifying surface. Smaller views below move around the skull, and a separate study repeats the dead leaf that lies beside it. Through this reiteration the painting intimates a turning of the skull, on its round table. As the skull becomes physically vivid, its meaning, in the span of attention, grows in the mind. In a note, Hélion described the skull in Ponge-like terms, as both a singular physical entity and a complex of meanings.

The affinities linking the work of Hélion, Giacometti and others to contemporary writers did not come about solely through the operations of élite culture. These artists'

113. **Georges Braque**, *The Shower*, 1952. Like Hélion (see plate 112), Braque painted *Vanitas* subjects, and in his late work he too constructed an interior realism. Francis Ponge, who wrote on Hélion, identified still more closely with Braque. Here, the substitution of signs for things achieves a haiku-like economy, whereby paint is more like a shower than a shower is.

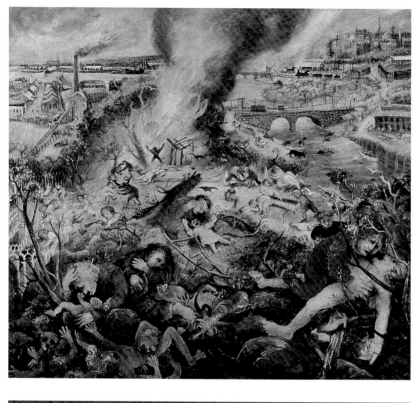

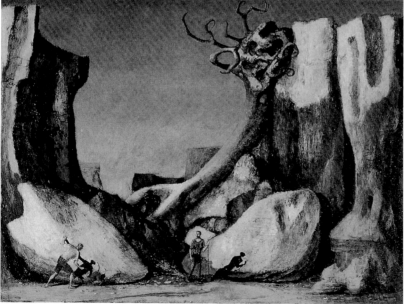

114. **Arthur Boyd**, *Melbourne Burning*, 1946–47. During the 1940s certain Australian painters produced some of the most intensely introspective images in art outside of France. Drawing on a range of modernist styles, with realism as a common denominator, these painters expressed and examined a troubled self-consciousness respecting national identity that was brought about by the war. In his apocalyptic vision from Breughel, Arthur Boyd (b. 1920) not only vents these feelings of insecurity, but makes vivid the displacement of European culture and myths. Both he and Drysdale (see plate 115) were later to take up the uncomfortable subject of the Aborigines.

115. **Russell Drysdale**, *The Rabbiters*, 1947. The Australian painter Russell Drysdale (1912–81) produced some of the most 'existentialist' paintings of the 1940s, when he took the outback of Australia as his subject. His rendering of a world alien to human venturers owes something to Surrealism, and something to the persistence of the colonist's sense of non-belonging. The rabbiters are as insecurely attached to this place as the name 'New South Wales' is to the territory in question.

116. Lascaux cave, painting of a bull and other animals. Georges Bataille, author of *Eroticism* and *Story of the Eye*, contrasted the profane bondage of work with the sovereignty of the animal. In his interpretation, the primeval painter compensated for the labour of hunting by venerating as sacred 'the power that surpassed him, which...never toiled, was always at play.'

construction of reality as insecure and provisional was inseparable from the collective experience of war, and specifically of Occupation (even if Hélion and Giacometti themselves had been in exile). Far from being merely self-enclosed, this introspective art participated in a national change or crisis in consciousness. There are parallels with Australian art of the wartime period which, while untouched by existentialism, expressed uncertainty concerning identity and belonging.

114, 115

However, in the work of one French painter close to Hélion and Giacometti we may find a decidedly hermetic and self-enclosed form of realism, carried over from the 1930s. Whereas they, by accentuating the artifice that underlies the perspective picture, prompt the viewer's attention to shift restlessly between surface and depth, actuality and image, Balthus issues no such invitation: his artifice is dedicated to sealing the image in its own domain. His paintings represent worlds that are discontinuous from ours; their surfaces are analogous to that of the mirror in Lewis Carroll's *Alice Through the Looking-Glass*. It was Balthus's brother Pierre Klossowski who drew attention to the influence of children's stories and their illustrations on the paintings. The scenes, for Klossowski, summon up an imaginary universe of childhood: 'a certain [domesticity] – the bourgeois ambiance of the parental home with all its everyday accessories (as one sees it in *Struwwelpeter*).' In *The Light Meal* (1940) an Alice-like girl gazes from the painting's edge at the still life that almost fills it: a knife in a piece of cheese, golden wine in a shining glass, impossibly luscious fruit in a silver container, all painted as if by a Cézanne returned to the seventeenth century. In eroticizing the young girls in his paintings, Balthus presents the worlds they inhabit as regions of sensual exploration and curiosity. Balthus paints them both as object of erotic attention, and as the erotic protagonists of their scenes.

118

For each of these four painters, technique is of particularly critical importance. We are to attend to the surface as much as to the illusory depth, we are to pause at the threshold of illusion. With Balthus, a contrived antiquity of method holds the pictorial beings at a perfected distance, and the surface is a hermetic seal. For Hélion, as for Ponge, a fresh apprehension of things, of sensuous reality, presupposed an equally new consideration of the means of representation. In the same year that Balthus painted *The Light Meal*, a discovery took place that was to provide another focus for such concerns: the finding of prehistoric cave paintings at Lascaux, France.

116

117. **Jean Hélion**, *Still Life with Rabbit*, 1952. As in *Nude with Loaves* (see plate 111), symmetry and a schematizing use of black outline withhold illusion. But, thus distanced, reality strikes back with force, in the nauseating pungency of contrasting flavours (rabbit, strawberries, prawns), the sexual violence of the flayed animal.

118. **Balthus**, *The Light Meal*, 1940. The painting is simultaneously highly self-conscious as art and vivid in its portrayal of material things. It is 'classical' and yet has the heavy sensuousness of a Courbet; while obsessively visual, it also alludes to the senses of smell and touch.

In 1955 Bataille, in his Skira monograph on the paintings, himself evoked the motif of a threshold: 'the initial coming into being of the work of art and the emergence of humankind'. Bataille's thesis was that the humans of Lascaux painted in order not so much to possess what they depicted as to become possessed – by the animals themselves, as embodying 'a force that surpasses [the human] infinitely'. Such a crossing over into possession by Being finds its nearest contemporary equivalent in the drawings of Artaud who, after nine years' confinement in mental institutions, gained his freedom in 1946. The energy of possession invests his writings and drawings, from his account of electric shock treatment ('an immense turning outward in flames') to his impassioned 1947 essay on Vincent van Gogh, who 're-collected nature as if he had re-perspired it and made it sweat'. In a self-portrait of 1946 we witness just such an eruption of Being, in indescribable pain. An invasive reality seizes hold, and crosses towards us, from the pressure of marks on the sheet.

119. **Antonin Artaud,**
Self Portrait, 11 May 1946.
'I have rendered my features from life not only with my hand but with my windpipe's rasping breath.' Artaud here depicts himself at the end of his nine years' confinement in asylums, without the use of a mirror, the pencil scoring deeply into the paper and tearing it. There is strategy at work here, not mere impulse: at lower left, looking down, is the observing face of a nurse, unmarked by eruptions.

The Plain Facts

Because Britain escaped German occupation, the British experienced the war very differently from the French, and there was a corresponding dissimilarity in the ways in which the war affected postwar life in the two countries. What made the contrast all the greater was a profound mutual dissimilarity in cultural and political life. British politics had no equivalent for the French political and literary intellectual – a key figure in France since the time of Dreyfus – and in Britain political divisions were drawn less sharply and in less expressly ideological terms than was the case in France. Furthermore, Britain had only a small Communist Party, and the Trade Unions were not politically militant. The Labour Party, in government after 1945, did take some radical measures, but the Conservative Party, returned to government in 1951, did not undo them. Social policy, particularly respecting health and education, was to become agreed common ground between the major parties; the wartime government had been a coalition, and consensualism continued to some extent into the postwar years. Official culture, represented by such institutions as the Arts Council and the BBC, was correspondingly consensual.

The Arts Council's wartime predecessor, for the Fine Arts, was the War Artists' Advisory Committee (WAAC), established in 1939 and chaired by Kenneth Clark, Director of the National Gallery, London. The WAAC appointed official war artists and also commissioned individual works. It was Clark's policy to avoid overt propaganda, while giving priority to issues of artistic quality. The underlying aim was to promote feelings of national identity and solidarity; paintings often focused on individuals working for the war effort and there was a pervasive emphasis on the rural. *A Land Girl and the Bail Bull* (1945) by Evelyn Dunbar (1906–60), the only woman to be appointed an official war artist, fits the pattern well. Such state-sponsored works were presented

120. **Evelyn Dunbar**, *A Land Girl and the Bail Bull*, 1945. Wartime demands overrode conventions concerning men's and women's work, and women took on the jobs of agricultural labourers. Dunbar, evoking a lyrical dawn, uses foreshortening to make the land girl heroic in scale, yet remain prosaically human.

to the public in exhibitions held throughout the country, and these proved highly popular. There was enough interest to warrant the publication of cheap booklets of reproductions.

Clark found room in his programme for the neo-romantic art that he favoured (it was redolent of national tradition), but excluded the geometric abstraction of Ben Nicholson (1894–1982), which was 'ultramodernist' and international. Conversely, highly descriptive forms of realism found a place, commissions being given to Meredith Frampton (1894–1984) and Laura Knight (1877–1970), both Royal Academicians. Knight, an adaptable if superficial painter of theatrical genre scenes, could paint industrial subjects with appropriate workman-like accuracy. Later, in drawings at Nuremberg, Germany, her adherence to fact produced documents more telling than the finished painting, which attempts to comment on the war-trial scene. Frampton, a more considerable artist, had developed an effigy-like style of portraiture during the era of pan-European neo-realism; in his wartime group portrait, he refines every object and surface towards an ideal perfection, rendering a reality seemingly cleansed of blemish. Actions are momentously frozen, and only the eyes have life.

Both Frampton and Knight were painters late in years (Frampton was soon to cease painting, due to failing eyesight) and both were outside the contemporary art scene. A far more central figure was William Coldstream (1908–87), by then long engaged with what he dryly termed 'the manifest problem of more or less accurate representation'. An official war artist from 1943 to 1945, Coldstream later chaired the WAAC's successor, the Art Panel of the Arts Council, as well as becoming Professor at the Slade School of Fine Art, London. Coldstream represented an important strand in British postwar realism, one that centred upon the discipline of the life room, and in general on the practice of painting from observation. He effected a renewal of the academic tradition, by way of a formalism inherited from Roger Fry (1866–1934). In effect, he re-academicized Cézanne, rendering volume through a practice of optical measurement Cézanne would not have entertained. By systematically gauging vertical and horizontal distances on the person or object, seen against a brush held at arm's length, and marking his canvas accordingly, Coldstream sought to let his subject emerge as if by itself, without having been merely willed. Equally, he was intent on respecting the integrity of the painting's surface, its beauty.

121. **Meredith Frampton**,
Sir Ernest Gowers, K.C.B., K.B.E.,
Senior Regional Commissioner
for London, Lt. Col. A. J. Child,
O.B.E., M.C., Director of
Operations and Intelligence,
and K. A. L. Parker, Deputy
Chief Administrative Officer,
in the London Regional Civil
Defence Control Room, 1943.
Ernest Gowers, a distinguished
civil servant, was also the
author of *Plain Words*, a guide
to lucid English (here himself
lucidly presented).

122. **Laura Knight**, *Ruby Loftus Screwing a Breech-Ring*, 1943. Women proved exceptionally skilful in machining operations formerly carried out by men. Here, the worker could not be spared and Knight painted her in situ; popular in industry (all the details were accurate), the painting was reproduced as a poster.

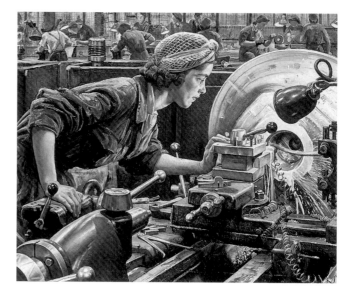

123. **Laura Knight**, sketch for *The Dock at Nuremberg*, 1946. Knight produced numerous studies for her painting of the Nuremberg war trials, in which the dock shades off towards a landscape of corpses and ruined cities. Here, the realization is all the more effective for simply recording the limits imposed by the artist's viewpoint, above balding heads, restless bodies, impassive helmets.

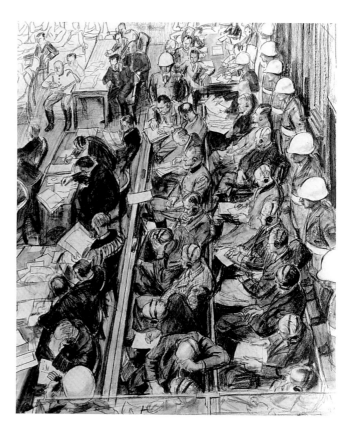

In his insistence on being 'ruled by what I see', Coldstream embodied both a long-standing tendency in British art (Constable, the Pre-Raphaelites, Ruskin, the Camden Town Group) and a more modern spirit of objectivity. During the 1930s he had a close and intellectually stimulating friendship with W. H. Auden, whose 1937 poem to him contains the lines 'Let's start with perceiving / Let me pretend that I'm the impersonal eye of / the camera.' Auden's close friend the novelist Christopher Isherwood was to use the camera-eye concept in *Goodbye to Berlin* (1939), but it already pervaded Modernism, from the cinema of the Russian director Dziga Vertov to the American John Dos Passos's novel *The 42nd Parallel* (1930), and the documentarism of the 1930s. Coldstream was himself a director of documentary films for a time, and after returning to painting participated (reluctantly) in one of the 'mass observation' social survey projects organized by the social anthropologist Tom Harrisson and the poet Charles Madge.

124. **William Coldstream**, *Seated Nude*, 1952–53. Commissioned by the English writer and painter Adrian Stokes to get Coldstream painting again, amidst his duties as Professor at the Slade School of Fine Art, London. Coldstream appreciated Stokes's concept of a 'carving' (as distinct from 'modelling') approach to form. This substantial yet tentative figure has the stillness associated with 'carving'.

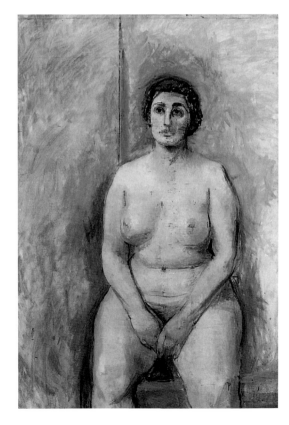

In the late 1930s, Coldstream joined Claude Rogers (1907–79) and Victor Pasmore (b. 1908) in setting up the Euston Road School – which gave its name to a style. At the time, he felt an affinity with Social Realism and participated in a debate held by the Marxist-oriented Artist's International Association, but soon saw that his own work was no vehicle for social art. What persisted, and informed his teaching, was the imperative to 'start with perceiving'. That, allied to a certain rationalist disposition, placed him centrally in the postwar British context. E. H. Gombrich, appointed Professor of Art History at the Slade School in 1956, in that year gave the lectures that later became his book *Art and Illusion*. Gombrich's central themes, the conventional basis of realist illusion, and the relevance of perceptual psychology for the understanding of art, accorded well not only with Coldstream's outlook and practice but with the work of more innovative artists, such as Pasmore and Richard Hamilton (b. 1922). Crucial with both of the latter as also with Gombrich (whose demystification of art was in accord with the ethos of the Independent Group, to which Hamilton belonged) was an analytical study of the relationship between the viewer and the notations of the painted surface.

125. **Victor Pasmore,**
The Studio of Ingres, 1945–47. Reworking a painting he had completed earlier (and introducing the reference to Ingres in the background), Pasmore produced a surface-conscious work transitional between realism and abstraction. Through the basic design course he later devised with Richard Hamilton, the fine tolerance methods of Euston Road realism found wider application to visual culture.

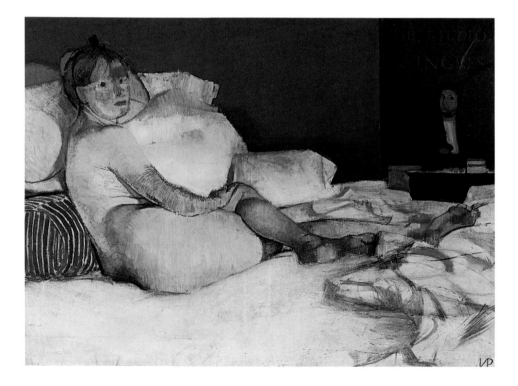

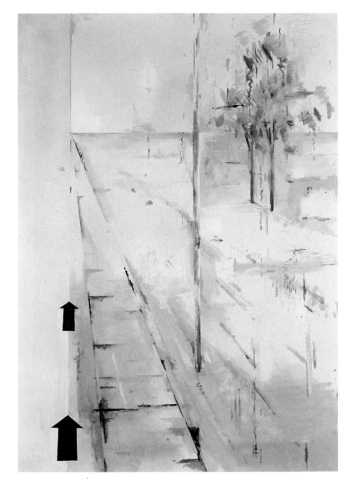

126. **Richard Hamilton**, *Trainsition III*, 1954. Hamilton's representation of landscape seen from a moving train owes something to Klee and to poster design (the tapering arrows); the notation of transparent strokes and dashes revisits the same modern perceptualist tradition that Coldstream had drawn upon (Hamilton had studied at the Slade School in London), and introduces a new experimentalism, drawing on the psychologist J. J. Gibson's *The Perception of the Visual World* (1950).

Such new developments both perpetuated and revised empiricist and perceptualist tendencies that were of long standing in British painting. In *Art and Illusion*, Gombrich in effect took up the cultural legacy of Constable and Ruskin while also criticizing their accounts of perception and pictorial illusion. Hamilton painted his *Trainsition* series with reference to perceptual experience, but on a modernist basis of experimental principle rather than from observation. Coldstream, as Chairman of the Art Panel of the Arts Council, supported the 1955 retrospective of Giacometti – whose late work also offered a new angle on the perceptual. There were, however, versions of realism that stood somewhat apart from perceptualism, and these emerged in the works respectively of David Bomberg (1890–1957) and of various Social Realists.

Essential in Bomberg's practice and teaching was an insistence on the centrality of touch, a principle based on Bishop Berkeley's account of perception (according to the eighteenth-century philosopher, the tactile sense makes vision three-dimensional) and reinforced by the example of Cézanne. Bomberg's teachers at the Slade School, where he studied between 1911 and 1913, had introduced him to Berkeley's ideas, but he came most recognizably to act on them in his later landscape practice. In his paintings of Ronda in Spain, his spreading and searching brushwork re-enacts the massive land formations in paint, rebuilding near to hand the substance distanced by sight. Both Bomberg's choice of subjects and his interpretation of them reflected a pursuit of 'mass', whose living cohesiveness was to be felt as much as seen (the Cézannism that Fry had introduced into British painting took a quite different form in his work than it did in Coldstream's). Although professionally isolated since the 1930s, Bomberg became influential as a teacher after 1945, chiefly at Borough Polytechnic in London. The part his example played in shaping the work of Frank Auerbach (b. 1931) and Leon Kossoff (b. 1926) will be touched on in the next chapter. At present, it is worth noting that he viewed teaching as a personal handing-on of knowledge in a succession which, for him, included Sickert as well as his own Slade School teachers.

128

A Sickertian spirit informed the domestic genre scenes of at least two members of the group known as the 'Kitchen Sink' painters, Jack Smith (b. 1928) and John Bratby (b. 1929). They, and two others, Derrick Greaves (b. 1927) and Edward Middleditch (b. 1923) were given solo exhibitions in the mid-1950s at the Beaux Arts Gallery, London, which also represented

129
127

127. **Derrick Greaves**, *Sheffield*, 1953. The art critic David Sylvester gave the 'Kitchen Sink' painters their label in a slighting reference to the content of Jack Smith's paintings. They could equally have been called Sheffield painters: Smith and Greaves came from there and Edward Middleditch, their friend at the Royal College of Art in London, went there with Greaves to paint. Greaves's vast and gaunt landscape of industrial decay is elemental rather than political.

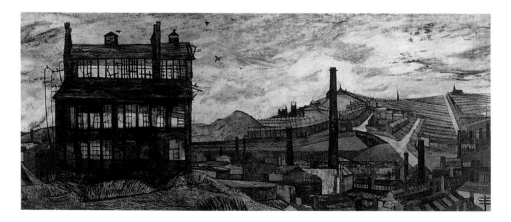

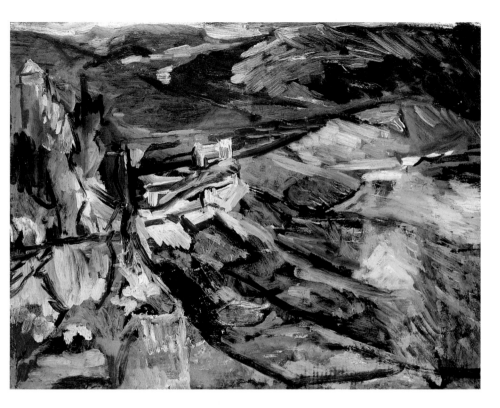

128. **David Bomberg**, *Ronda, towards El Barrio, San Francisco*, 1954. A member of the avant-garde Vorticist movement of 1914–15, Bomberg later became principally a painter of landscape, in Palestine in the 1920s and then in Spain. He moved from Pre-Raphaelite topography to a more painterly practice, consistently seeking out structure in mountainous terrain.

129. **John Bratby**, *Three People at a Table*, 1955. This is not a generic working-class scene, but represents Bratby's own family. The assertively painted and strong-hued breakfast clutter with its Kellogg's packet refers to the actuality and perhaps the tensions of everyday life, rather than to issues of social class.

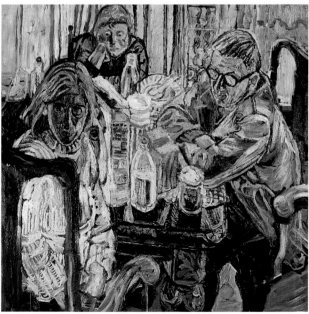

Auerbach and Kossoff. What distinguished the 'Beaux Arts Quartet', who graduated from the Royal College of Art, London, between 1952 and 1954, was their stark interpretation of urban and domestic themes. Since their work had evident social content, it found a critical advocate in John Berger, then writing reviews for the *New Statesman*. In 1952, Berger included Greaves and Middleditch in the first of a series of exhibitions entitled 'Looking Forward', whose overall tendency was Social Realist.

Berger's exhibitions and critical advocacy helped make realism a topic of debate. In 1955, when Guttuso's work was shown at the Leicester Galleries, it was Berger who wrote the catalogue introduction, in which he stressed the artist's political responsibility for what the 'canvas does to those who gaze at it'. At the Italian Institute, London, Guttuso debated the issue of realism versus abstraction with Patrick Heron (1920–99), Berger's critical antagonist at the *New Statesman*. However, much as some British realists might have admired the raw style of Guttuso's painting (or of Italian neo-realist cinema), they did not thereby commit themselves as outright political artists, and Smith, Bratby and the others were far from doing so. The fact that conditions in Britain were not favourable to political art has already been noted; during the 1950s even the Artists' International Association, which in the 1930s had been a vigorous leftist organization, abandoned its political commitment. Although one younger artist, Peter de Francia (b. 1921), who had studied with Guttuso and Léger and decidedly shared their political outlook, painted expressly political works in the 1950s, he did so in the full

130

130. **Peter de Francia**, *The Bombing of Sakiet*, 1955–58. De Francia's modern history painting responds to the bombing by French planes of a Tunisian village near to the border with Algeria during the Algerian war of independence (1954–62). Following Guttuso's example (see plate 104), de Francia creates a visual equivalent for violence: in the extended legs and arms, he makes allusion to Picasso's *Guernica* (see plate 95).

131. **Joan Eardley**, *Brother and Sister*, *c*. 1956. Eardley, born in London, studied art in Glasgow and developed her career in Scotland. Her denial of any 'social or political impetus' in paintings of Glasgow back-street children possibly reflected a concern that they might be seen sentimentally. The children appear obdurate and vigorous; the paint mimics the rawness of the graffiti.

knowledge that they would be 'virtually impossible to exhibit'. Conversely, paintings of scenes of impoverishment such as those of Joan Eardley (1921–63), who disclaimed any political purpose, could, for a time, attract attention. 131

As the Cold War deepened, Berger increasingly found it necessary to choose between his strong feeling for diverse kinds of art and his equally passionate commitment to social justice. In 1956, the year when Soviet tanks entered Budapest, he gave up reviewing. In his novel of 1958, *A Painter of Our Time*, he invented his exemplary political painter – significantly not a British artist, but a Hungarian. Berger's novel, with its heavily masculine central figure, now seems rather remote in time; yet his underlying concern with the social exclusiveness of visual art, its attachment to wealth, cannot be dismissed. He subsequently developed his critical views further in books on Picasso (1965) and on the Russian sculptor Ernst Neizvestny (1969). In the latter book, he applied Lukàcs's antithesis of naturalism and realism to visual art: 'a distinction', Berger wrote, 'between a submissive worship of events just because they occur, and the confident inclusion of them within a personally constructed but objectively truthful world view'. His intention was to distance Neizvestny from academic Socialist Realism; but the distinction he drew is as problematic as it is also suggestive, especially when applied outside of the Soviet context.

Lucian Freud's early paintings, for example, vouchsafe no 'objectively truthful world view' and are intensely detailed, and yet a principle of selection is at work. Admittedly, the principle governing the selection is one tending to emphasize the social isolation of the individual portrayed. We have only to compare Freud's *Interior at Paddington* (1951) with Gruber's waistcoated 132, 108 nude of 1944 (which Freud would probably have known): in the Gruber, figure and space are constructed together, while in the Freud they stand apart, plant and man appearing in absolute mutual estrangement. Individuality closes upon itself, known only by external, visual clues.

If there is a social context for the isolationist world of Freud's early paintings, it is the bohemia he frequented with his friend Francis Bacon. The Soho milieu of the 1950s, as described by Bacon's biographers, had the defining bohemian characteristic of

132. **Lucian Freud**, *Interior at Paddington*, 1951. Interviewed in 1954, the year he showed in the Venice Biennale, Freud spoke of observing the subject 'day and night' so that 'he, she or it' might 'reveal the *all*'. From the all, Freud selects nicotine-stained fingers, a rumpled carpet.

133. **Francis Bacon**, *Two Figures*, 1953. Bacon transforms Muybridge's photographic images of men wrestling into a scene of sexual violence. By virtue of a technique that combines erasure with disclosure, the viewer may at once recognize and disclaim evidence of a male sexual act, both observe and disregard an association of sex with power and aggression. What is seen is not to be seen.

flouting bourgeois norms and, by virtue of Bacon's sexuality and success, it opened simultaneously towards the worlds of the criminal and of the wealthy. A penumbra of myth and anecdote has consequently attached itself to Bacon's persona. As to the work itself, it has become the subject of exhaustive commentary, and the tabulation of Bacon's sources in Muybridge, medical photography and so forth has become an unavoidable ritual.

When Bacon's work became famous, during the 1950s, criticism focused frequently on his paintings after Velázquez's portrait of Pope Innocent X. For Berger, Bacon's painted screams were sentimental, if perversely so, sentimentality being 'a way of evading relevant facts'. 'Fact' was a term much used by Bacon himself with reference to his art, and (though this was not what he meant) we might recall his preference for working from 'factual' material including photographs, reproductions – including the Velázquez – and medical illustrations; he was as intent a visual archivist as members of the Independent Group such as Hamilton and Eduardo Paolozzi (b. 1924). Not a realist in Berger's terms (a different principle of 'relevance'), Bacon was drawn to scientific and other visual material of an intensely 'objective' kind. At the same time, he reflected in his work on the theme of pictorial illusion, which, as we have seen, had a certain

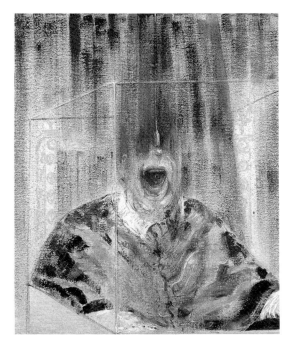

134. **Francis Bacon**, *Head VI*, 1949. 'I wanted to paint purple' was the explanation Bacon once gave for his series of popes, based on the portrait of Pope Innocent X by Velázquez. His technique is particularly evident here, where unprimed canvas shows between and through the loaded brushstrokes. The space frame and traces of throne mimic Velázquez' illusionism, and the open mouth, a dark cavity, is central to this game of surface and depth.

wider currency at the time. While his screaming popes may have come to appear hackneyed, even to him, his original choice and interpretation of the Velázquez was far from being so. In Velázquez, Bacon chose the most compelling and elusive of pictorial illusionists, and in his treatment of the papal image, he reduced baroque oil-painting technique to a kind of parodistic essence. Knowing that any painting, however illusionistic, is more like itself than it resembles any prior reality, Bacon sought to draw out and manipulate the uncanny aliveness of the painted image itself. With other, less famous source-material, Bacon also parodied the qualities of the originals. It is not important that we know what those sources are; we recognize, both in the thing seen and in our seeing, varieties of clinical, prurient and sadistic attention, without needing to know that the painter has drawn from Muybridge, or pictures of diseases of the mouth.

In crossing pastiched baroque painterly illusion with photography, Bacon achieved painted figures more carnal than reality itself: shockingly objectified as in a photograph, smeared as in a physical trace. Bacon, with his own *Musée imaginaire* of photographs and magazine plates littering the floor of his studio, ceaselessly translated images into each other, through painting. His paintings depend not on our knowing his sources, but on our common immersion in photographic culture. Recurrently, his paintings show a figure turning to look back, recognizably 'held', as if by a camera. What is important is the being 'held', not the photographic source (one existed, but we have all seen or taken such a shot). The dark ground of his 1950s paintings is that of photographic blackness, of baroque dark-ground painting, and of our own apprehension. Bacon pursued 'the brutality of fact' by means of a complex poetics of illusion.

Bacon was something of a pioneer in terms of the exploitation of photography in painting late in the twentieth century, but he never, or rarely, imitated the specifically photographic qualities of his source-material. This is precisely what others were to do, beginning in the 1960s, as we shall see in the next chapter. His younger friend Michael Andrews (1928–95) painted pictures in the early 1960s in which he glossed cinema in painting, translating the Italian film directors Fellini's and Antonioni's visions of glamorous irresponsible wealth, though without evident critical intent: a detachment more typical of the new decade than of the 1950s.

The United States: Realism at the Margins

It has become accepted wisdom that the CIA used Abstract Expressionism as a vehicle for cultural propaganda in Europe, but in fact the CIA needed to do very little. Although it established a front organization that funded intellectual reviews such as *Encounter*, such initiatives were insignificant compared to the wider impact of American culture; European museums asked, unprompted, for shows of new American art. That the United States might represent creative freedom was not an idea that needed to be insinuated: the most effective propaganda is that which we make up in our own minds.

American abstract art 'triumphed' principally in the United States, recasting the art world as it did so, enlarging it. What was triumphed over and left behind was realism – identified with the 1930s – and Europe, also a part of the past. While varieties of realist practice continued, they were necessarily marginal to the central, abstract theme.

Whatever 'realism' meant now – and it tended to become vaguely identifiable with the figurative, the non-abstract – it did not prominently imply social commitment. 'Magic realism', a new movement of the 1940s, manifested a broad humanism that was the common denominator for much figurative art of the period. By implication, against the background of an emphatically abstract art, the simple presentation of the human image was telling in itself. In 1959, Peter Selz organized an exhibition at the Museum of Modern Art in New York called 'New Images of Man', including both American and European artists (Bacon and Giacometti were included). Paul Tillich contributed an existentialist preface. Although there was no magic realism in this vaguely expressionist-oriented exhibition, a painting such as *Subway* (1950) by George Tooker (b. 1920) strikes a comparable note of pessimistic humanism, using Renaissance methods to construct an alienating maze.

There were two representational painters whose work did not fall within the rhetoric of 'Man', and both, in very different ways, drew on genre painting tradition. One, Fairfield Porter (1907–73), revisited Vuillard's theme of the inhabited space, treating domestic scenes with a beguiling informality. A painterly intelligence has judged where to place a saturated hue, a darker tone, yet nothing looks arranged. The brushwork is loose, messy, but – even then – inconsistently so.

135

136

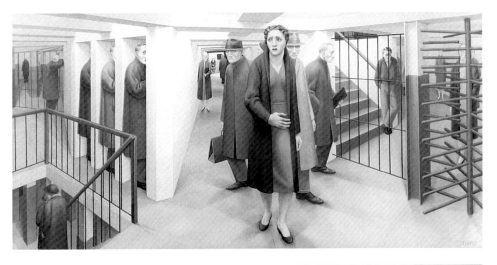

135. **George Tooker**, *Subway*, 1950. Painting in tempera on board, Tooker continued the modern revival of Renaissance technique initiated before the Second World War by Reginald Marsh and others.

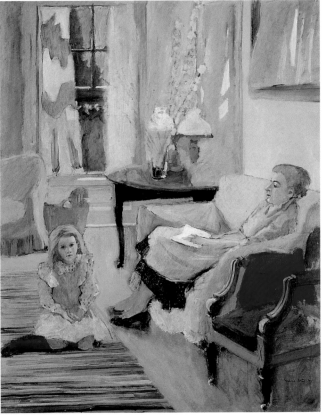

136. **Fairfield Porter**, *Katie and Anne*, 1955. Porter's paintings of the 1950s generally centred on his house and family, and here the subjects are his wife and daughter.

137. **Andrew Wyeth**,
The Revenant, 1949. A self-portrait as *Doppelgänger*, made effective by a characteristically fine control of tonal nuance. Wyeth's devices – the looming figure, the crack in the wall, the partially concealed open door – are akin to those used by directors of suspense films.

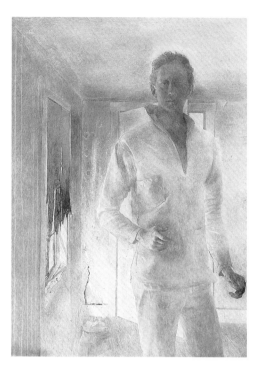

Against Porter's self-concealing sophistication, the art of Andrew Wyeth (b. 1917) can be seen to advertise its efforts. Here is a realm truly of the margins, for Wyeth has consistently focused on individuals he knows intimately, in two rural districts. A painter in watercolour and tempera, as well as in a meticulous drybrush technique, Wyeth works in a way suggestive of Northern European painting tradition of earlier centuries. Yet he is right to disclaim European references or sources. His father was a famous illustrator, and his own manner is as self-invented as an illustrator's. It is not cultivated like Porter's. Consistently with the high-definition effect of his tempera technique, he frames his subjects very much as if he were a photographer (again, there is a contrast with Porter).

The people are singular, idiosyncratic, closely particularized. They resist generalization along broader social lines. The exactingness of Wyeth's technique and the intensity of his focus enabled him, more effectively than any American contemporary in the 1940s and 1950s striving for an image of 'man', to evoke the strangeness of individual human existence. In *The Revenant* (1949), an exceptional work, selfhood appears as a kind of haunting.

137

Chapter 4: New Realities

In 1953 Edward Hopper joined forty-six fellow-artists in the United States to found the journal *Reality*, with the aim of voicing opposition to the critical consensus in favour of abstract art. 'Painting', he declared, 'will have to deal more fully and less obliquely with life and nature's phenomena before it can again become great.' 'Reality', in a certain sense, was soon to make a prominent reappearance in painting in the work of Pop artists; but this was no straightforward representation of 'life and nature'. The approaches to reality that have been most characteristic of painting in the decades following Pop art have in fact been decidedly oblique. The painter's source material has, typically, been itself an image, often photographic.

In its nineteenth-century beginnings, photography, like the practice of painting from nature, was linked to the pursuit of a lifelike representation of 'external' reality. The nineteenth-century photograph was analogous to the pictorial framed view.

138. **Gerhard Richter**, *Betty*, 1988. Richter's work in painting divides between the abstract and the photo-based. Here, he interprets a colour photograph of his daughter, treating an evidently appealing (if perverse) image with his customary formal austerity and exacting technique. His paintings of the 1980s based on colour photographs revisit earlier genres; here, portraiture, in other cases landscapes and the *memento mori* still life.

139. James Rosenquist, *The Light That Won't Fail*, 1961. In the early 1960s Rosenquist started to paint pictures in which he drew on his experience as a painter of billboards. He worked from collages of magazine images; here, the central image comes from a cigarette advertisement, where the slogan 'Believe in Yourself!' surmounts the smoker's upturned gaze. Rosenquist's title strikes a similar note.

140. Edward Hopper, *Ground Swell*, 1939. In intense sunlight, a bell-buoy tilts down the plane of a solidified wave beneath clouds arrayed in strict perspective; a frozen moment in which a bell tolls, beheld by a passing crew more wooden than their curving boat. While Hopper constructs pictorial space in the direct and unambiguous way that his 1953 statement suggests (see p. 155), he characteristically prevents any plain reading of the action, by holding it in unnatural suspense.

141. Malcolm Morley, *SS Amsterdam in Front of Rotterdam*, 1966. Morley painted ocean liners from postcards or brochures, squaring up the original and copying painstakingly in acrylic. The white border accentuates the artifice of paint, and suggests the appearance of printed image on paper.

During the twentieth century, and especially with the growth of consumer culture from the 1960s onwards, photography and visual technologies in general developed far more complex and pervasive applications. The reproduced photograph, flattened for visual immediacy rather than opening like a view, contributed to a general commerce in images. Pop artists such as James Rosenquist (b. 1933) used painting to present a cross-section of this commerce. Photography was important now not in so far as it was truthful but rather – given its mimetic power and vividness – because it was seductive and compelling.

The reality that the Pop painters restored to painting, in the wake of Abstract Expressionism, was thus not natural but artificial. Equally, it lacked spatial depth. Clement Greenberg famously held 'flatness' to be a defining property of modernist painting, from Manet to Pollock; while the Pop artists clearly were not concerned to follow Greenberg, their work certainly benefited from, and appropriated, the Abstract Expressionists' concern with the painted surface. Indeed, with the growth of the postwar art world, the large, unframed and flatly configured canvas acquired a normative status that it still retains. The new insistence on surface can be understood in more than purely technical terms, however. Despite (or because of) Greenberg's strictures to the contrary, numerous 'ambitious' painters since the 1950s have contrived effects of illusionist depth, thus ostensibly vitiating the integrity of the pictorial surface; if surface-consciousness has nonetheless persisted, it has been by virtue of a general shift in critical outlook. Critics, since Greenberg, and artists, since Jasper

Johns (b. 1930), have come to place renewed emphasis on the artificial and convention-bound character of painting, and to interpret the acts both of painting and of viewing as requiring expertise rather than imagination or special acuity of perception. If a previous model for modern painting (associated with the Impressionists or, say, Vassily Kandinsky) is that an original perception or emotion of the artist is transposed to the canvas and in turn retrieved by the viewer, the new model would have painter and viewer each carrying out a kind of work in front of the canvas. The viewer is looking not at a record of what the painter has seen, but at what he or she has done. (This is not to deny that Impressionist paintings were, and are, seen as artefacts; it is a question of a shift in critical outlook.)

Despite Hopper's urging, the new versions of realism that have emerged since the 1950s have been markedly indirect, for reasons that have to do with the use of photography and the new technical and critical emphasis on surface and artifice that has been referred to. Compare, for example, Hopper's *Ground Swell* (1939) with a painting by Malcolm Morley (b. 1931) of 1966 entitled *SS Amsterdam in Front of Rotterdam.* The Hopper, with its voyagers transfixed by the bell-buoy tilting on the wave, suggests the kind of attention we ourselves should give, as we peer into the depth of the picture. Morley, painting from a postcard or brochure image, dissociates the depicted scene from depth perception, inviting our gaze to glide like the liner itself across the surface, in a scanning movement. The Morley is characteristic still of our present era in its refusal to depict an object or a view as if it were something actually present to vision and external to the viewer. Correspondingly, developments in art history, criticism and art theory since the 1960s have diversely discouraged the belief that the meaning or the 'truth' of a painting lies within it. Feminist and psychoanalytical approaches invite us to look at paintings with suspicion; semioticians encourage us to read paintings more than to look at them; social historians direct us to the historical 'conjunctures' in which both painting and viewing have taken place. All, in different ways, focus on work done by the viewer, and terms such as beholder, spectator and observer have come to pervade the literature of art. Critics and art historians now look at art of all periods more obliquely than was formerly the case.

With some apparent exceptions, the period covered in this chapter has not seen the development of distinct realist movements. Instead, realism, illusion and imitation have been

pervasive concerns in painting, and have arisen within very disparate forms of practice. Thus Johns's work has significant realist aspects, even if Johns cannot be classed simply as a realist. The selection and the groupings that follow therefore have a largely thematic basis. The relationship between painting and photography plays an important part throughout. Three of the sections are linked to a period: those of Pop art, Photorealism and 1980s Neo-Expressionism. The section dealing with Freud, Bacon and others constitutes a partial exception to the thematic rule, as these artists share a milieu.

Reframing Reality: Realism in the Era of Pop Art

What Hopper had argued for in 1953 was a renewal of the western tradition of pictorial realism, as it had been practised between the Renaissance and the nineteenth century. A vital element in this tradition was the frame, the pictorial boundary, the function of which was to close off the depicted scene against surrounding reality, in favour of the given illusion. Greenberg, on his own very different terms, also wanted to seal off the experience of art in a region of its own; the principle of art for art's sake, first espoused in his essay 'Avant-Garde and Kitsch' in 1939, continued to inform his criticism in the postwar years. Since the late 1950s, however, a general shift in critical attitudes has caused attention to turn to the pictorial boundary itself; from the illusion to the conditions that make it possible. In 1966 the French philosopher Michel Foucault prefaced a discussion of representation with an essay on Velázquez's *Las Meninas* (1656), a painting of many frames. In 1978, his compatriot Jacques Derrida devoted much of his book *The Truth in Painting* to reflections on framing. One of his points of departure was a painting of a pair of shoes by Vincent van Gogh (1853–90), which had been the subject of scholarly dispute (the American art historian Meyer Schapiro had questioned the German philosopher Martin Heidegger's identification of the shoes as those of 'a peasant woman' in his essay on 'The Origin of the Work of Art'). Derrida's strategy is to call the scholarly and philosophical search for ultimate truth into question by invoking the promiscuity of language and by repeatedly directing attention away from the ostensible subject of enquiry to the margins (the frame of enquiry). He puns on lacing and unlacing, and points to the strange circular flourish whereby van Gogh brings the laces into association with the frame.

142. **Vincent van Gogh,**
Old Shoes with Laces, 1886.
Van Gogh painted this in Paris, before his encounter with Impressionism changed his palette; he uses chiaroscuro to set air around the objects, and re-enacts their physicality in thick impasto.

142

The new art movements that grew up in the wake of Abstract Expressionism in the late 1950s and early 1960s also dwelt on the

boundary between reality and illusion (or art); both Pop art and Neo-Dadaism came to be classified as realist by virtue of their engagement with the everyday. In 1954, an American precursor of Pop, Johns, who had been making Surrealist-inspired collage-constructions, began work on a painting he called *Flag*, whose ambivalence with respect to reality (is it a painting or is it a flag?) haunted the perceptions of those who saw it at his first solo exhibition in 1958. In choosing a flag (other motifs included targets and numbers), he had selected something abstract, the national symbol, which was also concretely manifest in actual flags; in his very material rendering of the flag, he compounded this ambivalence by accentuating the uncanny identification of the flag (a flat object) with the painting in which it was depicted.

Johns may not have been influenced by the paintings of Jackson Pollock (1912–56) when he painted *Flag*, but the later *White Flag* (1955) has the large scale of an Abstract Expressionist canvas, and its monochromaticism emphasizes its flatness. Here, too, the flag lies on (or in) the surface rather than beyond it, and is comprised of partly legible fragments of newspaper. The painting effectively has a double boundary, that of the canvas itself and that of the flag, whose perimeter symbolically includes all Americans. As the art historian Fred Orton has

143. **Jasper Johns**, *White Flag*, 1955. Johns dipped pieces of newspaper and cloth in melted wax and paint and applied them to the vast canvas, constructing each stripe and star separately and assembling the whole in three parts, like a real flag. Print fragmentarily shows through; brushstrokes in pale hues are superadded. The flag both materializes and withdraws, a substantial ghost.

144. **Daniel Spoerri**, *Tableau-piège au carré*, 1961 and 1964. Spoerri presents parts of the real world, in the manner of *trompe-l'oeil* painting. In the first manifesto of the Nouveaux Réalistes, 16 April 1960, Pierre Restany proclaimed the demise of easel painting and advocated 'The passionate adventure of the real perceived in itself and not through the prism of conceptualism or imaginative transcription.'

argued, the collage of unsensational newspaper fragments figures this inclusiveness as democratic rather than nationalistic: it represents the common currency, the murmur, of everyday life. Johns has invented nothing, for in putting a flag together from scraps of newspaper he has reframed a reality that was already given.

Johns's practice here matches a strategy employed more widely in art of the time, which followed the precedent of Duchamp and Dadaism: the artist works within the texture of reality itself, intervening so as to cause some aspect of the real to present itself freshly to view. The much-cited prototype was Duchamp's readymade – an ordinary object nominated as art – and it found a fitting successor in the composer John Cage's *4'33"*, in which the pianist refrains from playing for the duration specified. We might regard such practices as stunts or, equally, as methods for attuning spectators or audience to their own present reality, for alerting them to the conditions that govern their reception of art. Some members of the Paris-based group, the

145. **Wayne Thiebaud,**
*Jawbreaker Machine
(Bubblegum Machine)*, 1963.
Thiebaud thought of himself not
as a Pop artist but as a realist,
adapting the surface-conscious
practice of his generation of
painters in the United States to
the depiction of ordinary things
(the subjects he chose were in
fact in the province of Pop).
His canvases present the
objects frontally, as they appear
on counters or in shop windows,
and the paint re-enacts their
materiality, in a coloured relief.

146. **Andy Warhol,** *Lavender
Disaster (Electric Chair)*, 1964.
Other subjects in Warhol's photo-
silkscreened 'Death and Disaster'
series included fatal car accidents,
suicides and encounters
between police and civil-rights
protesters. Typically, the images
are repeated in black, sometimes
over a coloured ground, and
are imperfectly and variably
printed. Here, a sign over one of
the doors reads 'silence'. Warhol's
technique of repetition imparts
to even the most disconcerting
image the humdrum beat of the
everyday. The electric chair, as
much as Campbell's soup, is
seen to be part of the grain of
American life.

Nouveaux Réalistes, formed in 1960, worked in this spirit, among them being Daniel Spoerri (b. 1930), who glued a clutter of finished meals to the surfaces they had been eaten on, in his 'snare pictures'. Johns's bronze-cast and painted beer cans were kindred ventures. 144

Many painters since the 1960s could be seen as having set 'snares' for reality, as did Spoerri. Pop art might be thought of in these terms, with respect to its reframing of readymade images. Johns, as we have seen, contributed to this strategy, as did Roy Lichtenstein (1923–97) and, in a different way, Wayne Thiebaud (b. 1920); a particularly significant innovator, however, was Andy Warhol (1928–87), whose exploitation of photography had wide and lasting influence. At the beginning of the 1960s, Warhol developed a form of painting that was photo-based, both techni- cally (photo-silkscreen) and in terms of its sources. Since, addi- tionally, the photographs recognizably belonged to genres – the publicity shot, the press or police photo – Warhol succeeded in producing work that was highly mediated yet without obvious traces of authorship. In so doing, he redefined artistic practice, as constituting strategic intervention in the general social process of image production and consumption. 145 146

Writers on Warhol have long been divided as to whether his work casts its viewers as passive (and impassive) consumers, or affords a critical opening onto social reality. Warhol himself expressed admiration for the paintings of John Sloan and

Andrew Wyeth, and that fact might invite us to see him as producing representative images of American life, with a critical edge. Certainly, his art and his views reflect an identification with the popular, and he held egalitarian opinions. However, there is a fine line between his egalitarianism and his famous blankness. His representations of American life – if we so read his paintings – were arrived at by quite different means from Sloan's or Wyeth's; that is, through a filtering and reprocessing of already existing representations.

Despite the evidence of blankness or indifference, it could be argued that Warhol's work shows a more critical attitude than is often assumed, with respect both to technique and to subject matter. The American art historian Thomas Crow, most recently (in *Modern Art in the Common Culture*, 1996), has defended such a view, noting for instance the closeness in time of the film star Marilyn Monroe's suicide in August 1962 to the making of the first *Marilyn* a few weeks later, and pointing out that the execution of Caryl Chessman was still fresh in memory when the 'Electric Chair' pictures were produced. Warhol's proposed title for a Paris showing of his 'Death and Disaster' series was the far from neutral 'Death in America'. For some interpreters, Warhol's use of repetition and his variation of inking in this series aestheticizes the grim subjects; for Crow, however, these methods particularize the images and give meaning (while Hal Foster, another American art historian, sees Warhol as indeed aestheticizing a disturbing reality, yet contriving that it should insidiously break in upon the viewer's awareness).

Pop art, which Warhol helped to instigate, was the first international art movement in the postwar period, and it reconfirmed the dominance both of American art and of an American-originated commercial and popular culture. Early exhibitions of Pop art used the label 'New Realism', and Pop did epitomize the new urban reality of prosperous western countries. In Europe, Pop swept away the often dismal iconography of postwar Social Realism.

The German artist Gerhard Richter encountered Pop as a 138, 14 former Socialist Realist. One of a significant group of German artists who migrated from the Democratic Republic (East Germany) to the Federal Republic (West Germany) (Georg Baselitz was another), Richter had trained initially in the context of Socialist Realism, and knew modern art only as represented by Picasso, Rivera and Guttuso before seeing work by artists including Pollock and the Italian Lucio Fontana at the 'Documenta 2'

147. **Gerhard Richter**, *Confrontation (2)*,
Gugenüberstellung (2), from the series *Oktober
18, 1977*, 1988. On this date three members of the
Baader-Meinhof group (Red Army Faction), including
Baader himself and Gudrun Ensslin, shown here,
were found dead in their cells in Stammheim prison,
apparent suicides. Richter selected fifteen images from
a large range of (mainly) police photographs. The first
six show Ensslin alive three times, then dead.

148. **Gerhard Richter**, *Kitchen Chair*, 1965. Richter's practice with many of his photo-based paintings, as already established here, is to copy the photographs precisely and then to brush the oil paint across the canvas, blurring and distancing the original image.

exhibition in Kassel, Germany, in 1959. He studied again at Düsseldorf, under Josef Beuys, in the early 1960s, and presented himself initially as a German Pop artist. As if in pointed contradiction to his background, Richter and his fellow-student Konrad Lueg held an exhibition/happening in a furniture store in 1963, which they entitled 'Demonstration for Capitalist Realism'. The title was manifestly ironic: the conscientiously anti-ideological Richter was a supporter of no system; 'Capitalist Realism' alluded to Pop art, and it was in reproductions of paintings by Warhol and Lichtenstein that Richter found initial models for his own practice. The 'reality' embodied in Pop art was utterly unlike that represented by van Gogh's shoes; in place of items of use, Pop dealt with the circulation of commodities, and of images. It was specifically the circulation of photographic images, from snapshots to encyclopaedia illustrations, that came to preoccupy Richter, rather than the typical subject matter of Pop. He began to amass an archive of photographs, which he entitled 'Atlas', as if it were a model of the world.

Richter held that Duchamp's creation of the readymade – of crucial importance to him – amounted to 'the invention of reality', and that 'reality in contrast with the view of the world image is the only important thing'. Rather than affording a view of reality, painting 'is itself reality (produced by itself)'. His *Kitchen Chair* (1965) is 'reality produced by itself' in so far as the artist's role has been limited to selecting the photographic image and allowing the medium of painting to re-present it. By contrast with van Gogh's famous chair, personally experienced and expressively painted, this is an indirectly reported chair, impassively executed. The chair appears ordinary and banal, just as the grey hues embody a kind of average: anyone's chair. 148

Richter's grey version of the everyday stands in contrast to the commercial vernacular of Pop (as do Warhol's 'Death and Disaster' images). Conversely, it was precisely the commodified and superficial nature of American Pop that fascinated French artists and intellectuals. The international success of American artists from the late 1950s onwards threw French art into crisis, and enthusiastic Americanization was one response. French Pop belongs to this moment (as does the more original Nouveau Réalisme), and so do the paintings that Jacques Monory (b. 1924) produced in the 1960s. One of a number of French painters whose work drew on photography and American Pop, Monory was imaginatively wholly inside American culture (he was to visit the United States for the first time in 1970). *Murder no. 10/2* (1968) is 149 typical, in its 'American' scale and its many-layered obsession with surface; it actually anticipates qualities of American Photorealism. More broadly, Monory evokes the fascination that American

149. **Jacques Monory**, *Murder no. 10/2*, 1968. In blue monochrome, like most of Monory's canvases, this incorporates a mirror, shattered by gunshots. The play of reflections, real and simulated, the photographic (or cinematic) effect and the dislocated space are all characteristic of Monory's work. The running man is taken from Monory's short film *Ex* (1967).

culture (and capitalism) held for French Marxist (or ex-Marxist) intellectuals. What is strikingly evident in the writing of the philosopher Jean-François Lyotard (who wrote on Monory), or in the cinema of Jean-Luc Godard (whose *Alphaville* (1965) treats *film noir* somewhat as Monory does), is a sense of being willingly seduced. In the 1960s the French anarcho-Marxist Guy Debord described a collective life based on modern commerce as constituting a 'society of the spectacle', an unreal reality in which images govern social relationships. In Lyotard's writing and in that of the cultural critic Jean Baudrillard, the 'spectacle' is ultimately embraced. Both these theorists of the postmodern saw in the culture of American capitalism a surmounting or supplanting of reality, and a passage to the simulacral, a region of unbounded desire; Surrealism was a latent influence here, as with Monory. *Murder* manifests a teasing eroticism, infinitely deferring a view of the action, which is cut by the manifold frames.

Certain of the realist tendencies associated with Pop art present a heightened or doubled illusionism; Monory's work affords one example of this, while another, very different, is that of the British painter Patrick Caulfield (b. 1936). Others afford a disconcerting, drab or critical glimpse of reality through a screen of illusion; this is arguably the case with Warhol and Richter, and also with Richard Hamilton, a pioneer in the critical reinterpretation of seductive consumerist images. In all cases, the frame has been doubled or displaced; as our effort to see into the painting is deflected or impeded, our attention may become more self-aware and perhaps more critical.

150

151

150. **Patrick Caulfield,**
Santa Margherita Ligure, 1964.
Caulfield's painting, partly based on a postcard, reflects on the convention of the framed view; it renders in a schematizing style a scene that is itself artificial, and employs elaborate inner framing.

151. **Richard Hamilton**, *I'm Dreaming of a White Christmas*, 1967–68. The image upon which the painting was based was a still from the Hollywood musical *White Christmas* (1954), showing Bing Crosby in a hotel lobby. Hamilton rendered the scene in negative, changing all the original hues into their complementaries. Bing Crosby became black, an irony underlined by the title.

Light and Matter

The fifth 'Documenta' exhibition, held in Kassel, Germany, in 1972, took contemporary realism as its theme. The curator, Harald Szeemann, accommodated a wide range of art under this heading, but American Photorealism made the most conspicuous contribution. This style-label brackets together artists whose practices developed to some extent independently of each other from about the mid-1960s onwards; the West coast painters – Robert Cottingham (b. 1935), Robert Bechtle (b. 1932) and Richard McLean (b. 1934) and others – being most readily identifiable as practitioners of a common style. In the United States at least, the 1970s were the years in which realism attained some prominence, having become a focus of critical attention through a series of exhibitions held between the late 1960s and the early 1970s, including two important New York shows: 'Realism Now' at Vassar in 1968 and the Whitney Museum of American Art's '22 Realists' in 1970. Linda Nochlin, a Courbet scholar and an authority on nineteenth-century realism, organized 'Realism Now' and became a leading critical advocate of realism. (Her 1971 book *Realism* helped initiate a reappraisal of nineteenth-century realism; discussion came to focus particularly on Courbet, after

152

152. **Robert Bechtle**, *20th Street – Early Sunday Morning*, 1997. For Bechtle, the advantage of using the camera as an aid in painting is that 'you gain a certain veracity and control over location and light…that you might not get from direct observation'. By selecting relatively bare scenes, Bechtle isolates areas of typically photographic detail (the shadow of the nearby tree) and gives light an expansive role (the sunlight crossing the street). As with Hopper, action is stilled so that our attention may, with slow deliberation, take its time.

the centenary exhibition and following the publication of T. J. Clark's pathbreaking *Image of the People*.)

Nochlin directed her defence of realism against Greenberg's formalism, whose anti-realist antecedents she traced in classicist art theories of earlier centuries. She acknowledged, however, that abstract art had influenced a diversity of contemporary realisms. Many of the new 'realists', including Philip Pearlstein (b. 1924), began as abstract painters. In 1962, the year in which his former fellow-student Warhol took part in the Pop-oriented 'New Realists' show at Sidney Janis, New York, Pearlstein published an article that amounted to a manifesto for contemporary figure painting. Defying the 'tyranny' of 'flatness' and dismissing both Pop art and the vogue for existentialist figuration associated with the 'New Images of Man' exhibition at the Museum of Modern Art, New York, in 1959, Pearlstein also denounced the convention of 'the roving point-of-view'. The latter was an allusion to Cézanne. Pearlstein's paintings cannot be seen, like Cézanne's, as registering the shifting 'sensations' of the painter; they are dedicated to representing the static, objective presence of the human body. His realization of his models, consequently, is firmly three dimensional; and yet, schooled in Abstract Expressionism, he arranges them in highly formalized ways, on a large scale and with an evenly sharp focus. The eye is therefore invited to scan across the surface rather than plunge into depth. For all Pearlstein's denunciation of 'flatness', his eye retains an attunement to surface and painterly method gathered from his years as an abstract painter. As a realist, he accentuates the bony structure of the model's body and emphasizes the pressure of leg against chair arm; as a painter schooled in abstraction, he exploits the formal intricacy of the tripartite shadow.

The new kinds of realism that developed in the United States through the 1970s were generally as internally divided as Pearlstein's respecting abstract art. Given the commercial and critical standing of abstraction, the emergence of new realisms necessarily appeared as a challenge to it, something that the painters in question variously welcomed or disclaimed. Linda Nochlin combatively defended what she termed the 'crimes' of realism against abstract 'law', alluding to the perceived restrictiveness of Greenbergian doctrine. Transgression requires a law, and the more assertive kinds of realism conspicuously broke the rule of 'flatness', of surface integrity, that they also necessarily invoked. This was true of Pearlstein's work, and also of the more tumultuous painting of neo-traditionalists such

153. **Philip Pearlstein**, *Female Nude on Platform Rocker*, 1978. From the mid-1960s onwards, Pearlstein painted from models using three daylight floodlights; hence the play of shadows he has studied here. The sharp definition, the differentiation of values and the clear articulation of anatomy are all typical, as is the cropping and the rendering of the figure at more than life size.

154. **Euan Uglow**, *Curled Nude on a Stool*, 1982–83. In comparison to Pearlstein, the English painter Euan Uglow (b. 1932) shows little concern with physical realism, and his approach to the nude is more markedly formalistic. A pupil of Coldstream, he employs a method of visual gauging and measurement, whose effect is to reduce all relationships of depth to surface configuration.

155. **Richard Estes**, *Supreme Hardware Store*, 1973. This was painted at the high point of Photorealism. Estes's work was distinctive at the time both for its run-down urban subject matter and for its relatively loose and painterly technique. Estes neither squared up his photographs nor projected slides onto the canvas, but redrew, often making use of several photographs.

as Alfred Leslie (b. 1927) and Jack Beal (b. 1931), whereas Alex Katz (b. 1927), by contrast, has evolved a realism closely akin to the coolest abstract art.

The rule-breaking appeal of realism essentially consisted in putting the surface at risk by opening it to non-art. Photography afforded a means of achieving such an opening. The Photorealist Richard Estes (b. 1932), whose use of photography arose through his work as an illustrator, painted from photographs of run-down parts of New York which are manifestly squalid and banal. Yet far from being indifferent to the painted surface, he aspired to a beauty of depiction like that found in painting of earlier traditions. There is in fact an interaction in his paintings between the beauty of the painted surface and the ugliness of depicted actuality; only in the unlocatable painted reflections is beauty untrammelled. There is a certain resemblance to Pop art, but Photorealism pointedly substitutes for the perfected commercial surface of Pop the actual and material façade of the everyday. Nothing is more tawdry than the once-new which has lost its sheen, or the cheap version of commercial high gloss.

Estes's view of New York contrasts starkly with that of George Bellows, where impressionistic technique intimated involvement in the given scene. Estes's sharply differentiated account of city streets, while intensely illusionistic, holds our attention at the surface, and so communicates no sense of 'being

156. **Fairfield Porter**, *Near Union Square – Looking up Park Avenue*, 1975. Porter's painterly simplification, and his assertion of a pedestrian viewpoint, stand in contrast both with Richard Estes and with Wayne Thiebaud. He paints the city (New York) at larger scale than either, but to less alienating effect, softening architecture into a light-receiving space.

157. **Wayne Thiebaud**, *Corner Apartments (Down 18th Street)*, 1980. Influenced by Bay Area Figuration, in particular by Richard Diebenkorn's (1922–93) San Francisco paintings, Thiebaud exploited the strange topography of San Francisco to paint cityscapes that defy perspectival expectation. Here, where both viewer and view are elevated, the usual co-ordination of ground plane and horizon is missing; liquid brushwork makes apartment blocks and snaking paths adhere to the picture surface.

158. **Ed Ruscha**, *The Los Angeles County Museum on Fire*, 1965–68. Ruscha first treated the blank urban landscape of Los Angeles in photographic books, starting with *Twentysix Gasoline Stations* (1963). Gas stations became a subject for paintings, rendered, like the museum here, in an ambiguous combination of flatly painted planes and deep perspective. Ruscha builds a bland replica of the grandiose building at monumental scale, as seen from an elevated viewpoint, then sets it ablaze.

there'. We never actually see a street in this way; as we are about our business we scan the scene, as Estes has noted, and select according to our needs. The painting's sharp differentiations awaken this scanning activity but allow it no resolution. We see the city as if for the first time, as so much mere arbitrary and contingent clutter, while our scanning simultaneously takes in the complex structuring of the painted surface. (Estes's West Coast contemporaries Thiebaud and Ed Ruscha (b. 1939) also exploited 157, 158 disorienting ambiguities of surface and depth, in paintings of San Francisco and Los Angeles, respectively.)

Photorealists are surface-conscious depictors of surfaces. The 'reality' their paintings represent is usually itself artificial, both physically (Estes's shopfronts) and culturally (Morley's brochure photographs). The West coast Photorealists sometimes focus on the artefacts and artificial worlds of a slightly earlier time, such as 1940s diners or 1930s Los Angeles suburbs, compounding the sense of distance and strangeness. In his *The Return of the Real* (1996), the American art historian Hal Foster, following Jacques Lacan's tripartite psychoanalytic schema of the real, the symbolic and the imaginary, sees Photorealism (he prefers the term 'superrealism') as engaged in a hyperbolic pursuit of appearance that works so as to mask a repressed reality; the real, in this psychic sense, is a darkness at the centre of existence that we wish to avoid, and that cannot be represented. In the very anxiety of its concern with gleaming surfaces, Foster argues, Photorealism points to that which it would conceal.

159. **Chuck Close**, *Alex*, 1991.

159. **Chuck Close**, *Alex*, 1991. Whereas many of Close's early source photographs are frontally lit, here the pattern of light and shade is more complex. This is well suited to the technique he began to develop in the late 1980s. Rather than bearing a descriptive relationship to the portrayed features, the components of the pictorial mosaic comprise miniature chromatic and tonal compositions. This fact is conspicuous when Close works from colour photographs, but he uses the same methods to interpret black-and-white images, as in this case, where variegated lozenges disclose the bared teeth of a grimacing Alex Katz.

While this is plausible for much Photorealism, Estes, in at least some of his work, takes material decay, rather than commercial sheen, as his direct subject; and in Chuck Close's *Self-Portrait* 160 (1967–68), a burning cigarette between fleshy lips makes a *trompe-l'oeil* hole in the perfected surface.

The work of Chuck Close (b. 1940) should not be straight-forwardly identified with Photorealism, however. The existence of a wider movement in photo-based art was clearly a factor in making his own practice viable; nonetheless, Close refused inclusion in exhibitions of realism until 1970, when his work was shown in '22 Realists' at the Whitney Museum of American Art in New York. As a student, Close had painted de Kooning-style canvases, and he continued to regard his paintings as allied to abstract art. He arrived at his photo-based practice not through an antecedent commitment to realism (as did Estes), but almost as a way of continuing abstraction by other means. However, the human subject matter of Close's art is clearly important (and without equivalent in Photorealism).

In earlier portrait convention, the sitter looks back at us from an illusionistic depth, comes near from a distance. Close, whose first portrait (1967–68) was a self-portrait, assumes the unseeing 'gaze to camera' typical of passport photographs; consequently, despite the apparent nearness to the frontal plane, the painted image is remote. A reversal has taken place, relative to tradition, whereby the person – the communicative human subject – has been distanced and bodily presence made imminent; the shallow depth of field emphasizes this sense of physical nearness (and betrays the photographic source). In looking at the painting, we find ourselves scanning its extensive surface, attending to the interpretation in paint of the magnified blemishes of the skin, working out how Close has notated stray hairs and stubble. The face decomposes into painted formations, recomposes into an illusion of monstrous fleshiness.

Photorealism promises a (photographic) view into depth, which it simultaneously cancels through its preoccupation with the superficial. In Close's case, the phenomenon of human skin is the median term in a complex reiteration of surface, from face to 159 photograph to painting. The surface of the human body is its boundary with the physical world, a sensitive boundary that feels what it also is part of; touch puts it in close contact with other physical entities, while sensitivity to light interposes distance. Close's paintings address this intimate and primary sense of what it is to be inside our skins. There is a parallel with the work

160. **Chuck Close**, *Self-Portrait*, 1967–68. This was the first of Close's portraits, based on a photograph with a typically shallow depth of field, which he squared for transfer to a huge canvas. Most viewers feel the urge to peer at the surfaces of Close's paintings and find how he has effected the translation; here, the paintedness of some details (such as the glasses) is more manifest than would be the case in his paintings of the 1970s.

161. **Robert Ryman**, *VII*, 1969. Ryman brushed white-pigmented shellac onto the corrugated paper in such a way that overlapping strokes create bands linking the seven panels. For most of his career, he has painted in white, varying paint and support surfaces, and always treating the support as integral to the work. Painting is seen to reduce to the interaction between light and matter.

of minimalist and process-oriented artists who achieved prominence at the same time as Close, and with that of Robert Ryman 161 (b. 1930) in particular: artists engaged in an investigation of our apprehension of matter as both visual and tactile, near and remote; as sharing our space and as beheld by us, rather than as representing anything. Ryman referred to his art as 'realist', since it presents the viewer with nothing but the literal material givens of the work. Despite the element of depiction in Close's paintings, his approach is as literalist as Ryman's; and even though Ryman depicts nothing, the constitution of his works, radically reduced to the interplay of light and matter, presents a physical analogy to our own sensitive surface, our skin.

Both Close and his contemporary Vija Celmins (b. 1939), who also began as an abstract painter, seek an alliance between illusory depth and actual materiality. The very subjects they choose lend themselves to such a project – Celmins's areas of sea surface 162 and of stellar space as much as Close's impersonally photographed faces. The viewer is bound to come near to Celmins's

162. **Vija Celmins**, *Untitled,* 1990. The ocean surface has been one of Celmins's constant subjects since she first drew from photographs of the Pacific in the 1970s. This is painted on canvas, at customarily small scale. The depicted subject answers to the action of brushing the painted surface.

pictures and study the working of the surface. The image itself comes and goes, like a memory; to look at the sea or the night sky is to become lost in it. Celmins used a camera to reduce the spreading sea surface to 'an object to scan', and translated that scanning into movements of the painting hand over the canvas; no intrusion of sky or shore interrupts the even passage of hand and eye. Close, interviewing her, commented on the interplay between the ethereal and the physical in her drawings: the greatest density of graphite for the profoundest distance of outer space.

163

163. **Vija Celmins**, *Lamp # 1*, 1964. Celmins's earliest non-abstract paintings were of objects in her large shopfront studio. The arrangement here recalls Morandi (whose work she had studied in reproduction – his work was widely reproduced in 1964, the year of his death). She was to relinquish the painterly brushing, however, in regard for painting's 'essential stillness'.

There is a decided emotional suggestiveness in Celmins's actions of bringing the remote near to hand, and containing that which recedes. In her interview with Close, she referred to Cézanne and 'space that is in front of you, here and now'. In early works she painted objects in her immediate surroundings, and re-created things she remembered from her childhood in Lithuania. Her objects take on an almost-living character, like that assumed by familiar things in a child's environment; there is something uncannily animate in Celmins's double lamp of 1964. At the period when she was painting objects, she was looking at reproductions of Morandi, whose paintings very much deal with 'the space in front of you', the closed circuit between light, object, eye, painting hand and canvas. In Morandi's small canvases, the brush attends to the whole surface, making it, and the softened objects, yield to the touch; critics of the 1920s Neo-Classicism with which Morandi was associated have indeed dwelt on its evocation of the infantile, of dolls and puppets – manipulable and responsive entities, objects near to hand.

164

164. **Giorgio Morandi**, *Still Life*, 1963. One of Morandi's late paintings (he died in 1964). In his late still lifes the adaptation of objects to picture-plane becomes increasingly apparent; the faint background lines, similarly, accommodate themselves to the foreground shapes, rather than defining a recessive space. Painting is a means of overcoming separation.

Embedded Matter

In his essay 'The Origin of the Work of Art', Heidegger refers in passing to 'the fortunately obsolete view that art is an imitation and depiction of reality'. A work of art (including van Gogh's manifestly realist painting of a pair of shoes) is not a picture of the world, but is something that brings a world into being. 'World', in this sense, 'is never an object that stands before us and can be seen', but is historical, cultural and collective; it is affective and social. In this sense, we can perhaps agree that van Gogh's painting is more than simply a picture of a pair of shoes. It does however participate in a tradition of depicting from nature, of framing an apparent depth, and herein lies its manifest realism. Although the practice of painting from something beheld continued into the twentieth century, it tended to become peripheral,

165. **Avigdor Arikha**, *Slippers and Undershirt*, 1979. Arikha paints and draws from life at one sitting, applying oil paint in a generally uniform covering of strokes, which let the ground show through. Many of the paintings, like this, depict everyday things.

except during the 1940s when a certain revival took place, as we have seen. Since then, the painter whose work has come most powerfully to command attention in this context is Lucian Freud – whose career began in the postwar years.

Freud's paintings ostensibly offer critics of this kind of realism clear evidence to support their views. At first sight, his paintings seem designed to illustrate the workings of what the British art historian and theorist Norman Bryson (one such critic) has called 'the gaze'. In Bryson's account, 'the gaze' commands an objectified world external to itself; it is so searchingly engaged in perceptual scrutiny that it dissociates the visual faculty from the linguistic and the social – and from meaning in general. Bryson took his term partly from the writing of Jacques Lacan, whose complex ideas respecting the gaze drew on the culture of existentialism. Although Bryson has not written about Lucian Freud, his theme of the gaze would appear singularly applicable to the painter's work, since Freud, as we have seen, formed his initial

realist practice in response to Parisian art of the existentialist period. If we now recall his long-lived friendship with Bacon, whose paintings recurrently touch on photography, mirror reflection and acts of witnessing, we can see Freud's preoccupation with the gaze as being especially strongly determined. However, it does not inevitably follow that his approach entails merely a domination by the viewer of the viewed. His small self-portrait in a hand mirror dwells on the limitations of vision, specifically respecting the effort of seeing oneself. Freud's face, isolated in the black oval frame, squints against the light coming through the opalescent glass. The double framing, by mirror and window, yields a double opacity, since the painter's unseeing face, closed upon itself, lies at the centre of an obstructed view.

166

166. **Lucian Freud**, *Interior with Hand Mirror (Self-Portrait)*, 1967. The canvas is only ten inches (25.5 cm) in height. Several of Freud's self-portraits indicate that what is painted is a reflection; the late full-length self-portrait he exhibited at the Whitechapel Gallery, London, in 1993, in which he looks out from the canvas he paints, shows no mirror but is entitled *Painter Working, Reflection*. The alliance of painting and reflection, and the practice of self-scrutiny, are seen to be paradoxical.

167. Lucian Freud, *Naked Portrait on a Red Sofa*, 1989–91. Freud's brush has evidently pressed hard against the canvas, pushing it back onto the stretcher. He feels what he paints: the brush sweeps across the floor, insinuates itself into the recesses of the sofa, flows around and over the body, thickening coarsely where the surface is most heavily worked.

Admittedly, Freud's paintings in general might seem to epitomize the dominance and even cruelty of vision, since his subjects are typically reduced to an abject state. Yet his images of defenceless and vulnerable bodies, far from rendering us powerful as viewers, induce us instinctively to drop our guard. Rather than yielding passively to our gaze, therefore, Freud's subjects press on it invasively. Their reality is excessive. In his early postwar paintings, Freud finely painted enlarged, liquid eyes, sensuous lips and tense nostrils; much later, he brushed paint thickly and sweepingly to depict bodies held together in dynamic tension

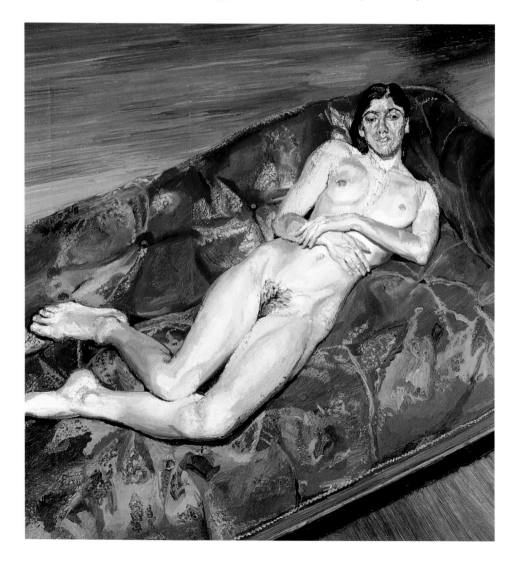

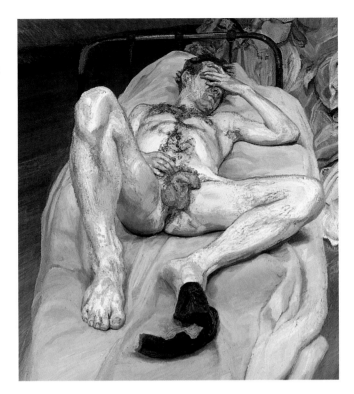

168. **Lucian Freud**,
Naked Man in a Bed, 1989–90.
The spartan setting of Freud's
studio has become familiar from
his paintings. Models pose against
bare floorboards, a pile of paint
rags, under harsh light.

between bone, flesh, muscle and the weight of inner organs. The naked sitters are often drowsing or asleep, their eyes closed or listless. The body at rest, naked, abandoned into itself in a way that is common to all drowsing mammals, becomes more like its surroundings, as if in defensive camouflage. *Naked Portrait on a Red Sofa* (1989–91) compares taut living flesh with the worn leather of the sofa. By means of the skin of paint and the painted skin, the painting addresses us (invasively) through our own skins and in terms of our bodily awareness; in this connection, notice also the peeled sock of the *Naked Man in a Bed* (1989–90), the firmly planted right foot, the anus on view instead of the eye.

167

168

Aggressive though their presence may be, the figures in Freud's paintings are undeniably 'objects that stand [or lie] before us and can be seen', far more so than those in paintings by the artists with whom Freud has been most closely associated, Auerbach and Bacon. Different as the three painters were from each other, however, they differed still more from most of their contemporaries in English figurative painting. None, in fact, was English by birth; Bacon was brought up in Ireland, while Freud

and Auerbach, both born into middle-class Jewish families in Berlin, arrived in England as refugees. In the work of each of the three, we may find the relatively un-English traits of emotional intensity and painterly style. The latter quality, emerging only gradually in Freud's work, but always strongly evident in that of the other two, drew all three of the painters towards Baroque realism, to Velázquez and Rembrandt; inherent in Baroque realism is a symbolic exchange, whereby the painted figure is seen to draw life from the painter's action, traced on the canvas.

The French painter Avigdor Arikha (b. 1929), reflecting on the vanished technical secrets of Baroque art, declared the ambition of retrieving the lost 'pictorial code' by way of 'the twentieth century's experience'. Yet the implicit disassociation of technique from experience and belief can be called into question.

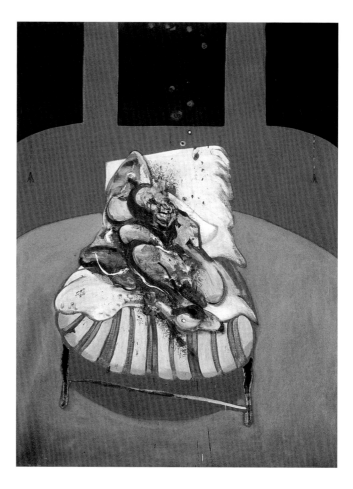

169. **Francis Bacon**, central panel from *Three Studies for a Crucifixion*, 1962. The left panel shows two turning figures and sides of meat. The right panel contains an inverted crucifixion motif. These elements, like the central figure on the bed and the blinds, recur in different paintings.

170. **Chaim Soutine**, *Carcass of Beef*, c. 1925. Francis Bacon admired Soutine's (1894–1943) painterly chromaticism. Soutine, a Russian-born artist who worked in Paris, painted several versions of this subject, based on Rembrandt's *Slaughtered Ox* (1655) in the Louvre, Paris.

In Baroque realism, from Caravaggio onwards, the representation of the body's materiality points indirectly to its spirituality. In the seventeenth century, the idea of the incarnate soul was still culturally dominant, as it steadily ceased to be in subsequent eras; if it is recollected in painting, it is as an absence or diminished echo. Bacon, keenly aware of such issues, invokes the technical amplitude of Baroque painting in his triptychs, but to decidedly claustrophobic effect. His exploration of Christian imagery is particularly relevant here, the concept of incarnation being central to Christianity, in the doctrine of the double nature of Christ. In *Three Studies for a Crucifixion*, a famous triptych of 1962, Bacon 169 inverts the image of the crucified, giving it the violent animality that is recurrent in his paintings of the period. To many English viewers, such images appear either horrific or else contrived and rhetorical. Conversely, it is unsurprising that Bacon should have been so well received in France, being accorded an exhibition in Paris at the Grand Palais in 1971. French writers who published significant texts on Bacon's work included the former Surrealist Michel Leiris and the philosopher Gilles Deleuze. An important factor in French responses to Bacon is the Catholic imagination, as informed, blasphemously, by Surrealism. Georges Bataille's identification of the sacred with a descent into animality – referred to in chapter three – is particularly relevant.

Bacon's art is systematically perverse and contradictory. Describing his practice as realist, he defines realism ('fundamentally subjective') as the opposite of 'illustration'; he alludes to the Christian 'real body' of God in order to deny divinity; his triptychs isolate their painterly figures on grounds of even colour as 171 if for visual inspection, but render those figures visually illegible. Deleuze, in his discussion of Bacon, draws on Artaud's concept of the 'body without organs', a schizophrenic apprehension of the body as a miraculously unified and powerfully expressive entity; in Artaud's late performance for radio, the bodies of listener and performer alike are shaken by the intensity of Artaud's cries and screams. The *performed* body is different in kind from the objectified body of medical science, and Bacon both evokes the medical body and performs a paroxysmic change of state. Using photographs as sources precisely because they objectify the body, Bacon re-enacts them in paint and transforms them into fluid, unfixed states. In Bacon's recently discovered works on paper, Muybridge's frozen images of the body in motion regain movement and mortal existence as smears and traces.

The shift from photograph to painting (to the 'body without organs') is a shift from the apparently solid to the palpably liquid: the eye senses the fluid tactility of brushstrokes and paint smears. Muybridge's photography stands at one extreme of realist representation, which we might term the effigy; its opposite is the performed image, which, in Bacon's words, returns us to life, to the 'nervous system'. Painterly realism, since the Baroque period, has negotiated between these extremes (Bryson's petrifying 'gaze' and animating 'glance' are here inseparable). The Baroque painterly realists addressed the paradox that a painter can only make a figure or object appear solid – and in that sense 'real' – at the cost of making it remote: it is on the 'other side' of the painted surface, withdrawn into the purely visible. Painterly practice entailed both creating this effigy and endowing it with life, through intimation of movement, suggestion of texture and allusion to non-visual senses, and by exploiting the tactility of oil paint and its suggestive colouristic richness. (Alternatively, painters such as Vermeer treat subjects in which life is naturally subdued and still.) In their divergent reinventions of this tradition, both Bacon and Freud operate between effigy and performance, but they do so without the context of a religious culture and in terms of a correspondingly intensified contrast between the opposed extremes. Rembrandt's Professor Tulp in the *Anatomy Lesson of Professor Tulp* (1632) lectures over the body as the carnal image of God, as distinct from the objectified body of modern medical science that underlies much of Bacon's imagery (and appears in Eakins's *The Gross Clinic*). Conversely, the acknowledgment of human animality in Freud and Bacon has no seventeenth-century precedent (we sense Christ in Rembrandt's ox carcass – later desecrated in versions by Bacon).

171. **Francis Bacon**, *Three Studies for a Portrait of Lucian Freud*, 1965. The tripartite structure of Bacon's portraits alludes to police photographs. People close to us never appear as in photographs, since we know them in life, not in a frozen view. Here, the head is isolated like a photographic object, but paroxysmic movements (by painter, of sitter) efface objective features.

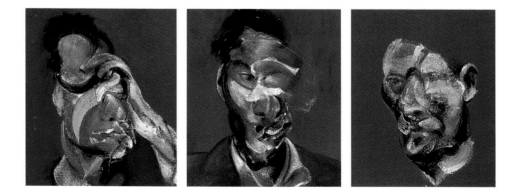

172. **Frank Auerbach**, *E.O.W. on her Blue Eiderdown II*, 1965. In the 1960s, Auerbach turned from his earlier greys, blacks and earth colours to the brighter hues that he could now afford. This relatively small canvas is quite thickly painted and the nude is embedded in its surface.

Bacon deploys a range of devices to evoke the pictorial effigy: forms of inner framing; allusions to photography; a use of circles, arrows, *trompe-l'oeil* pins; references to surveillance. The focal elements, however, are not static likenesses but are fluid enactments, and the kind of action Bacon cultivates – most effectively in work of the 1960s – is readable as *involuntary*. That is, his actions as a painter are suggestive of paroxysmic, habitual or compulsive movements – which are often reiterative. The Baconian figure is two-sided, in that it is the trace of an action which depicts an action: the enactment of an enactment. Freud acknowledged a comparable ambiguity when he said of his sitters that he wanted 'to *portray* them, like an actor'.

Freud registers both the solidity that makes the body a thing among others and the liquidity that makes it different, even when still; effigy and the animate are formed together. Auerbach's paintings, on the other hand, hold the sense of an effigy, an external likeness, only in as much as they have been painted from observation. That fundamental principle of painting something that is beheld anchors Auerbach's work, like that of his friend Kossoff, in the realist tradition. Both Auerbach and Kossoff, however, prevent their figures from assuming a free-standing presence within the painting. There is no projection in depth; the figures and scenes appear to be in no place other than the skin of paint. The brushstrokes of both painters are seen to lie on the surface, merged together in an overall liquidity. Auerbach's E.O.W. is wholly a figure in paint, in no degree estranged or objectified. His way of painting owes more to Willem de Kooning's example than it does to that of Bacon (whose work he also admired).

Both Auerbach and Kossoff bring the world close. Following Bomberg in their preoccupation with 'mass' ('I always begin with a lump', said Auerbach), they portray things and beings as bodied-forth, rather than as cut out against a space external to them. Some of Auerbach's early paintings were of building sites, excavations – where space, instead of containing mass, is contained by it. Something similar happens in Kossoff's paintings of railway landscapes. The city, in his paintings, loses its solidity, most explicitly in the paintings of swimming pools: the communion of liquid matter.

173. **Frank Auerbach,**
Head of CD II, 1977. Drawing has a significant place both in Auerbach's work and in Leon Kossoff's, and it is here that David Bomberg's influence is most evident. Two thick sheets of paper are glued together, to allow for abrasion by erasing. The aim is not to demonstrate effort; as with painting, working and reworking proceed until a state is reached that is not laboured but light.

172

174

174. **Leon Kossoff**, *Children's Swimming Pool, 11 o'clock, Saturday Morning*, August 1969. Kossoff's urban scenes tend to suggest loneliness and desolation, his series of swimming-pool paintings constituting an exception. Characterized by playfulness rather than pathos, they achieve an interidentification of paint, the body, water and collective life, bringing rectangular pool and painted canvas into close association.

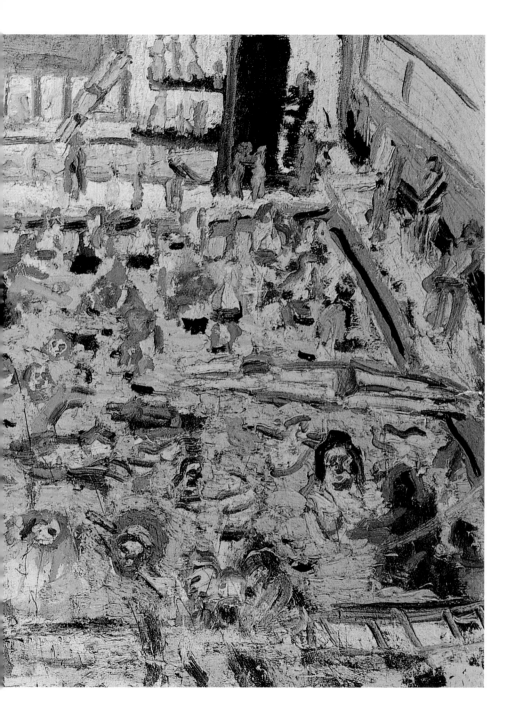

Critical Realism and the Critique of Realism

175. **Jorg Immendorf**,
Café Deutschland I, 1978.
Immendorf's (b. 1945) paintings
combine a painterly bravura
typical of much German 'Neo-
Expressionism' with politically
satirical content. In the late 1970s
Immendorf, hitherto a radical
performance artist, took Renato
Guttuso's *Caffè Greco* as the
model for paintings which define
the collective mental space of Cold
War Germany (East and West).
West Germany becomes a sleazy
disco and the artist, set between
totems representing the opposed
political systems, reaches through
the Wall to the painter A. R. Penck
(b. 1939), whose reflection from
East Berlin appears on the mirror
column at the centre. The image
of Brecht appears at top right, in
this political theatre.

176. **Miquel Barceló**,
The Big Spanish Dinner, 1985.
The Spanish painter Barceló
(b. 1957) was one among the
range of artists whose work
achieved prominence during
the 1980s, the era of Neo-
Expressionism. His paintings
are typical of this moment in their
exploitation of large-scale and
highly wrought painterly surface,
but show little of the concomitant
concern with narrative. Instead,
they dwell on the transformative
nature of painting, particularly
as found in still life; the meal
painted here is in itself a scene
of transformation.

The preceding section of this chapter is the only one in which the painters discussed can clearly be seen as sharing a milieu. It was not only a common environment that brought them together, but a certain community of practice and a shared respect for painterly tradition. The present section returns to the chapter's more general pattern: painters approach tradition and representation by way of contemporary visual culture, and shape their practice in response to critical ideas, styles and fashions which are disseminated internationally, and recur over time; the work of painters operating quite independently of each other may therefore be seen to reveal affinities, or respond to common concerns.

The 1980s saw a resumption or continuation, on the part of certain painters, of the critically self-conscious practice described earlier with reference to framing, but in the context of a very different international art movement. During the 1980s, a much-proclaimed 'return to painting' took place, predominantly Neo-Expressionist and uniformly figurative in character (the main 175, 176 protagonists included Georg Baselitz, Francesco Clemente and Julian Schnabel); the rise of this new movement, which coincided with the demise of conceptual art, incongruously assisted the development of new critical initiatives in painting – incongruously, since the ethos of Neo-Expressionism was decidedly anti-critical. The painters who are to be considered here were acutely aware of critical issues concerning pictorial representation, realism and illusion, and their work had something of the sceptical tenor of conceptualism. At the same time, it was the newly buoyant market for painting that gave their work prominence. The market, like the Neo-Expressionist movement itself, was international, and the range of reference here is correspondingly diverse: it includes the American Mark Tansey (b. 1949), the English group Art & Language, an older American painter, Leon Golub, and the German Gerhard Richter, whose work constitutes a link with the earlier section.

177. **Mark Tansey**, *Triumph of the
New York School*, 1984. Tansey's
large monochrome canvases
present fictional scenarios, often
concerned with ideas about art.
Clement Greenberg (reflected in
the puddle as an abstract form)
takes the surrender from André
Breton. Picasso, dressed as a First
World War airman, stands next
to Matisse. Pollock is beside
the photographer, and Duchamp
smiles in the background.
A newer modernism outguns
its predecessors.

Tansey's *Triumph of the New York School* (1984) is doubly significant here, since it breaches (and pillories) Greenberg's veto on illustration and illusionism, while also mounting a critique of realism. The presence of the photographer at centre-right alludes to the realist 'capturing' of reality, while the use of monochrome makes the painting photograph-like, a true report; yet the scene represented is fictional, and also historically impossible in its conjoining of different times. It is not actual but allegorical, and 'real' only if we conceive of reality as being, as Tansey puts it, 'multidimensional'. If pictorial illusion requires a suspension of disbelief, Tansey's is a perverse illusionism which breeds scepticism and doubt (there is a parallel here with Richter).

178. **Mark Tansey**, *Close Reading*, 1990. The reader climbs a rockface of silkscreened words; 'Blindness and Insight', printed at top left, alludes to Paul de Man's book, and to his view that the insight afforded by close reading entails contextual blindness. The rockface is horizontally divided, an enigma for the viewer (who sees a little more than the 'reader').

It is through this sceptical illusionism that critical ideas assume visual form in Tansey's paintings. His pictures hold out the illusionist promise that, in looking, we will see reality, the truth, yet they simultaneously show that promise to be unrealizable. The quest we are drawn into is bottomless. However, a fully consistent denial of first-hand or communicable experience in art or life risks relinquishing any reality that might matter to us. Unlike Tansey, all the other painters considered here acknowledge this dilemma, particularly in so far as they attempt a social reference. The Art & Language painters, who had been leading participants in the Conceptual Art movement, were decided critics of what they termed 'first order' expression (as in the instinctual, expressive brushstroke), yet their experience in painting convinced them of its persisting, if paradoxical, importance. In the maquette for their paintings of *The Studio at 3 Wesley Place* 179 (1981–82) they employ a 'conservative' perspectival illusionism; the work's intended 'realism', however, consists not in this but in the application of what they termed a 'genetic' principle: the painting portrays it own genesis. As a painting of their studio, incorporating depictions of their own previous work and other paintings in the 'artist's studio' genre – including Courbet's

179. Art & Language, *Index: the Studio at 3 Wesley Place; Drawing (i)*, 1981–82. This is a maquette for paintings that Mel Ramsden (b. 1944) and Michael Baldwin (b. 1945) subsequently painted holding brushes in their mouths, with resulting deformation of the image. The artists are shown here mouth-painting an earlier picture, other projects being variously alluded to. On the easel is *Portrait of Lenin in the Style of Jackson Pollock*.

180. **Eric Fischl**, *The Old Man's Boat and the Old Man's Dog*, 1982. Fischl (b. 1948), a central figure in the 1980s 'return to painting', achieved prominence with neo-realist pictures which often suggest guilty pleasure. There are connotations, often, both of transgression and of social privilege, as here. Fischl, if not exactly a critical realist, summons a critical mood.

famous canvas of 1854–55 entitled *The Painter's Studio* – it is programmatically historical. Its critical significance is to be found in the canvas on the easel and in the painting-by-mouth enacted below, since these record the artists' disconcerting experience of being drawn into the very 'first order' expressive experience they parodied. What they consequently sought was a reconciliation of Greenberg's 'high genre' with a sustained critical and realist practice: a deliberate echo of Courbet's attempt to open the civic space of high art to a wider public reality.

The painters seek to give their work a social dimension, but can do so only by indirect and critical means. Similarly, when Richter addressed a manifestly public and historical subject, in 1988, he did so in characteristically oblique fashion – and having trained as a Socialist Realist, he knew what he was doing. The paintings refer to the enigmatic deaths in prison of three members of the Baader-Meinhof group (the Red Army Faction, led by Ulrike Meinhof and Andreas Baader, carried out bombings and assassinations directed against capitalism and the West German State). In the series of 15 paintings that comprise *Oktober 18, 1977*, Richter preserves a sense of distance from the troubling nature of the subject – and precisely in so doing, establishes the conditions necessary for the viewer to feel troubled. His procedure – the blurring that differs for each image, the varying of scale, the sequencing – sustains the viewer's uncertainty as to orientation. He distances us from the original police photographs of dead bodies. A body may be seen and photographed, but a death and its history are not objects to be viewed; by holding the 'facts' at a remove, Richter allows the events to haunt us. We may not get to the bottom of the matter, but were we to feel that there were no facts at all, no reality in which we too were involved, the paintings would lose their grip on us.

The painter offers no viewpoint, yet nobody looking at the paintings could feel detached – and German viewers in 1988 would still have felt unease respecting the history of the Red Army Faction and the prison deaths, since the repressive measures taken in response to the RAF's campaign had left a lasting memory. The paintings remain unsettling – not only for German viewers – insofar as they more widely concern our relationship as individuals to the state and its power, our personal involvement and implicatedness in the public sphere. This covert insinuation of power into the fabric of everyday life was precisely what Leon Golub came to address, as his work attained a new prominence in the 1980s. In 1959, Golub had participated in 'New Images of

147

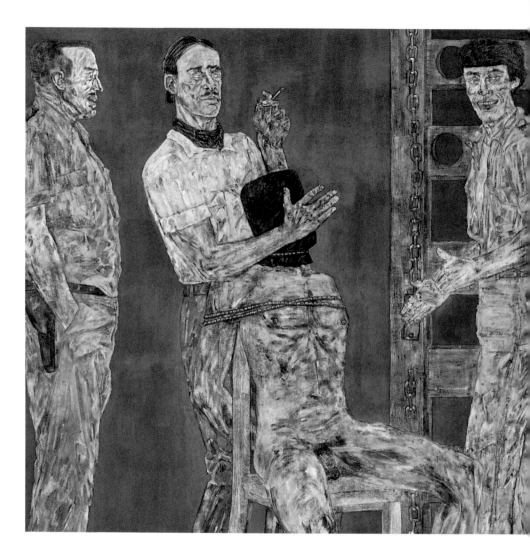

Man', an exhibition at the Museum of Modern Art in New York
which reconciled existentialist-oriented figuration with figural
Abstract Expressionism. Between that time and the late 1970s,
when he began his 'Mercenaries' series, Golub – who lived in
Paris for a time – painted large 'Gigantomachies' inspired by
Hellenistic and Roman art. His paintings took on a contempo-
rary reference after his return to the United States and in connec-
tion with the Vietnam War, but it was only with the 'Mercenaries'
and 'Interrogators' paintings that he achieved real complexity in
treating his long-standing theme of power and masculinity.

181

181. **Leon Golub**, *Interrogation II*, 1981. Golub painted his Mercenaries and Interrogators at larger than life scale, on unframed canvases and with feet cut off (to suggest continuity between their space and that of the viewer), isolated confrontationally against an abstract background. By painting, scraping-down and then reworking, he flattened his figures into the grain of the canvas while giving them a harsh, non-illusionistic physicality.

This complexity has much to do with the fact that, even more markedly than in other cases discussed in this chapter, different registers of representation are simultaneously present: large-scale abstraction, the monumental frieze, S&M photographs. Golub's sexualized interpretations of his scenes invite the viewer's complicit apprehension of something that is hidden and yet monumentally public.

The insidiousness of Golub's paintings consists in their ability to suggest that power is ubiquitous. The interrogators and mercenaries are not specifically located, and they call to the viewer as they have been called, without knowledge of higher ends and without question. Enlarged, they are brought close. Golub conceived earlier paintings as flayed skins, and a metaphorics of skin is in play here too, around the naked hooded victim. Golub has remarked that the Romans covered both their public and private wall surfaces with images of power, but that today we lack a public space of depiction. His paintings figure skin itself as the common surface on which power is inscribed. Placing his scraped figures on an abstract ground, he combines modernist and classical universality, to evoke the space of 'news'. Like Warhol and Richter, he draws from universal transmission. Still existentialist, he paints a reality as close to us as our skins.

Flesh and Image

Since the 1960s, the practice of art in Europe and North America has been influenced by two factors above all others: the critical and commercial ascendancy of American abstract art at the beginning of the period, and the cultural transformation brought about by the accelerated growth in communications media and associated technologies. From Warhol to Close, Estes to Golub, painters present reality indirectly or as if through a screen. According to the French theorists mentioned earlier, paintings like Warhol's imply that there is no reality outside the play of images; only hyperrealist strategies can do justice to the experience of 'late capitalism', of shopping malls, freeways and televized warfare: contemporary reality is wholly virtual. Golub's paintings, however, clearly imply otherwise. While his figures are as placeless and anonymous as the subjects of news reports, they nonetheless assume insistently material form. In the hands of the painter, the transmitted image materializes, becomes flesh, and may engage us not as mass consumers but on more intimate ground. This final section discusses the work of painters who explore the intimate significance of the second order, mediated

reality of magazine images, popular culture and urban style. It focuses on the pictorial interplay between human flesh and the mechanized (or electronic or digital) image.

As with the last section, the artists to be considered are of diverse nationalities and different generations, for the issues involved have been of persisting and pervasive importance – as they had been earlier in the twentieth century. In representing human appearance at second or third hand, by way of photography and the mass-produced image, these artists touched on matters that Walter Benjamin had addressed, in two celebrated essays. In 1936, in 'The Work of Art in the Age of Mechanical Reproduction', Benjamin set out a concept of the 'aura', which he developed further three years later in an essay on Baudelaire, to define a distinctive quality in our perception of other persons: a special sense of distance, arising from the fact that only a person can return our gaze. In the 'Work of Art' essay, he had identified the aura with cult images; he had asserted that photography, by contrast with painting, abolishes auratic distance and brings its subjects close to the viewer. Benjamin's notion of the aura is complex and in some respects counter-intuitive (the capacity of others to return our gaze does not obviously imply distance, and photographs often make their subjects remote), but an interplay between distance and nearness might certainly be said to attend our perception of the human image in painting and photography. We have already seen how Chuck Close's pictorial portraiture sets in play a complex dialectic of distance and nearness, through a hybridizing of photography and painting.

In the early 1970s, another American photorealist, Audrey Flack (b. 1931), painted a series of *Macarenas* based on photographs of Spanish Baroque sculptures; she thereby linked together photography, painting and the cult image. The power of the religious image, as Flack shows us, depends on a *simultaneous* remoteness and immediacy: the painted sculpture is manifestly artificial and yet personally vivid for the worshipper. It comes close from a distance, image becoming flesh. Flack, having deliberately chosen a popular type of devotional image, uses her photorealist technique to redouble or reaffirm the original illusion, whereby the sculpture itself enacts a miracle in making the Virgin a living presence. The painting's illusionistic surface becomes, by association, miraculous. It grants our wishes.

Flack's work might usefully be compared with that of Cindy Sherman (b. 1954) who, during the 1980s, produced a series of photographs imitative of painting, some based on religious

images. Sherman herself appears as the model, with the aid of costume, prostheses and make-up; the effect is disturbing, so obtrusive and grotesque is the misalliance of the real and the fictitious – or the alliance of two false realities. Whereas Flack unifies the elements that constitute her image, in a compelling illusion, Sherman prevents any such synthesis occurring. Her practice is characteristic of a period during which the prevailing critical mood turned against painting, in favour of forms of deconstructive practice that invite viewers to decode what they see. As we have observed, painting itself often reflected – and even anticipated – this new critical spirit, from Pop art onwards. The mechanized image, as we have also seen, has often been used in painting to fragmenting and dissociative effect. In its cold and schizoid character, therefore, Sherman's work is characteristic of much visual art of the period.

Certain painters, however, might be seen as moving in a contrary direction within this general dispensation, by reinvesting the replicated image with humanity. Flack's *Macarena of Miracles* (1971) and her later Photorealist treatments of mass-produced kitsch are relevant examples. Flack had painted Social Realist paintings before her turn to Photorealism, and a sense of the

184. **Alice Neel**, *Andy Warhol*, 1970. A comment of Neel's suggests that Warhol chose to present himself in this way, revealing the scars from the operation following Valerie Solanas's attempt on his life, and the medical corset he had to wear. Neel's concise, unsparing style renders Warhol as a figure of ambivalent gender, with fleshy breasts. Despite exposing his body to view, Warhol maintains his customary self-containment; his eyes are closed, his pose self-contained.

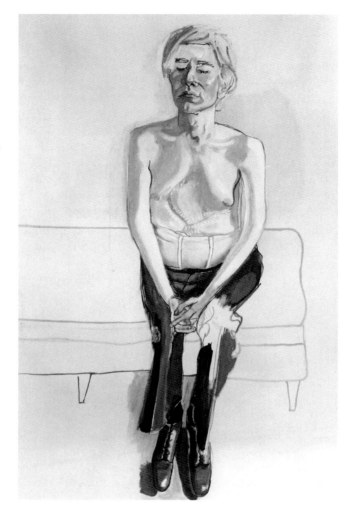

social communicativeness of mass imagery, its involvement in life, underlies her work. There is a parallel here with an older painter, Alice Neel (1900–84), who began a remarkable late career in the 1960s. Neel, a portraitist who had started painting in the era of American Social Realism, approached the theme of the shaping of the cool modern urban persona – the social image – from the ethical standpoint of the earlier period. Her caricatural method negotiates between physical being and social self, and her distinctiveness as a portraitist consists in addressing both these aspects of individuality simultaneously. Nowhere is the conjunction more telling than in her portrait of Andy Warhol, posed to reveal his wounded body; the most consciously artificial of men

appears as vulnerable flesh. Sherman, by contrast, disconcertingly equates the substance of her own (fictionalized) body with the lifeless materiality of the wax fruit she holds.

By comparison with Sherman's photograph, Neel's painting is relatively depthless, and in her flattened space she draws together the terms that Sherman obtrusively separates: image and body; modernist 'flatness' finds a humanist adaptation. Something similar could be said of paintings produced in the early 1960s by David Hockney (b. 1937), a member of the British Pop art generation. The works in question, made in Los Angeles on Hockney's arrival there from Britain as a young and newly successful artist, portray a wholly artificial environment in a version of cool modernist style. The nude male bathers that inhabit some of these settings are a degree less artificial: just solid enough to evoke bodily reality without breaking the spell of the fictional world. Hockney had in fact invented his pictorial Los Angeles before he went to live there in 1964. The year before, he had painted *Domestic Scene, Los Angeles*, which shows one man washing another in a shower, a picture based on images in a gay magazine published in Los Angeles; the title alludes to that fact (and to the incongruous domestic settings common in sex magazines). In Hockney's Los Angeles paintings, style carries an

185

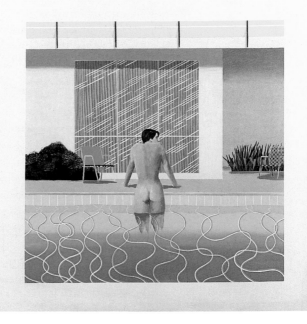

185. **David Hockney**, *Peter Getting out of Nick's Pool*, 1966. One of a series of swimming-pool subjects painted in Los Angeles, this typically combines modernist surface-conscious treatment with a depicted setting of pared modern design. An unpainted border emphasizes the artifice of paint. The 'real' and desired body is placed between two unlocatable reflective surfaces, in a painting that takes superficiality itself as its theme.

emotional implication; his artificial worlds reflect human reality and desire. At the same time, he has an unsuppressibly satirical eye, as does Neel. The conjunction or misalliance of self-image and bodily self has always offered material to visual satirists, and it is worth noting that Hockney based an early suite of etchings on *The Rake's Progress*, a famous satirical sequence by the eighteenth-century English painter William Hogarth.

To portray reality as paper-thin is a typical strategy of the satirist, and something of the satirist's detachment also informs the social scenes of the American painter Alex Katz (b. 1927). Yet, like Neel and Hockney, Katz, who was associated at the outset of his career in the 1950s with 'painterly perceptualists' such as Fairfield Porter and Larry Rivers, identifies with the milieu he depicts. In broad terms, his subject is modern civility, which found its first artistic expression in the 'company' paintings of Hals and Rembrandt. There, the world of social appearance is securely anchored in bodily being, held in place formally by the chiaroscuro, and morally by the evidence of social hierarchy. Katz's painted gatherings are less securely grounded, being rendered in a way that combines the aesthetic of American abstraction with the graphic idiom of billboards and fashion illustrations. The figures, which evidently belong wholly to the world of appearance and to the painted surface (Katz has at times painted metal cutout personages), hesitate between perfect poise and self-betrayal, as we may see in *The Cocktail Party* (1965).

186

The only wholly assured presences in Katz's paintings tend to be those of dancers (he designed for Paul Taylor's dance company), and of fashionably costumed beauties, particularly his wife Ada. In *The Red Smile* (1973), Ada's image occupies an area equal to a space that is painted in an unbroken red. A passage of red, a beautiful face, a fashionable hairstyle all let the gaze glide around and over, in an undisturbed transit. In *Blue Umbrella # 2* (1972), a vast image of Ada appears as if in passing view (*Passing* is the title of a famous self-portrait by Katz); sharply profiled against the blurred shapes beyond, she is as if momentarily held for vision, while gazing elsewhere. The painting is intended as a vision of unreachable beauty, a passing glimpse. Katz's paintings, whether showing grace or betraying unease, speak to our urban condition: we live among images and in some sense as images, theatrically.

187

To compare the world to a stage and society to a theatre are very ancient conceits, much favoured – again – by satirists. It is appropriate that both Hockney and Katz have been successful stage designers. However, their pictorial theatre is social and

186. **Alex Katz**, *The Cocktail Party*, 1965. This is one of two large paintings in which Katz first attempted multi-figure subjects. The problems he encountered started him on a fresh investigation of Baroque pictorial construction. The setting is Katz's studio. The neon signs are reversed, presumably to prevent their assuming undue significance. Always concerned with the representation of light, Katz here sets fluorescent-bleached hues against jet black.

187. **Alex Katz**, *Blue Umbrella # 2*, 1972. The huge scale (eight feet high) is characteristic of Katz's later work. He plans his paintings carefully, from preliminary drawing to full-scale cartoon, then paints rapidly and with assurance, completing the work while the oil paint remains wet. A dance-like action at theatrical scale achieves an interplay of soft and blended forms, strong contrasts and soft transitions.

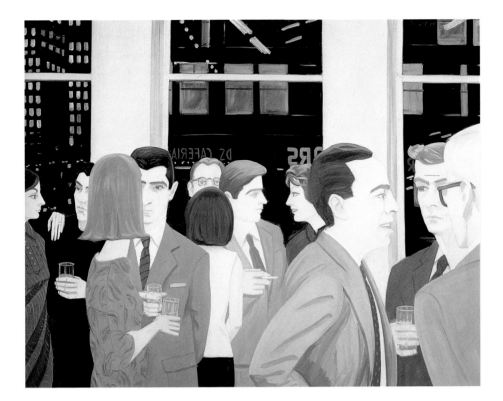

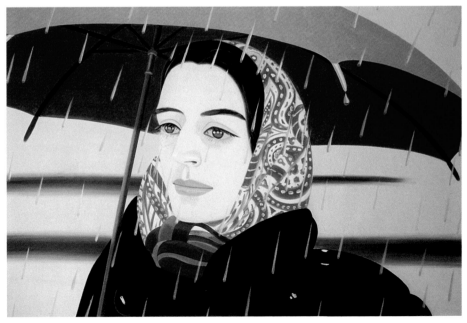

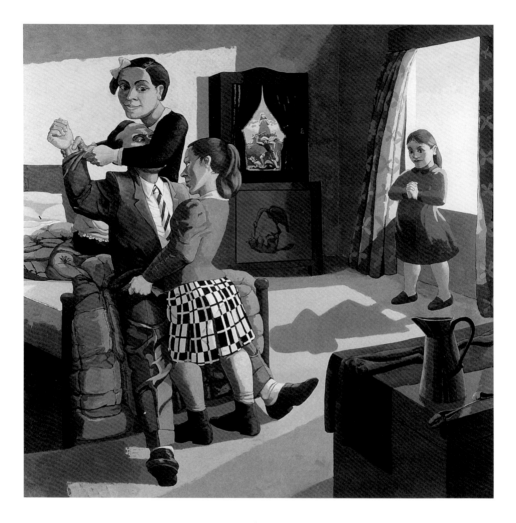

public; for interior and private drama, we must look to the work of Paula Rego (b. 1935). In the 1980s, Rego, a Portuguese-born painter who studied in England, painted psychologically suggestive scenes in stage-like settings, where Catholic religious imagery, children's book illustration, Goya and the cinema of the Spanish film director Luis Buñuel (satire again) mingle together: a miscegenation favoured by the culture of 'mechanical reproduction'. In Rego's pictorial theatre, the invested *persona*, or mask – the body as image – is an attribute of power; in *The Family* (1988), the male figure is obscured and his perceived powerlessness is associated with the concealment of his image.

188

188. **Paula Rego**, *The Family*, 1988. Rego's large narrative scenes of the late 1980s have the enigmatic hyper-reality of dreams, in which everything is meaningful and yet no meaning is certain. Here, acts of assistance have an air of murderous or sexual menace. Rego's painter husband, Victor Willing, who suffered from multiple sclerosis, died in 1988. The originally intended title was *The Raising of Lazarus*.

Rego's staging of the self is utterly different from Katz's, evoking emotions foreign to his tense, urbane social landscape. Where he refines character, she intensifies it; common to both, however, is the alliance of body and image – or the sense of identification with a role. (Their paintings also suggest cartoon strips and animated films – living images.) Psychologists have used the concept of the 'body image' to explain our involuntary and habitual patterning of posture and gesture – the social ballet captured in Katz's scenes of human interaction. There is an affinity with the social image of ourselves that we project or live up to. Both are as real to us as our bodies, inseparable from them; in each of us, they constitute a subtle body.

New technologies of imaging, as applied both in art and in science, have brought us new versions of the subtle body. Medical science monitors and images the body from its earliest stages, capturing it as a pulse, a system of pulses. The video artist Bill Viola has exploited the pulse-like and fluid properties of the television image, monitoring human life at its early and late stages. The British painter Mark Fairnington's (b. 1957) *First Baby* (1996) achieves a comparable intimacy, showing the tendency that Walter Benjamin, in the 1930s, attributed jointly to the surgeon and the camera: to come close, to look inside.

189

189. **Mark Fairnington**, *First Baby*, 1996. Fairnington here interprets the human subject equivalently to his small-scale treatments of insect life. He partially bleaches the image so that the infant, of unspecified gender, appears as wholly an appetite, its mouth the opening of a digestive tract.

In his long poem 'On the Nature of Things', the Roman poet Lucretius (*c.* 100–*c.* 55 BC) explains visual perception by proposing that all things give off fine films of their substance, which pass through the air and so through our eyes; even finer films may pass through the brain, causing dreams and imaginings. Lucretius's fantasy may serve as an allegory for our modern life among images, and for the operation of painters upon second-order reality. Here painting retains a certain advantage, even if it lacks the cultural prestige and centrality it once possessed. Painters may slow down and frame the passing images for longer and more intimate attention, portraying the subtle body in all its registers, from the emotional to the imaginary and the cultural. Equally, we might imagine the self as a subtle body, neither brittle and artificial nor heavily substantial: a fine film. The South African-born painter Marlene Dumas (b. 1953) has made the elusive and almost immaterial character of the photographic image the basis of her painting style, working from photographs and improvizing photographic faces. These multiple selves are more material than photographs, yet as light as condensed breath on a pane of glass. *The Painter* (1994), from a photograph of her daughter, evokes the primordial act of painting: with our bodies, we make something that looks back at us, a real image, of and from ourselves. Depicted as a fine film, the human image appears at once substantial and ephemeral, there, yet not-there: a new version of that alliance of the actual and the elusive that has haunted pictorial realism in its many historical incarnations.

190. **Marlene Dumas**, *Chlorosis*, 1994. Dumas's central subject is the human image, its guises and transformations. Her paintings refer to genres of photography, from the school group photo to images in pornographic magazines. Her painting technique restores malleability and softness to the image, relative to photography. Individuality and difference appear as variations in a common medium, a single skin.

191. **Marlene Dumas,** *The Painter*, 1994. The infant, thinly painted on a canvas two metres in height, is not only the creation but the reflection of the painter. The naked frontal pose, the shaded gaze, the paint-saturated hands, together afford a primordial image of the painter, and of painting's intimate relationship to bodily existence. The image invokes the long-standing association between art and infantile play, but abolishes any connotation of innocence.

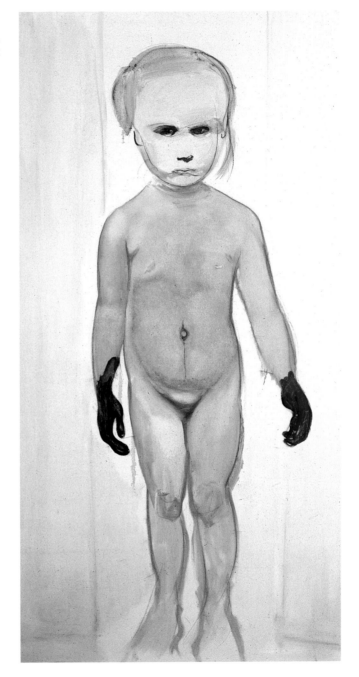

Select Bibliography

General

The nineteenth century is an unavoidable starting-point for considering twentieth-century realism, partly because, since the 1930s, influential critical protagonists of social and political realism have looked to nineteenth-century models. The renewed political radicalism of the 1960s and 1970s favoured further reconsideration of nineteenth-century realism; landmark publications were Linda Nochlin's *Realism*, London and New York, 1971, and two books by T. J. Clark – *Image of the People: Gustave Courbet and the 1848 Revolution*, London, 1973, and *The Absolute Bourgeois: Artists and Politics in France, 1848–1851*, London, 1973. Students of twentieth-century Social Realism have concentrated particularly on the interwar period (see below). Many new critical perspectives on the more inclusive topic of pictorial realism have emerged since the publication of E. H. Gombrich's *Art and Illusion* first published in 1960. Critical debate has been influenced not only by Gombrich but by semiotics, literary theory and feminist studies; see, for example, Norman Bryson, Michael Ann Holly and Keith Moxey, eds, *Visual Theory*, Oxford and Hanover, NH, 1991; Michael Fried, *Courbet's Realism*, London and Chicago, 1990; Griselda Pollock, *Vision and Difference: Femininity, Feminism and the Histories of Art*, London and New York, 1988. Some of Gombrich's themes have been reconsidered recently in Michael Baxandall, *Shadows and Enlightenment*, London and New York, 1995, Michael Podro, *Depiction*, London and New Haven, 1998, and Julian Bell, *What is Painting? Representation and Modern Art*, London and New York, 1999. Among the few general books on twentieth-century realism are a brief survey by James Malpas, *Realism*, London, 1997, and Edward Lucie-Smith, *American Realism*, London and New York, 1994, surveying art in the United States from the eighteenth century to the 1990s. Listed below are major monographs, catalogues and general works, together with some significant articles and important critical sources.

Chapter One
From the Nineteenth Century

Paul Hayes Tucker, ed., *Manet's 'Le Déjeuner sur l'herbe'*, Cambridge and New York, 1998.

Manet: 1832–1883, exh. cat., The Metropolitan Museum of Art, New York, 1983.

Lois Marie Fink, *American Art and the Nineteenth-Century Paris Salons*, Cambridge and Washington, D.C., 1990.

Michael Fried, *Realism, Writing, Disfiguration: on Thomas Eakins and Stephen Crane*, London and Chicago, 1987.

Lloyd Goodrich, *Thomas Eakins* (2 vols), London and Cambridge, MA, 1982.

Michael Hatt, 'Muscles, Morals, Mind: the Nude Body in Thomas Eakins' *Salutat*', in Kathleen Adler and Marcia Pointon, eds, *The Body Imaged: the Human Form and Visual Culture Since the Renaissance*, Cambridge and New York, 1992, pp. 57–69.

Elizabeth Johns, *Thomas Eakins: The Heroism of Modern Life*, Guildford and Princeton, 1983.

Susan Danby and Cheryl Leibold, eds, *Eakins and the Photograph: Works by Thomas Eakins and his Circle in the Collection of the Pennsylvania Academy of Fine Arts*, Washington, D.C., 1994.

Linda Nochlin, 'Issues of Gender in Cassatt and Eakins', in Stephen F. Eisenman, ed., *Nineteenth Century Art: A Critical History*, London and New York, 1994, pp. 255–72.

David M. Lubin, *Act of Portrayal: Eakins, Sargent, James*, London and New Haven, 1985.

Richard Ormond, *John Singer Sargent: Complete Paintings, Vol. 1, The Early Portraits*, London and New Haven, 1998.

Elaine Kilmurray and Richard Ormond, eds, *John Singer Sargent*, exh. cat., Tate Gallery, London, 1998.

The Social Fabric (The Ashcan School)

Doreen Bolger and Nicolai Cikovsky, Jr, eds, *American Art Around 1900*, National Gallery of Art, Washington, D.C., 1990.

Elizabeth Milroy and Gwendolyn Owens, *Painters of a New Century: The Eight and American Art*, Milwaukee, 1991.

Bernard S. Perlman, *The Immortal Eight: American Painting from Eakins to the Armory Show 1870–1913*, Westport, CT, 1979.

Marianne Doezema, *George Bellows and Urban America*, London and New Haven, 1992.

Rowland Elzea and Elizabeth Hawkes, *John Sloan's Oil Paintings: a Catalogue Raisonné* (2 vols), London and Newark, DE, 1992.

John Loughery, *John Sloan, Painter and Rebel*, New York, 1995.

Bruce Robertson, *Reckoning with Winslow Homer: his Late Paintings and their Influence*, Cleveland, 1990.

Jacob Riis, *How the Other Half Lives*, New York, 1890.

The Subjective and the Counterfeit

Les Nabis 1888–1900, Grand Palais, Paris, 1993.

Timothy Hyman, *Bonnard*, London and New York, 1998.

Nicholas Watkins, *Bonnard*, London, 1994.

Bonnard, exh. cat., Tate Gallery, London, 1998.

Belinda Thomson, *Vuillard*, London, 1991.

Wendy Baron, *The Camden Town Group*, London, 1979.

———, and Richard Shone, eds, *Sickert*, exh. cat., Royal Academy of Arts, London, 1992.

Alicia Foster, *Gwen John*, London and Princeton, 1999.

Cecily Langdale, *Gwen John: with a Catalogue Raisonné of the Paintings and a Selection of the Drawings*, London and New Haven, 1987.

Corporeality:

Nancy Mowll Matthews, *Mary Cassatt*, New York, 1989.

———, *Mary Cassatt: a Life*, New York, 1994.

Griselda Pollock, *Mary Cassatt*, London and New York, 1980.

———, *Mary Cassatt, Painter of Modern Women*, London and New York, 1998.

Gill Perry, *Paula Modersohn-Becker*, London, 1979.

Günter Busch and Wolfgang Werner, *Paula Modersohn-Becker, Werverzeichnis der Gemälde* (2 vols), Munich, 1998.

Peter-Klaus Schuster, Christoph Vitali and Barbara Butts, *Lovis Corinth*, exh. cat., Tate Gallery, London, 1997.

Sharon L. Hirsh, *Ferdinand Hodler*, London and New York, 1982.

Jane Kallir, *Egon Schiele: the Complete Works*, London and New York, 1990.

Vienne 1880–1938: l'Apocalypse Joyeuse, exh. cat., Centre Georges Pompidou, Paris, 1986.

Christine Poggi, *In Defiance of Painting: Cubism, Futurism and the Invention of Collage*, London and New Haven, 1992.

Chapter 2
General

Les Réalismes, 1919–1939, exh. cat., Centre Georges Pompidou, Paris, 1981.

Briony Fer, David Batchelor and Paul Wood, *Realism, Rationalism, Surrealism; Art between the Wars*, London and New Haven, 1993.

Charles Harrison, Paul Wood, eds, *Art in Theory 1900–1990; an Anthology of Changing Ideas*, London, 1992: Sections IVB, 'Realism as Figuration' and IVC, 'Realism as Critique'.

Suspended Reality (Inter-War Neo-Classicism and New Objectivity)

Walter Benjamin, *Illuminations*, ed. Hannah Arendt, tr. Harry Zohn, London, 1979.

———, 'The Author as Producer', tr. Anya Bostock in Walter Benjamin, *Understanding Brecht*, London, 1983.

Elizabeth Cowling and Jennifer Mundy, *On Classic Ground; Picasso, Léger, de Chirico and the New Classicism, 1910–1930*, exh. cat., Tate Gallery, London, 1990.

Romy Golan, *Modernity and Nostalgia; Art and Politics in France Between the Wars*, London and New York, 1995.

Christopher Green, *Cubism and its Enemies: Modern Movements and Realism in French Art, 1916–1928*, London and New Haven, 1987.

Anton Kass, Martin Jay and Edward Dimandberg, eds, *The Weimar Republic Source Book*, London, 1994.

Neue Sachlichkeit and German Realism of the Twenties, exh. cat., Hayward Gallery, London, 1978.

Kenneth E. Silver, *Esprit de Corps. The Art of the Parisian Avant-Garde and the First World War 1914–1925*, London and Princeton, 1989.

Ronald Taylor, ed., *Aesthetics and Politics*, London, 1977.

John Willett, *The New Sobriety: Art and Politics in the Weimar Period 1917–33*, London, 1978.

André Derain, le Peintre du 'trouble moderne', exh. cat., Musée d'art Moderne de la Ville de Paris, Paris, 1994.

William Rubin, Wieland Schmied and Jean Clair, *Giorgio de Chirico*, exh. cat., Centre Georges Pompidou, Paris, 1982.

Massimo Carrà, *Metaphysical Art* (with Patrick Waldberg and Ewald Rathke; writings by Carrà and de Chirico); tr. and foreword by Caroline Tisdall, New York, 1971.

Maria Mimita Lamberti and Paolo Fosiati, *Felice Casorati 1883–1963*, Turin, 1985.

Giorgio Morandi, 1890–1964, Accademia Italiana, London, 1989.

Michael Raeburn, ed., text by Ian Gibson et al., *Salvador Dali: the Early Years*, exh. cat., South Bank Centre, London, 1994.

Frank Whitford, ed., *The Berlin of George Grosz. Drawings, Watercolours and Prints 1912–1930*, exh. cat., Royal Academy of Arts, London, 1997.

Beth Irwin Lewis, *George Grosz, Art and Politics in the Weimar Republic*, Princeton, 1971.

George Grosz, tr. Arnold J. Pomerans, *A Little Yes and a Big No*, London, 1982.

———, and Wieland Herzfelde, 'Art is in Danger', tr. Gabriele Bennet, in Lucy Lippard, ed., *Dadas on Art*, New Jersey, 1971.

Matthias Eberle, *World War 1 and the Weimar Artists. Dix, Grosz, Beckmann, Schlemmer*, London and New Haven, 1985.

Carla Schulz-Hoffmann and Judith C. Weiss, eds, *Max Beckmann: Retrospective*, London and St Louis, 1984.

Sabine Rewald, *Balthus*, exh. cat., The Metropolitan Museum of Art, New York, 1984.

Nicholas Fox Weber, *Balthus, a Biography*, London and New York, 1999.

Karen Lucic, *Charles Sheeler and the Cult of the Machine*, London and Cambridge, MA, 1991.

Carol Troyen and Erica E. Hirshler, *Charles Sheeler: Paintings and Drawings*, exh. cat., Museum of Fine Arts, Boston, 1987.

Mary Jane Jacob and Linda Downs, *The Rouge: The Image of Industry in the Art of Charles Sheeler and Diego Rivera*, Detroit Institute of Art, Detroit, 1978.

Gail Levin, *Edward Hopper, the Art and the Artist*, London and New York, 1980.

———, *Edward Hopper, an Intimate Biography*, London and Berkeley, 1995.

Human Reality – the Personal and the Political

Fiona McCarthy, *Stanley Spencer, an English Vision*, New Haven, 1997.

Duncan Robinson, *Stanley Spencer at Burghclere*, The National Trust, London, 1991.

Otto Dix, 1891–1969, exh. cat., Tate Gallery, London, 1992.

Dora Apel, '"Heroes" and "Whores": the Politics of Gender in Weimar Antiwar Imagery', *Art Bulletin*, September 1997, pp. 366–84.

Julian Freeman, 'Professor Tonks: War Artist', *Burlington Magazine*, Vol. 127, May 1985, pp. 284–93.

Peter Junk and Wendelin Zimmer, *Felix Nussbaum, Leben und Werk*, Cologne, 1982.

Jonathan Harris, *Federal Art and National Culture; the Politics of Identity in New Deal America*, Cambridge, 1995.

Andrew Hemingway, 'Critical Realism in the History of American Art', in Deborah L. Madsen, ed., *Visions of America Since 1492*, London and New York, 1994, pp. 111–44.

——— and others, articles on Meyer Schapiro in special issue of *The Oxford Art Journal*, 17: 1, 1994.

Patricia Hills, *Social Concern and Urban Realism: American Painting of the 1930s*, Boston, 1983.

Francis V. O'Connor, *The New Deal Art Projects, an Anthology of Memoirs*, Washington, D.C., 1972.

———, ed., *Art for the Millions, Essays from the 1930s by Artists and Administrators of the WPA Federal Art Project*, Boston, 1973.

Madeleine Park and Gerald E. Markowitz, *New Deal for Art. The Government Projects of the 1930s with Examples from New York City State*, New York, 1977.

Rhapsodies in Black: Art of the Harlem Renaissance, exh. cat., Hayward Gallery, London, 1997.

David Schapiro, ed. and intro., *Social Realism: Art as a Weapon*, New York, 1973.

Wanda M. Corn, 'The Birth of a National Icon: Grant Wood's *American Gothic*', in Marianne Doezema and Elizabeth Milroy, eds, *Reading American Art*, New Haven, 1998, p. 387ff.

Ellen Wiley Todd, 'The Question of Difference: Isabel Bishop's Deferential Office Girls', in Doezema and Milroy, *Ibid.*, p. 409ff.

John I. H. Baur, *Philip Evergood*, New York, 1975.

Kendall Taylor, *Philip Evergood: Never Separate from the Heart*, London and Lewisburg, PA, 1987.

John D. Morse, ed., *Ben Shahn*, London and New York, 1972.

Ellen Hakins Wheat, with a contribution by Patricia Hills, *Jacob Lawrence, American Painter*, Seattle, 1986.

Social Reality, Public Space and Collective Identity

Erica Doss, *Benton, Pollock and the Politics of Modernism: From Regionalism to Abstract Expressionism*, Chicago, 1991.

Dawn Ades, *Art in Latin America; the Modern Era, 1820–1980*, exh. cat., South Bank Centre, London and New Haven, 1989.

Leonard Folgarait, *Mural Painting and Social Revolution in Mexico, 1920–1940; Art of the New Order*, Cambridge and New York, 1998.

Lawrence D. Hurlburt, *The Mexican Muralists in the United States*, Albuquerque, 1989.

Desmond Rochfort, *Mexican Muralists*, London, 1993.

Dawn Ades et al., *Art and Power; Europe under the Dictators 1930–45*, exh. cat., Hayward Gallery, London, 1996.

Matthew Cullerne Bown, *Socialist Realist Painting*, London and New Haven, 1998.

———, *Art Under Stalin*, Oxford and New York, 1991.

———, Brandon Taylor, eds, *Art of the Soviets; Painting, Sculpture and Architecture in a One-Party State, 1917–1993*, Manchester and New York, 1993.

Alla Efimova, 'To Touch on the Raw; the Aesthetic Affections of Socialist Realism', *Art Journal*, Spring 1997, pp. 72–79.

Igor Golomstock, *Totalitarian Art*, New York, 1990.

Boris Groys, *The Total Art of Stalinism: Avant-Garde Aesthetic Dictatorship, and Beyond*, tr. Charles Rougle, Oxford and Princeton, 1992.

C. Vaughan James, *Soviet Socialist Realism*, London, 1973.

Régine Rolin, *Socialist Realism: an Impossible Aesthetic*, Stanford, 1992.

Brandon Taylor, *Art and Literature under the Bolsheviks* (2 vols), London, 1991 and 1992.

Elizabeth Valkenier, *Russian Realist Art: the State and Society; the Peredvizhniki and their Tradition*, exh. cat., Ann Arbor, 1977.

———, *The Wanderers, Masters of 19th Century Russian Painting*, Fort Worth, 1990.

Peter Adam, *The Arts of the Third Reich*, London and New York, 1992.

Mortimer G. Davidson, *Kunst in Deutschland, 1933–1945* (3 vols), Tübingen, 1988, 1991 and 1992.

Bertold Hinz, *Art in the Third Reich*, Oxford, 1980.

Brandon Taylor, Wilfried van der Will, eds, *The Nazification of Art; Art, Design, Music, Architecture and Film in the Third Reich*, Winchester, 1990.

Helen Graham and Paul Preston, eds, *The Popular Front in Europe*, London, 1987.

Fernand Léger: the Later Years, exh. cat., Whitechapel Gallery, London, 1987. (See in particular Sarah Wilson, 'Fernand Léger, Art and Politics 1935–1955'.)

Peter de Francia, *Fernand Léger*, London and New Haven, 1983.

Chapter 3
General

Aftermath: France 1945–54: New Images of Man, exh. cat., Barbican Gallery, London, 1982.

Michèle C. Cone, *Artists under Vichy. A Case of Prejudice and Persecution*, Princeton, 1992.

Laurence Bertrand-Dorléac, 'L'Art en France pendant l'Occupation', three articles, in *Beaux-Arts Magazine*, nos 132, 133 and 135, March, April and June 1995.

Brian Foss, 'Message and Medium: Government Patronage, National Identity and National Culture in Britain, 1939–45', in *The Oxford Art Journal*, 14:2 1991, pp. 52–72.

Serge Guilbaut, *How New York Stole the Idea of Modern Art: Abstract Expressionism, Freedom and the Cold War*, London and Chicago, 1983.

Francis Frascina, 'The Politics of Representation', in Paul Wood et al., *Modernism in Dispute; Art since the Forties*, London and New Haven, 1993, pp. 77–169.

Margaret Garlake, *New Art, New World. British Art in Postwar Society*, London and New Haven, 1998.

Max Harris et al., *Angry Penguins and Realist Painting in Melbourne in the 1940s*, exh. cat., South Bank Centre, London, 1988.

Christopher Allen, *Art in Australia, from Colonization to Postmodernism*, London and New York, 1997.

Herbert R. Lottmann, *The Left Bank: Writers, Artists and Politics, from the Popular Front to the Cold War*, London, 1982.

Ann Massey, *The Independent Group: Modernism and Mass Culture in Britain 1945–59*, Manchester, 1995.

Francis Morris, ed., with essays by David Mellor and Sarah Wilson, *Paris Post-War, Art and Existentialism 1943–55*, exh. cat., Tate Gallery, London, 1993.

Paris-Paris, Créations en France 1937–1957, exh. cat., Centre Georges Pompidou, Paris, 1981.

Julian Spalding, *The Forgotten Fifties*, exh. cat., Sheffield City Art Galleries, 1984.

Tim Wilcox, ed., *The Pursuit of the Real. British Figurative Painting from Sickert to Bacon*, with essays by Andrew Causey, Lynda Checketts and Michael Peppiatt, Manchester City Art Galleries, 1990.

Relevant contemporary publications include

John Berger, *A Painter of our Time*, London, 1958 and 1976.

———, *Permanent Red*, London, 1960.

Clement Greenberg, *Art and Culture*, Boston, 1961.

Georg Lukács, tr. John and Necke Mander, *The Meaning of Contemporary Realism*, London, 1963 (first published Budapest, 1957).

Martin Heidegger, 'The Origin of the Work of Art', in *Poetry, Language, Thought*, tr. Albert Hofstadter, New York, 1971 (published in German in 1950; first version a lecture given in 1935).

Maurice Merleau-Ponty, 'Cézanne's Doubt', in *Sense and Non-Sense*, tr. Hubert L. Dreyfus and Patricia Allen Dreyfus, Evanston, 1964 (Paris, 1948).

Simone de Beauvoir, *The Second Sex*, tr. H. M. Parshley, London, 1953 (Paris, 1949).

Antonin Artaud, 'Van Gogh, the Man Suicided by Society', tr. Helen Weaver, in Susan Sontag, ed., *Antonin Artaud: Selected Writings*, Los Angeles, 1976–88 (Paris, 1947).

Georges Bataille, *Lascaux, or the Birth of Art: Prehistoric Painting*, tr. Austryn Wainhouse, Lausanne, 1955.

Alberto Giacometti, *Ecrits*, eds Michel Leiris and Jacques Dupin, Paris, 1992.

Jean-Paul Sartre, 'The Search for the Absolute', in *Giacometti*, exh. cat., Pierre Matisse Gallery, New York, 1948.

———, 'Giacometti in Search of Space', *Art News* 54, no. 5 (Sept 1955), pp. 26–29, 63–65 (published in French, 1954).

David Sylvester, *About Modern Art: Critical Essays, 1948–96*, London, 1996 (reprints essays from the period).

New Images of Man, exh. cat., Museum of Modern Art, New York, 1959; catalogue by Peter Selz, with essay by Paul Tillich.

See also: Charles Harrison and Paul Wood, eds, *Art in Theory 1900–1990*, London, 1992, sections VB and VC, pp. 587–679.

Literature on individual artists includes

Guttuso, exh. cat., Whitechapel Gallery, London, 1996; essays by Maurizio Calvesi, Sarah Whitfield, James Hyman and Massimo Onofri.

Henri-Claude Cousseau et al., *Jean Hélion*, exh. cat., Tate Gallery, Liverpool, 1990.

Hélion; peintures et dessins 1925–1983, Musée d'Art Moderne de la Ville de Paris, 1984.

Raymond Perrot, *Esthétique de Fougeron*, Paris, 1996.

Stephen Barber, *Antonin Artaud, Blows and Bombs*, London, 1993.

Yves Bonnefoy, *Alberto Giacometti, a Biography of his Work*, tr. Jean Stewart, Paris, 1991.

Valerie Fletcher, *Alberto Giacometti*, exh. cat., Hirshhorn Museum, Washington, D.C., 1988.

Toni Stoos and Patrick Elliott, *Alberto Giacometti 1901–1966*, exh. cat., Royal Academy of Arts, London, 1996.

David Sylvester, *Looking at Giacometti*, London, 1994.

James Lord, *Giacometti: a Biography*, London and New York, 1985.

Fernand Léger, Grand Palais, Paris, 1971, illustrates the *Les Constructeurs* series and related studies (see also Léger entries for Chapter two).

Richard Cork, *David Bomberg*, London and New Haven, 1987.

Lawrence Gowing and David Sylvester, *The Paintings of William Coldstream 1908–1987*, exh. cat., Tate Gallery, London, 1990.

Peter de Francia: Paintings and Drawings 1959–1977, exh. cat., Camden Arts Centre, London, 1977.

Peter de Francia, *Peter de Francia: Painter and Professor*, London, 1987.

Janet Dunbar, *Laura Knight*, London, 1975.

Caroline Fox, *Dame Laura Knight*, Oxford, 1988.

Richard Morphet, *Meredith Frampton*, exh. cat., Tate Gallery, London, 1982.

John T. Spike, *Fairfield Porter: An American Classic*, New York, 1992.

Wanda M. Corn, *The Art of Andrew Wyeth*, with contributions by Brian O'Doherty, Richard Meryman and E. P. Richardson, San Francisco, 1973.

(For Bacon and Freud, see Chapter four entries)

Chapter 4
Reframing Reality:
Realism in the Era of Pop Art

Jacques Derrida, *The Truth in Painting*, tr. G. Bennington and I. McLeod, Chicago, 1987.

Meyer Schapiro, 'The Still-life as Personal Object – a Note on Heidegger and van Gogh' (1968), reprinted in Schapiro, *Theory and Philosophy of Art: Style, Artist and Society*, New York, 1994, pp. 135–42, with 'Further Notes on Heidegger and van Gogh', pp. 143–51.

Lucy Lippard, *Pop Art*, London, 1966.

Michael Crichton, *Jasper Johns*, London and New York, 1977.

Fred Orton, *Figuring Jasper Johns*, London and Cambridge, MA, 1994.

1960 Le Nouveau réalisme, intro. Pierre Restany, Musée d'Art Moderne de la Ville de Paris, Paris, 1986.

Kynaston McShine, ed., *Andy Warhol: a Retrospective*, exh. cat., New York, 1989, pp. 39–57.

Rainer Crone, *Andy Warhol*, tr. J. W. Gabriel, London, 1970.

Thomas Crow, 'Saturday Disasters: Trace and Reference in Early Warhol', in Crow, *Modern Art in the Common Culture*, London and New Haven, 1996.

Hal Foster, *The Return of the Real*, London and Cambridge, MA, 1996.

Alan Pratt, ed., *The Critical Response to Andy Warhol*, London and Westport, CT, 1997.

Carter Ratcliff, *Andy Warhol*, New York, 1983.

Gerhard Richter, *Gerhard Richter: Daily Practice of Painting – Writings 1962–1993*, ed. Hans-Ulrich Obrist, London and Cambridge, MA, 1995.

Gerhard Richter, exh. cat., Tate Gallery, London, 1991.

Benjamin Buchloh, 'Divided Memory and Post-Traditional Identity: Gerhard Richter's Work of Mourning', *October* 75, Winter 1996, pp. 61–82.

Pierre Gaudibert and Alain Jouffroy, *Monory*, Paris, 1972.

Jean-François Lyotard, *The Assassination of Experience by Painting – Monory*, tr. Rachel Bowlby; ed. with intro. by Sarah Wilson, London, 1998.

Light and Matter

Gregory Battcock, *Super-Realism: a Critical Anthology*, Oxford and New York, 1979.

Frank H. Goodyear, Jr, *Contemporary American Realism since 1960*, Boston, 1982.

Louis K. Meisel, *Photorealism*, New York, 1980.

Russell Bowman, *Philip Pearlstein, the Complete Paintings*, London and New York, 1983.

John Perrault, *Philip Pearlstein: Drawings and Watercolours*, New York, 1988.

Jerome Viola, *The Painting and Teaching of Philip Pearlstein*, New York, 1982.

Richard Estes: the Urban Landscape, exh. cat., Museum of Fine Arts, Boston, 1978; essay by John Canaday.

Louis K. Meisel, *Richard Estes: The Complete Paintings 1966–1985*, New York, 1986.

Karen Tsujimoto, *Wayne Thiebaud*, London and Seattle, 1985.

Lisa Lyons and Robert Storr, *Chuck Close*, New York, 1987.

Robert Storr, with essays by Kirk Varnedoe and Deborah Wye, *Chuck Close*, exh. cat., Museum of Modern Art, New York, 1998.

Richard Shiff, 'Closeness', in *Postcards on Photography: Photorealism and the Reproduction*, exh. cat., ed. Naomi Salaman and Ronnie Simpson, Cambridge Darkroom Gallery, Cambridge, 1998.

Robert Storr, *Robert Ryman*, exh. cat., Tate Gallery, London, 1993.

James Lingwood, ed., *Vija Celmins*, ICA, London, 1996.

William S. Bartman, ed., *Vija Celmins*, with interview by Chuck Close, New York, 1992.

Embedded Matter

Lucian Freud: Recent Work, exh. cat. with essay by Catherine Lampert, Whitechapel Gallery, London, 1993.

Lucian Freud Paintings, exh. cat. with essay by Robert Hughes, British Council, London, 1987.

Andrew Benjamin, 'Betraying Faces: Lucian Freud's Self-Portraits', in Benjamin, *Art, Mimesis and the Avant-Garde*, London and New York, 1991.

Lawrence Gowing, *Lucian Freud*, London and New York, 1982.

Francis Bacon, exh. cat., Centre Georges Pompidou, Paris, 1996. (Essays by David Sylvester and others, with an anthology of criticism and an extensive bibliography.)

Dawn Ades and Andrew Forge, *Francis Bacon*, exh. cat., Tate Gallery, London, 1985.

Ernst van Alphen, *Francis Bacon and the Loss of Self*, London, 1992.

Michel Archimbaud, *Francis Bacon in Conversation with Michel Archimbaud*, London, 1993.

Hugh Davies and Sally Yard, *Francis Bacon*, New York, 1986.

Gilles Deleuze, *Francis Bacon: Logique de la sensation*, Paris, 1984.

Daniel Farson, *The Gilded Gutter Life of Francis Bacon*, London and New York, 1993.

Matthew Gale, *Francis Bacon: Working on Paper*, Tate Gallery, London, 1999.

Michel Leiris, *Francis Bacon, Full Face and In Profile*, London and New York, 1983.

Michael Peppiatt, *Francis Bacon, Anatomy of an Enigma*, London and New York, 1996.

John Russell, *Francis Bacon*, rev. edn, London and New York, 1993.

David Sylvester, *Interviews with Francis Bacon*, rev. edn, London, 1993.

Robert Hughes, *Frank Auerbach*, London and New York, 1990.

Paul Moorhouse, *Leon Kossoff*, exh. cat., Tate Gallery, London, 1996.

Critical Realism and the Critique of Realism

Arthur C. Danto, *Mark Tansey: Visions and Revisions*, New York, 1992.

Judi Freeman, *Mark Tansey*, exh. cat., with contributions by Alain Robbe-Grillet and Mark Tansey, Los Angeles County Museum of Art, 1993.

Art & Language, 'Portrait of V.I. Lenin', in Charles Harrison and Fred Orton, eds, *Modernism, Criticism, Realism*, London and San Francisco, 1984, pp. 145–69.

Art & Language, 'Art & Language Paints a Picture', in Charles Harrison and Paul Wood, *Art in Theory 1900–1990*, London and Cambridge, MA, 1993, pp. 1018–28.

Charles Harrison, *Essays on Art & Language*, Oxford, 1991.

Gerhard Richter: 18 Oktober 1977, ICA, London, 1989.

David Elliott, *Tradition and Renewal: Contemporary Art in the German Democratic Republic*, exh. cat., Museum of Modern Art, Oxford, 1984.

Jon Bird, 'Infuitabile fatum: Leon Golub's History Painting', *The Oxford Art Journal*, 20: 1, 1997, pp. 81–94.

Leon Golub: Mercenaries and Interrogators, exh. cat., ICA, London, 1982; with interview by Michael Newman and essay by Jon Bird.

Donald Kuspit, *Leon Golub: Existential Activist Painter*, New Brunswick, NJ, 1985.

Flesh and Image

Thalia Gouma-Peterson, *Breaking the Rules: Audrey Flack, a Retrospective 1950–1990*, New York, 1992.

Cindy Sherman History Portraits, essay by Arthur C. Danto, New York, 1991.

Rosalind Krauss, with essay by Norman Bryson, *Cindy Sherman 1975–1993*, New York, 1993.

Patricia Hills, *Alice Neel*, New York, 1983.

David Hockney: a Retrospective, exh. cat., Los Angeles County Museum of Art, 1988.

David Hockney: Paintings, Prints and Drawings, 1960–1970, exh. cat., Whitechapel Gallery, London, 1970; intro. Mark Glazebrook.

David Hockney, Nikos Stangos, ed., *David Hockney*, London, 1976.

Marco Livingstone, *David Hockney*, London and New York, 1981.

Alex Katz: Twenty Five Years of Painting, From the Saatchi Collection, intro. and interview David Sylvester, commentaries Merlin James.

Vincent Katz, ed., *Invented Symbols*, Ostfildern-Ruit, 1997. (Vol. 2 of series 'Positions in Modern Art', Museum für Moderne Kunst, Frankfurt am Main; in German and English.)

Irving Sandler, *Alex Katz: a Retrospective*, New York, 1998.

John McEwen, *Paula Rego*, London and New York, 1992.

Marlene Dumas, London, 1999; with contributions by the artist and by Barbara Bloom, Dominic van den Boogerd and Mariuccia Casadio.

Ernst van Alphen, 'The Portrait's Dispersal: Concepts of Representation and Subjectivity in Contemporary Portraiture', in Joanna Woodall, ed., *Portraiture: Facing the Subject*, Manchester and New York, 1997, pp. 239–56.

List of Illustrations

Measurements are in centimetres, followed by inches, height before width before depth

Frontispiece: Richard Estes, *Escalator*, 1970. © Richard Estes, courtesy, Marlborough Gallery, New York; **1** René Magritte, *Euclidean Walks*, 1955. Oil on canvas 162.5 × 130 (64 × 51¼). The Minneapolis Institute of Fine Arts. © ADAGP, Paris and DACS, London 2000; **2** Henri Matisse, *Male Model*, 1900. Oil on canvas 99.3 × 72.7 (39⅛ × 28⅝). Museum of Modern Art, New York, Purchase. © Succession H Matisse/DACS 2000; **3** George Bellows, *Shore House*, 1911. Oil on canvas 101.6 × 106.7 (40 × 42). Private collection; **4** Edouard Manet, *Le Déjeuner sur l'herbe*, 1863. Oil on canvas 208 × 264 (81⅞ × 103¾). Musée d'Orsay, Paris; **5** Thomas Eakins, *The Gross Clinic*, 1875. Oil on canvas 243.8 × 198.1 (96 × 78). Jefferson Medical College of Jefferson University, Philadelphia ; **6** John Singer Sargent, *Ena and Betty, Daughters of Mr and Mrs Asher Wertheimer*, 1901. Oil on canvas 185.4 × 130.8 (73 × 51½). Tate Gallery, London; **7** Thomas Eakins, *The Thinker, Portrait of Louis N. Kenton*, 1900. Oil on canvas 213.4 × 106.7 (84 × 42). The Metropolitan Museum of Art, New York. Kennedy Fund, 1917; **8** Thomas Eakins, *William Rush Carving his Allegorical Figure of the Schuylkill River*, 1908. Oil on canvas 92.5 × 123 (36⅜ × 48⅜). The Brooklyn Museum of Art, New York. Dick S. Ramsay Fund 39.461; **9** Paul Cézanne, *Standing Female Nude*, 1898–99. Oil on canvas 92.7 × 71.1 (36½ × 28). Private collection; **10** William Adolphe Bouguereau, *Birth of Venus*, 1879. Oil on canvas 300 × 218 (118¼ × 85¾). Musée d'Orsay, Paris. Photo © RMN; **11** Diego Velázquez, *Fable of Arachne ('The Spinners')*, c. 1657. Oil on canvas 220 × 289 (86⅝ × 135½). Museo del Prado, Madrid; **12** Gustave Courbet, *The Painter's Studio. A Real Allegory Determining a Phase of Seven Years in my Artistic Life*, 1854–55. Oil on canvas 361 × 598 (142⅛ × 235½). Musée d'Orsay, Paris; **13** George Bellows, *Both Members of this Club*, 1909. Oil on canvas 115 × 160.5 (45¼ × 63¼). National Gallery of Art, Washington, D.C. Chester Dale Collection; **14** George Bellows, *The Cliff Dwellers*, 1913. Oil on canvas 100.3 × 105.3 (39½ × 41⅛). © 1993 Museum Associates, Los Angeles County Museum of Art. All Rights Reserved. Los Angeles County Funds; **15** Jacob Riis, *Coffee at One Cent, from How the Other Half Lives*, 1890; **16** John Sloan, *The Haymarket*, 1907. Oil on canvas 66.6 × 81.4 (26¼ × 32⅒). The Brooklyn Museum of Art, New York. Gift of Mrs Harry Payne Whitney; **17** Winslow Homer, *Right and Left*, 1909. Oil on canvas 71.8 × 122.9 (28¼ × 48⅜). National Gallery of Art,

Washington, D.C. Gift of the Avalon Foundation; **18** Rockwell Kent, *Toilers of the Sea*, 1907. Oil on canvas 96.5 × 111.8 (38 × 44). From the Collection of the New Britain Museum of American Art, New Britain, Connecticut. Charles F. Smith Fund. Photo Michael Agee; **19** George Bellows, *Blue Morning*, 1909. Oil on canvas 80.3 × 112 (31⅝ × 43¾). National Gallery of Art, Washington, D.C. Chester Dale Collection; **20** Sir Lawrence Alma-Tadema, *A Favourite Custom*, 1909. Oil on wood 58 × 45 (23 × 17¾). Leighton House, London; **21** Edouard Manet, *The Railway*, 1873. Oil on canvas 93.3 × 111.5 (36¾ × 45⅛). National Gallery of Art, Washington, D.C. Gift of Horace Havemeyer in memory of his mother, Louisine W. Havemeyer; **22** Edouard Vuillard, *Misia at Villeneuve-sur-Yonne*, 1897–99. Oil on canvas 42 × 62 (16½ × 24½). Musée des Beaux-Arts, Lyon. Photo Studio Bassett. © ADAGP, Paris and DACS, London 2000; **23** Edouard Vuillard, *La Femme qui balaie (Woman Sweeping)*, 1899–1900. Oil on cardboard 44.1 × 47.3 (17⅜ × 18⅝). The Phillips Collection, Washington, D.C. © ADAGP, Paris and DACS, London 2000; **24** Félix Vallotton, *La Chambre rouge (The Red Room)*, 1898. Gouache on cardboard 49 × 67.5 (19¼ × 26½). Musée Cantonal des Beaux-Arts, Lausanne; **25** Pierre Bonnard, *Man and Woman*, 1900. Oil on canvas 115 × 72.5 (45¼ × 28½). Musée d'Orsay, Paris. © ADAGP, Paris and DACS, London 2000; **26** Félix Vallotton, *Le Bon marché*, 1898. Oil on cardboard 70 × 200 (27½ × 78¾). Private collection; **27** Frederick Spencer Gore, *Gauguins and Connoisseurs at the Stafford Gallery*, 1911–12. Oil on canvas 84 × 72 (33 × 28⅜). Private collection; **28** Walter Sickert, *Noctes Ambrosianae*, 1908. Oil on canvas 63.5 × 76.2 (25 × 30). Nottingham Museums, Castle Museum and Art Gallery. © Estate of Walter Richard Sickert 2000. All rights reserved. Photo The Bridgeman Art Library, London; **29** Everett Shinn, *London Hippodrome*, 1902. Oil on canvas 67 × 89.5 (26⅜ × 35¼). The Art Institute of Chicago. Friends of the American Art Collection, the Goodman Fund, 1928.197. Photograph © 2000, The Art Institute of Chicago. All Rights Reserved; **30** Mary Cassatt, *Woman in Black at the Opera*, 1880. Oil on canvas 80 × 64.7 (31½ × 25½). Courtesy Museum of Fine Arts, Boston. The Hayden Collection; **31** Walter Sickert, *L'Affaire de Camden Town*, 1909. Oil on canvas 61 × 40.6 (24 × 16). Private collection. © Estate of Walter Richard Sickert 2000. All rights reserved; **32** Walter Sickert, *La Hollandaise*, 1906. Oil on canvas 50.6 × 40.6 (20 × 16). Tate Gallery, London. © Estate of Walter Richard Sickert 2000. All rights reserved; **33** Pierre Bonnard, *The Bathroom*, 1908. Oil on canvas 124.5 × 109 (49 × 43). Musée Royale des Beaux-Arts, Brussels. © ADAGP, Paris and DACS, London 2000;

34 Gwen John, *Girl Reading at a Window*, 1911. Oil on canvas 40.9 × 25.3 (16⅛ × 10). The Museum of Modern Art, New York. Mary Anderson Conroy Bequest in memory of her mother, Julia Quinn Anderson. Photograph © 1999 The Museum of Modern Art, New York. © Estate of Gwen John 2000. All rights reserved DACS; **35** Gwen John, *Nude Girl*, c. 1909–10. Oil on canvas 44.5 × 28 (17½ × 11). Tate Gallery, London. © Estate of Gwen John 2000. All rights reserved DACS; **36** Mary Cassatt, *The Bath*, 1892. Oil on canvas 100.4 × 66 (39½ × 26). The Art Institute of Chicago. Robert A. Waller Fund. 1910.2; **37** Paula Modersohn-Becker, *Kneeling Mother and Child*, 1906. Oil on canvas 113 × 74 (44½ × 29¼). Ludwig-Roselius Sammlung, Bottcherstrasse, Bremen; **38** Lovis Corinth, *A Mother's Love*, 1911. Oil on canvas 130 × 100 (51¼ × 39½). Nationalgalerie, Berlin; **39** Lovis Corinth, *The Blinded Samson*, 1912. Oil on canvas 130 × 105 (51¼ × 41⅜). Nationalgalerie, Berlin; **40** Egon Schiele, *Nude Self-Portrait, Grimacing*, 1910. Gouache, watercolour and pencil with white heightening on paper 55.8 × 36.9 (22 × 14½). Graphische Sammlung Albertina, Vienna; **41** Ferdinand Hodler, *The Dying Valentine Godé-Darel*, 1915. Oil on canvas 60 × 90.5 (23⅝ × 35⅝). Oeffentliche Kunstsammlung, Basel; **42** Egon Schiele, *The Family (Squatting Couple)*, 1918. Oil on canvas 152.5 × 162.5 (60 × 64). Osterreichische Galerie, Vienna; **43** Pablo Picasso, *Seated Female Nude*, 1910. Oil on canvas 92 × 73 (36¼ × 28¾). Tate Gallery, London. © Succession Picasso/DACS 2000; **44** Georges Braque, *Clarinet, Glass and Newspaper on a Table*, c. 1913. Pasted paper, oil, charcoal, chalk and pencil on canvas 95.2 × 120.3 (37½ × 47¾). The Museum of Modern Art, New York. Nelson A. Rockefeller Bequest 1945. Photograph © 1999 The Museum of Modern Art, New York. © ADAGP, Paris and DACS, London 2000; **45** Thomas Eakins, *A Man Jumping Horizontally*, 1885. Albumen print 23.2 × 28.6 (9⅛ × 11¼). The Library Company of Philadelphia; **46** Marcel Duchamp, *Nude Descending a Staircase, no. 2*, 1912. Oil on canvas 147 × 89 (58 × 35). Philadelphia Museum of Art, Louise and Walter Arensberg Collection. © Succession Duchamp/ADAGP, Paris and DACS, London 2000; **47** Pavel Filonov, *Portrait of Stalin*, 1936. Oil on canvas 99 × 67 (39 × 26½). State Russian Museum, St Petersburg; **48** R. de la Fresnaye, *Portrait of Jean-Louis Gampert*, 1920. Musée National d'Art Moderne, Centre Georges Pompidou, Paris; **49** André Derain, *Saturday*, 1913. Oil on canvas 181 × 228 (71¼ × 89¾). Pushkin Museum, Moscow. © ADAGP, Paris and DACS, London 2000; **50** André Derain, *Harlequin and Pierrot*, 1924. Oil on canvas 176 × 176 (69¼ × 69¼). Musée l'Orangerie, Paris. © ADAGP, Paris and DACS, London 2000; **51** Giorgio de

Chirico, *Song of Love*, 1914. Oil on canvas 73 × 59.1 (28¾ × 23⅜). The Museum of Modern Art, New York. Nelson A. Rockefeller Bequest. Photograph © 1999 the Museum of Modern Art, New York. © DACS, 2000; **52** Carlo Carrà, *The Metaphysical Muse*, 1917. Oil on canvas 90 × 66 (35⅜ × 26). Pinacoteca di Brera, Milan. Photo Scala. © DACS, 2000; **53** Felice Casorati, *Silvana Cenni*, 1922. Tempera on canvas 205 × 105 (80¾ × 41⅜). Private collection. © DACS, 2000; **54** Dod Procter, *Morning*, 1926. Oil on canvas 76.2 × 152.4 (30 × 60). Tate Gallery, London; **55** Giorgio Morandi, *Still Life*, 1921. Oil on canvas 44.7 × 52.8 (17⅝ × 20¾). Museum Ludwig, Cologne. Photo Rheinisches Bildarchiv, Cologne. © DACS, 2000; **56** Salvador Dalí, *Basket of Bread*, 1926. Oil on panel 32 × 32 (12½ × 12½). Collection of the Salvador Dalí Museum, St Petersburg, Florida. © 2000 Salvador Dalí Museum, Inc.; **57** Rudolf Schlichter, *Studio Roof*, 1920. Watercolour, pen, etching 45.8 × 63.8 (18 × 25¼). Galerie Nierendorf, Berlin. Photo AKG, London; **58** George Grosz, *Grey Day*, 1921. Oil on canvas 115 × 80 (45¼ × 31½). Staatliche Museen Preussischer Kulturbesitz, Nationalgalerie, Berlin. © DACS, 2000; **59** Hannah Höch, *The Beautiful Girl*, 1919–20. Photomontage 35 × 29 (13¾ × 11⁷⁄₁₆). Private collection. © DACS, 2000; **60** Christian Schad, *Self-Portrait with Model*, 1927. Oil on wood 76 × 71.5 (30 × 28¼). Private collection. © DACS, 2000; **61** Max Beckmann, *Self-Portrait with Tuxedo*, 1927. Oil on canvas 141 × 96 (55½ × 37¾). Busch-Reisinger Museum, Harvard University. Museum Purchase, Cambridge, Massachusetts. © DACS, 2000; **62** Otto Dix, *Metropolis*, 1928. Mixed media on wood, centre panel 181 × 201 (71¼ × 78¾). Galerie der Stadt Stuttgart. © DACS, 2000; **63** Balthus, *The Street*, 1933. Oil on canvas 195 × 240 (6' 4¾" × 7' 10½"). The Museum of Modern Art, New York. James Thrall Soby Bequest. Photograph © 1999 The Museum of Modern Art, New York. © ADAGP, Paris and DACS, London 2000; **64** Georgia O'Keeffe, *Radiator Building, Night, New York*, 1927. Oil on canvas 121.9 × 76.2 (48 × 30). Carl van Vechten Gallery of Fine Arts, Fisk University. ARS, NY and DACS, London 2000; **65** Charles Sheeler, *City Interior*, 1935. Oil on canvas 55.9 × 68.9 (22 × 27¼). Worcester Art Museum, Worcester, MA; **66** Charles Sheeler, *River Rouge Plant*, 1932. Oil on canvas 50.8 × 61 (20 × 24). Whitney Museum of American Art, New York; **67** Edward Hopper, *New York Movie*, 1939. Oil on canvas 81.9 × 101.9 (32¼ × 40¼). The Museum of Modern Art, New York. Given anonymously. Photograph © 1999 The Museum of Modern Art, New York; **68** Edward Hopper, *Approaching a City*, 1946. Oil on canvas 68.6 × 91.4 (27 × 36). The Phillips Collection, Washington, D.C.; **69** Stanley Spencer, *Tea in the Hospital*

Ward, 1932. Oil on canvas. Sandham Memorial Chapel, Burghclere, The National Trust. © Estate of Stanley Spencer 2000. All rights reserved; **70** Otto Dix, *War Wounded*, 1922. Watercolour on paper 49 × 37 (19¼ × 14⅝). Private collection. © ADAGP, Paris and DACS, London 2000; **71** Henry Tonks, *Study of Facial Wounds*, 1916–17. Pastel 25.4 × 20.3 (10 × 8). Reproduced by kind permission of the President and Council of the Royal College of Surgeons of England, London; **72** Stanley Spencer, *Self-Portrait with Patricia Preece*, 1936. Oil on canvas 61 × 91.5 (24 × 36). Fitzwilliam Museum, Cambridge. © Estate of Stanley Spencer 2000; **73** Käthe Kollwitz, *The Mothers* from the series *War*, 1922–23. Woodcut 34 × 40 (13⅜ × 15¾). Private collection. © DACS 2000; **74** Felix Nussbaum, *Self-Portrait with Judenpaß*, *c.* 1943. Oil on canvas 56 × 49 (22 × 19¼). Sammlung Felix Nussbuam der Niedersächsischen Sparkassenstiftung im Kulturgeschichtliches Museum, Osnabrück. Photo Strenger, Osnabrück/Christian Grovermann. © DACS, 2000; **75** Grant Wood, *American Gothic*, 1930. Oil on beaver board 74.3 × 62.4 (29¼ × 25¼). All rights reserved by The Art Institute of Chicago and VAGA, New York, NY, 1930.934. Friends of American Art Collection. Photograph courtesy of The Art Institute of Chicago; **76** Reginald Marsh, *The Bowl*, 1933. Egg tempera on pressed wood panel 91.2 × 152.2 (35⅞ × 59⅞). The Brooklyn Museum of Art, New York. Gift of William T. Evans; **77** Isabel Bishop, *Two Girls*, 1935. Oil and tempera on pressed wood 50.8 × 61.2 (20 × 24). The Metropolitan Museum of Art, New York. Arthur Hoppock Hearn Fund, 1936. Courtesy DC Moore Gallery, New York City; **78** Raphael Soyer, *How Long Since You Wrote To Mother?*, *c.* 1934. Oil on canvas 55.9 × 81.3 (22 × 32). Private collection. Courtesy of the Estate of Raphael Soyer, Forum Gallery, New York; **79** Philip Evergood, *American Tragedy*, 1937. Oil on canvas 74.9 × 100.3 (29½ × 39½). Private collection; **80** Philip Evergood, *Nude by the El*, 1934. Oil on canvas 94.9 × 108.9 (37⅜ × 42⅞). Hirshhorn Museum and Sculpture Garden, Smithsonian Institution, Washington, D.C. Gift of the Joseph H. Hirshhorn Foundation, 1966; **81** Ben Shahn, *Handball*, 1939. Tempera on paper over composition board 57.8 × 79.4 (22¾ × 31¼). The Museum of Modern Art, New York. Abby Aldrich Rockefeller Fund. Photograph © 2000 The Museum of Modern Art, New York. © Estate of Ben Shahn/DACS, London and VAGA, NY 2000; **82** Mark Rothko, *Entrance to a Subway*, 1938. Oil on canvas 86.4 × 117.5 (34 × 46). Private collection. © Kate Rothko Prizel and Christopher Rothko/DACS 2000; **83** Jacob Lawrence, *Race Riots were Numerous. White workers were hostile toward the migrants who had been hired to*

break strikes. Panel 50 from *The Migration* series, 1940–41 (text and title revised by the artist, 1993). Tempera on gesso on composition board 45.7 × 30.5 (18 × 12). The Museum of Modern Art, New York. Gift of Mrs David M. Levy. Photograph © 1999 The Museum of Modern Art, New York. Courtesy DC Moore Gallery, New York City; **84** Thomas Hart Benton, *City Building*, from *America Today*, 1930. Distemper, egg tempera and oil glaze on linen 234 × 297.2 (92 × 117). The Equitable Life Assurance Society of the United States. © Thomas Hart Benton Trust/DACS, London/VAGA, NY 2000; **85** José Clemente Orozco, *Felipe Carillo Puerto (of Yucatán)*, 1931. Fresco, approx. 180 × 215 (6 × 7'). New School of Social Research, New York. © Clemente V. Orozco; **86** Diego Rivera, *Detroit Industry*, north wall, 1933. Fresco, north wall. The Detroit Institute of Art. By permission of the Bank of Mexico; **87** Frida Kahlo, *Self-Portrait on the Border Between Mexico and the United States*, 1932. Oil on sheet metal 31.1 × 35 (12½ × 13¾). Private collection. By permission of the Bank of Mexico; **88** David Alfaro Siqueiros, *Portrait of the Bourgeoisie*, 1939–40. Pyroxilin on cement. Mexican Union of Electricians, Mexico City; **89** Aleksandr Deineka, *Female Textile Workers*, 1927. Oil on canvas 171 × 195 (66 × 77). Russian Museum, St Petersburg. Photo AKG, London; **90** Yuri Pimenov, *New Moscow*, 1937. Oil on canvas 140 × 170 (55 × 67). Tretyakov Gallery, Moscow. © DACS, 2000. Photo AKG, London; **91** Arkadi Plastov, *A Collective Farm Festival*, 1937. Oil on canvas 188 × 307 (74 × 121). Russian Museum, St Petersburg. © DACS, 2000. Photo AKG, London; **92** Adolf Ziegler, *Female Nude*, *c.* 1937. Oil on canvas 180 × 150 (70⅞ × 59). Property of the Federal Republic of Germany. Photo AKG, London; **93** Fernand Léger, *Adam and Eve*, 1935–39. Oil on canvas 228 × 324.5 (89¾ × 127¾). Kunstsammlung Nordrhein-Westfalen, Düsseldorf. © ADAGP, Paris and DACS, London 2000; **94** Serafima Ryangina, *Higher and Higher*, 1934. Oil on canvas 149 × 100 (59 × 39). Kiev Museum of Russian Art; **95** Pablo Picasso, *Guernica*, 1937. Oil on canvas 3.5 m × 7.8 m (11'6" × 25'8"). The Museum of Modern Art, New York. © Succession Picasso/DACS 2000; **96** Renato Guttuso, *The Discussion*, 1959–60. Oil on canvas 220 × 248 (86½ × 97½). Tate Gallery, London. © DACS, 2000; **97** Francis Gruber, *Job*, 1944. Oil on canvas 161.9 × 129.9 (63¾ × 51¼). Tate Gallery, London. © ADAGP, Paris and DACS, London 2000; **98** Fernand Léger, *Les Loisirs, Hommage à Louis David*, 1948–49. Oil on canvas 154 × 182 (60⅝ × 71¾). Musée National d'Art Moderne, Paris. © ADAGP, Paris and DACS, London 2000; **99** André Fougeron, *The Judges*, 1950. Oil on canvas 130 × 195 (51¼ × 76¾).

Artist's Collection, Paris. © ADAGP, Paris and DACS, London 2000; **100** Fernand Léger, *Les Constructeurs*, 1950. Oil on canvas 300 × 200 (118½ × 78¾). Musée National Fernand Léger, Biot. © ADAGP, Paris and DACS, London 2000; **101** Arkadi Plastov, *Threshing Corn on a Collective Farm*, 1949. Oil on canvas 200 × 382 (79 × 150). Museum of Russian Art, Kiev; **102** Aleksandr Laktionov, *A Letter from the Front*, 1947. Oil on canvas 226 × 115 (89 × 45). Tretyakov Gallery, Moscow. Photo AKG, London; **103** Geli M. Korzhev, *Raising the Banner*, 1957–60. Oil on canvas 156 × 290 (61 × 114). Russian Museum, St Petersburg; **104** Renato Guttuso, *Flight from Etna*, 1938–39. Oil on canvas 144 × 254 (56¾ × 100). Galleria Nazionale d'Arte Moderna, Rome. © DACS, 2000; **105** Giuseppe Pelliza da Volpedo, *The Fourth Estate*, 1901. Oil on canvas 283 × 550 (111¾ × 216¾). Civica Galleria d'Arte Moderna, Milan; **106** Renato Guttuso, *The Beach*, 1955–56. Oil on canvas 45 × 301 (17¾ × 118½). Palazzo della Pilotta, Parma. © DACS 2000; **107** André Fougeron, *Atlantic Civilisation*, 1953. Oil on canvas 380 × 560 (149⅝ × 220½). Collection of the artist. © ADAGP, Paris and DACS, London 2000; **108** Francis Gruber, *Nude in a Red Waistcoat*, 1944. Oil on canvas 115 × 86 (45¼ × 33⅞). Private collection. © ADAGP, Paris and DACS, London 2000; **109** Alberto Giacometti, *The Artist's Mother*, 1950. Oil on canvas 89.9 × 61 (35⅜ × 24). The Museum of Modern Art, New York. Acquired through the Lillie P. Bliss Request. Photograph © 1999 The Museum of Modern Art, New York. © ADAGP, Paris and DACS, London 2000; **110** Alberto Giacometti, *Annette*, 1954. Oil on canvas 65 × 54.6 (25⅝ × 21½). Staatsgalerie, Stuttgart. © ADAGP, Paris and DACS, London 2000; **111** Jean Hélion, *Nude with Loaves*, 1952. Oil on canvas 130.1 × 97 (51¼ × 38⅛). Tate Gallery, London. © ADAGP, Paris and DACS, London 2000; **112** Jean Hélion, *Vanitas with Dead Leaf*, 1957–58. Oil on canvas 81 × 100 (32 × 39⅜). Private collection. © ADAGP, Paris and DACS, London 2000; **113** Georges Braque, *The Shower*, 1952. Oil on canvas 34.9 × 54.6 (13¾ × 21½). Phillips Collection, Washington, D.C. © ADAGP, Paris and DACS, London 2000; **114** Arthur Boyd, *Melbourne Burning*, 1946–47. Oil and tempera on canvas on board 90.2 × 100.5 (35½ × 39½). The Holmes à Court Collection, courtesy of Heytesbury; **115** Russell Drysdale, *The Rabbiters*,1947. Oil on canvas 75.4 × 100.8 (29¾ × 39¾). National Gallery of Victoria, Melbourne. Purchased 1947; **116** Lascaux cave, painting of a bull and other animals. Photo Caisse Nationale des Monuments Historiques, Paris; **117** Jean Hélion, *Still Life with Rabbit*, 1952. Oil on canvas 81 × 99 (32 × 39). Collection du Musée Cantini, Marseille. © ADAGP, Paris and DACS, London 2000 (dépôt du Fonds National

d'Art Contemporain). Photo Jean Bernard; **118** Balthus, *The Light Meal*, 1940. Oil on wood panel 73 × 92 (28⅞ × 36¼). Private collection. © ADAGP, Paris and DACS, London 2000; **119** Antonin Artaud, *Self Portrait*, 11 May 1946. Pencil on paper 63 × 49 (24¾ × 19¼). Private collection. © ADAGP, Paris and DACS, London 2000; **120** Evelyn Dunbar, *A Land Girl and the Bail Bull*, 1945. Oil on canvas 91.4 × 182.9 (36 × 72). Tate Gallery, London; **121** Meredith Frampton, *Sir Ernest Gowers, K.C.B., K.B.E., Senior Regional Commissioner for London, Lt. Col. A. J. Child, O.B.E., M.C., Director of Operations and Intelligence, and K. A. L. Parker, Deputy Chief Administrative Officer, in the London Regional Civil Defence Control Room*, 1943. Oil on canvas 147.6 × 168.2 (58¼ × 66¼). The Imperial War Museum, London; **122** Laura Knight, *Ruby Loftus Screwing a Breech-Ring*, 1943. Oil on canvas 86. 4 × 111.6 (34 × 40). The Imperial War Museum, London; **123** Laura Knight, Sketch for *The Dock at Nuremberg*, 1946. Chalk and wash on paper 78.7 × 57.1 (31 × 22½). The Imperial War Museum, London; **124** William Coldstream, *Seated Nude*, 1952–53. Oil on canvas 106.7 × 70.7 (42 × 27⅞). Tate Gallery, London. © Courtesy of the artist's estate/The Bridgeman Art Library, London; **125** Victor Pasmore, *The Studio of Ingres*, 1945–47. Oil on canvas 76 × 101.5 (30 × 40). Private collection; **126** Richard Hamilton, *Transition III*, 1954. Oil on canvas 76 × 56 (30 × 22). Private collection; **127** Derrick Greaves, *Sheffield*, 1953. Oil on canvas 86.2 × 203.3 (34 × 80). Sheffield City Art Galleries and Museum Trust/City Art Gallery; **128** David Bomberg, *Ronda, towards El Barrio, San Francisco*, 1954. Oil on board 71 × 91.5 (28 × 36). Private collection. Photo courtesy Bernard Jacobson Gallery, London; **129** John Bratby, *Three People at a Table*, 1955. Oil on board 120.7 × 120.7 (47⅛ × 47½). The British Council; **130** Peter de Francia, *The Bombing of Sakiet*, 1955–58. Oil on canvas 190 × 365 (74⅞ × 143¾). Private collection, on loan to Sheffield Art Galleries and Museums Trust, UK; **131** Joan Eardley, *Brother and Sister, c.* 1956. Oil on canvas 101.6 × 75.9 (40 × 29⅞). City of Aberdeen Art Gallery and Museums Collections; **132** Lucian Freud, *Interior at Paddington*, 1951. Oil on canvas 152.5 × 114.3 (60 × 45). Walker Art Gallery, Liverpool; **133** Francis Bacon, *Two Figures*, 1953. Oil on canvas 152.5 × 116.5 (60 × 45⅞). Private collection. © Estate of Francis Bacon 2000. All Rights Reserved, DACS; **134** Francis Bacon, *Head VI*, 1949, detail. Oil on canvas 93.2 × 76.5 (36⅝ × 30⅛). Arts Council Collection, London. © Estate of Francis Bacon 2000. All Rights Reserved, DACS; **135** George Tooker, *Subway*, 1950. Egg tempera on composition board 46 × 91.8 (18⅛ × 36⅛). Collection of Whitney Museum of American Art, New York.

Purchase with funds from the Juliana Force Purchase Award. 50.2. Courtesy DC Moore Gallery, New York City; **136** Fairfield Porter, *Katie and Anne*, 1955. Oil on canvas 203.5 × 157.7 (80⅛ × 62⅛). Hirshhorn Museum and Sculpture Garden, Smithsonian Institution, Washington, D.C. Gift of Joseph H. Hirshhorn, 1966; **137** Andrew Wyeth, *The Revenant*, 1949. Tempera 76.2 × 50.8 (30 × 20). From the collection of the New Britain Museum of American Art, New Britain, Connecticut. Harriet Russell Stanley Fund. Photo Michael Agee; **138** Gerhard Richter, *Betty*, 1988. Oil on canvas 102 × 72 (40⅛ × 28⅜). Courtesy Anthony d'Offay Gallery, London; **139** James Rosenquist, *The Light That Won't Fail*, 1961. Oil on canvas 182.2 × 244.5 (71¾ × 96¼). Hirshhorn Museum and Sculpture Garden, Smithsonian Institution, Washington, D.C. Gift of the Joseph H. Hirshhorn Foundation, 1966. Photo Lee Stalsworth. © James Rosenquist/ VAGA, New York/DACS 2000; **140** Edward Hopper, *Ground Swell*, 1939. Oil on canvas 91.5 × 127 (36 × 50). The Corcoran Gallery of Art, Washington, D.C.; **141** Malcolm Morley, *SS Amsterdam in Front of Rotterdam*, 1966. Acrylic on canvas 157.5 × 213.5 (62 × 84). Private collection; **142** Vincent van Gogh, *Old Shoes with Laces*, 1886. Oil on canvas 37.5 × 45 (14¾ × 17½). Rijksmuseum, Amsterdam. Vincent van Gogh Collection; **143** Jasper Johns, *White Flag*, 1955. Encaustic and collage on canvas 198.9 × 306.7 (78¾ × 120¾). Artist's Collection. © Jasper Johns/DACS, London/VAGA, NY 2000; **144** Daniel Spoerri, *Tableau-piège au carré*, 1961 and 1964. Mixed media on chipboard 165.5 × 153 × 64 (65¼ × 60¼ × 25¼). Kunstmuseum Düsseldorf. © DACS 2000; **145** Wayne Thiebaud, *Jawbreaker Machine (Bubblegum Machine)*, 1963. Oil on canvas 66 × 88 (26 × 34⅝). Nelson Atkins Museum. Gift of Mr and Mrs Jack Glenn through the Friends of Art. Photo E. G. Schempf; **146** Andy Warhol, *Lavender Disaster (Electric Chair)*, 1964. Silkscreen 185.4 × 137 (73 × 54). Private collection. © The Andy Warhol Foundation for the Visual Arts, Inc./ARS, NY and DACS, London 2000; **147** Gerhard Richter, *Confrontation (2), Gugenüberstellung (2)*, from the series *October 18, 1977*, 1988. Oil on canvas 112 × 102 (44⅛ × 40⅛). The Museum of Modern Art, New York. Purchase. Photograph © 2000 The Museum of Modern Art, New York; **148** Gerhard Richter, *Kitchen Chair*, 1965. Oil on canvas 100 × 80 (39¾ × 31⅛). Kunsthalle Recklinghausen; **149** Jacques Monory, *Murder no. 10/2*, 1968. Oil on canvas and mirror 162 × 425 (63¾ × 167¾). Musée National d'Art Moderne, Paris. © ADAGP, Paris and DACS, London 2000; **150** Patrick Caulfield, *Santa Margherita Ligure*, 1964. Oil on board 122 × 244 (48 × 96). Private collection. © Patrick Caulfield

2000. All Rights Reserved, DACS; **151** Richard Hamilton, *I'm Dreaming of a White Christmas*, 1967–68. Oil on canvas 106.5 × 160 (42 × 63). Private collection. © Richard Hamilton 2000. All rights reserved. DACS; **152** Robert Bechtle, *20th Street – Early Sunday Morning*, 1997. Oil on canvas 91.4 × 167.6 (36 × 66). Photo Schopplein Studio; **153** Philip Pearlstein, *Female Nude on Platform Rocker*, 1978. Oil on canvas 183.5 × 244.2 (72¼ × 96¼). The Brooklyn Museum of Art, New York. John B. Woodward Memorial Fund and Other Restricted Income Funds 79.17. © Philip Pearlstein. Courtesy Robert Miller Gallery, New York; **154** Euan Uglow, *Curled Nude on a Stool*, 1982–83. Oil on canvas 77.7 × 100 (30½ × 39⅜). Ferens City Art Gallery: Hull City Museums and Art Galleries. © The artist; **155** Richard Estes, *Supreme Hardware Store*, 1973. Oil and acrylic on canvas 101.6 × 168.3 (40 × 66¼). High Museum of Art, Atlanta. Gift of Virginia Carroll Crawford, 1978.119; **156** Fairfield Porter, *Near Union Square – Looking up Park Avenue*, 1975. Oil on canvas 155.6 × 182.9 (61¼ × 72). The Metropolitan Museum of Art, New York; **157** Wayne Thiebaud, *Corner Apartments (Down 18th Street)*, 1980. Oil on charcoal on canvas 121.8 × 91.2 (48 × 35⅞). Hirshhorn Museum and Sculpture Garden, Smithsonian Institution, Washington, D.C. Museum Purchase with Funds Donated by Edward R. Downe, Jr, 1980. Photo Ricardo Blanc; **158** Ed Ruscha, *The Los Angeles County Museum on Fire*, 1965–68. Oil on canvas 136 × 339 (53½ × 133½). Hirshhorn Museum and Sculpture Garden, Smithsonian Institution, Washington, D.C. Gift of Joseph H. Hirshhorn, 1972. Photo Lee Stalsworth; **159** Chuck Close, *Alex*, 1991. Oil on canvas 254 × 213.4 (100 × 84). The Art Institute of Chicago; **160** Chuck Close, *Self-Portrait*, 1967–68. Acrylic on canvas 274.3 × 213.4 (108 × 84). Walker Art Center, Minneapolis; **161** Robert Ryman, *VII*, 1969. Installation view at the Stedelijk Museum, Amsterdam; **162** Vija Celmins, *Untitled*, 1990. Oil on linen 38.7 × 47.6 (15¼ × 18¾). Private collection. McKee Gallery, New York; **163** Vija Celmins, *Lamp # 1*, 1964. Oil on canvas 62.2 × 88.9 (24½ × 35). Collection of the artist. McKee Gallery, New York; **164** Giorgio Morandi, *Still Life*, 1963. Oil on canvas 30 × 35 (11⅞ × 13¾). Private collection. © DACS, 2000; **165** Avigdor Arikha, *Slippers and Undershirt*, 1979. Oil on canvas 81 × 65 (31⅞ × 25⅝). Private collection. © Avigdor Arikha, courtesy, Marlborough Gallery, New York; **166** Lucian Freud, *Interior with Hand Mirror (Self-Portrait)*, 1967. Oil on canvas 25.5 × 17.8 (10 × 7). Private collection; **167** Lucian Freud, *Naked Portrait on a Red Sofa*, 1989–91. Oil on canvas 100.3 × 90.3 (39½ × 35½). Private collection. Photo courtesy Acquavella Galleries, New York; **168** Lucian Freud, *Naked Man in a Bed*,

1989–90. Oil on canvas 81.3 × 69.3 (32 × 27¼). Private collection. Photo The Bridgeman Art Library, London; **169** Francis Bacon, central panel from *Three Studies for a Crucifixion*, 1962. Oil on canvas 198.2 × 144.8 (78 × 57). Solomon R. Guggenheim Museum, New York. © Estate of Francis Bacon 2000. All Rights Reserved, DACS; **170** Soutine, *Carcass of Beef, c.* 1925. Oil on canvas 140 × 82 (55¼ × 32⅜). The Albright-Knox Art Gallery, Buffalo, New York. © ADAGP, Paris and DACS, London 2000; **171** Francis Bacon, *Three Studies for a Portrait of Lucian Freud*, 1965. Oil on canvas, each panel 35.5 × 30.5 (14 × 12). Private collection. © Estate of Francis Bacon 2000. All Rights Reserved, DACS; **172** Frank Auerbach, *E.O.W. on her Blue Eiderdown II*, 1965. Oil on board 45.7 × 61 (18 × 24). Private collection. Photo Marlborough Fine Art (London) Ltd; **173** Frank Auerbach, *Head of CD II*, 1977. Chalk and charcoal on paper 73.7 × 55.9 (29 × 22). Yale Center for British Art. Paul Mellon Collection, New Haven. Photo Marlborough Fine Art (London) Ltd; **174** Leon Kossoff, *Children's Swimming Pool, 11 o'clock, Saturday Morning, August 1969*. Oil on board 152 × 205 (60 × 81). Private collection; **175** Jorg Immendorf, *Café Deutschland 1*, 1978. Oil on canvas 282 × 330 (111 × 129¾). Museum Ludwig, Cologne; **176** Miquel Barceló, *The Big Spanish Dinner*, 1985. Mixed media on canvas 200 × 300 (78¾ × 118⅛). Museo Nacional Centro de Arte Reina Sofia, Madrid. © ADAGP, Paris and DACS, London 2000; **177** Mark Tansey, *Triumph of the New York School*, 1984. Oil on canvas 188 × 304.8 (74 × 120). Whitney Museum of American Art, New York. Promised gift of Robert M. Kaye. Courtesy of Curt Marcus Gallery, New York; **178** Mark Tansey, *Close Reading*, 1990. Oil on canvas 367 × 117 (144½ × 46). Collection of the Modern Art Museum of Fort Worth. Museum Purchase, Sid W. Richardson Foundation Endowment Fund. Courtesy of Curt Marcus Gallery, New York; **179** Art & Language, *Index: the Studio at 3 Wesley Place; Drawing (i)*, 1981–82. Pencil, ink, watercolour and collage on paper 76 × 162 (29⅞ × 63¾). Tate Gallery, London; **180** Eric Fischl, *The Old Man's Boat and Old Man's Dog*, 1982. Oil on canvas (213 × 208) 84 × 82. Saatchi Collection, London; **181** Leon Golub, *Interrogation II*, 1981. Acrylic on canvas 304.8 × 426.7 (120 × 168). The Art Institute of Chicago. Gift of The Society of Contemporary Art, 1983.264. Photograph © 1999, The Art Institute of Chicago. All Rights Reserved; **182** Audrey Flack, *Macarena of Miracles*, 1971. Oil on canvas 66 × 46 (26 × 18⅛). The Metropolitan Museum of Art, New York. Gift of Paul F. Walkter, 1979; **183** Cindy Sherman, *Untitled # 224*, 1990. Colour photograph 122 × 96.5 (48 × 38). Courtesy Metro Pictures, New York; **184** Alice Neel, *Andy Warhol*, 1970. Oil

on canvas 152.4 × 101.6 (60 × 40). Whitney Museum of American Art, New York. © The Estate of Alice Neel. Courtesy Robert Miller Gallery, New York; **185** David Hockney, *Peter Getting out of Nick's Pool*, 1966. Acrylic on canvas 213.4 × 213.4 (84 × 84). Walker Art Gallery, Liverpool. © David Hockney; **186** Alex Katz, *The Cocktail Party*, 1965. Oil on canvas 183 × 241.3 (72 × 95). Private collection. © Alex Katz, courtesy, Marlborough Gallery, New York; **187** Alex Katz, *Blue Umbrella # 2*, 1972. Oil on canvas 243.8 × 365.7 (96 × 144). Saatchi Collection. © Alex Katz, courtesy, Marlborough Gallery, New York; **188** Paula Rego, *The Family*, 1988. Acrylic on paper 213.4 × 213.4 (84 × 84). Private collection. Photo courtesy, Marlborough Fine Art (London) Ltd; **189** Mark Fairnington, *First Baby*, 1996. Oil on canvas 20 × 20 (7⅞ × 7⅞). Private collection; **190** Marlene Dumas, *Chlorosis*, 1994. Ink, gouache and synthetic polymer paint on paper, each 66.2 × 49.5 (26 × 19½). The Museum of Modern Art, New York. The Herbert and Nannette Rothschild Memorial Fund in memory of Judith Rothschild. Photograph © 2000 The Museum of Modern Art, New York. Courtesy the artist and Jack Tilton Gallery, New York; **191** Marlene Dumas, *The Painter*, 1994. Oil on canvas 198 × 99 (78 × 39). Courtesy the artist and Jack Tilton Gallery, New York

Index

Italic numerals refer to plate numbers

Abstract Expressionism 108, 152, 156,
 159–60, 173, 202
academic tradition, theory and practice 8–9,
 10–11, 14–16; see also life room;
 Renaissance; Wanderers
Agee, James 90
AKhRR 100–01
allegory 19–21, 107, 199
Alma-Tadema, Sir Lawrence 10, 32; *20*
American Artists' Congress 87–88
'American Scene' painting 79
Andrews, Michael 151
Apollinaire, Guillaume 57
Aragon, Louis 110, 114, 116
Arikha, Avigdor 188; *165*
Armory Show 25, 38, 53, 74
Art & Language 197, 200–01; *179*
Artaud, Antonin 73–74, 135, 189; *119*
Artists' International Association 142, 146
Ashcan School 10, 24, 79, 84, 87
Auden, W. H. 107, 141
Auerbach, Frank 144, 146, 187–88, 191,
 193; *172, 174*
Australian art, and realism in (1940s) 133;
 114, 115

Baader-Meinhof group (Red Army Faction)
 165, 201
Bacon, Francis 25, 149–52, 185, 187–93;
 133, 134, 169, 171
Baldwin, Michael, see Art & Language
Balthus 72–74, 126, 133–34; *63, 118*
Barceló, Miquel 197; *176*
Baroque realism 188–89
Baselitz, Georg 164, 197
Bataille, Georges 126, 133, 135, 189
Baudelaire, Charles 204
Baudrillard, Jean 168
Bay Area Figuration 177
Beaux-Arts Gallery, 'Beaux Arts Quartet'
 144, 146
Bechtle, Robert 169–70; *152*
Beckmann, Max 58, 71–72, 89; *61*
Bellows, George 16, 21, 24–29, 31–33, 79,
 175; *3, 13, 14, 19*
Benjamin, Walter 68, 204, 211
Benton, Thomas Hart 92–94; *84*
Berger, John 125, 146–47, 150
Berkeley, George 144
Berlin Secession 47
Bernheim-Jeune 37
Beuys, Josef 166
Bishop, Isabel 84, 87; *77*
Böcklin, Arnold 10, 59
Bolshevik Revolution 54, 101
Bomberg, David 143–45, 193; *128*
Bonnard, Marthe 35, 42
Bonnard, Pierre 33, 34, 35–36, 37, 42, 43;
 25, 33
Bonnat, Léon 15, 16
Bouguereau, William Adolphe 18, 19; *10*
Bown, Matthew Cullerne 121
Boyd, Arthur 133; *114*
Brancusi, Constantin 99–100

Braque, Georges 53, 56, 131; *44, 113*
Bratby, John 144–46; *129*
Brecht, Bertolt 92, 121, 197
Breton, André 57, 59, 198
Bryson, Norman 184, 190
Buffet, Bernard 109
Buñuel, Luis 210

Cage, John 161
Callot, Jacques 127
'call to order' movement 55–56
Camden Town Group, the 37, 38, 41, 42,
 141
Camus, Albert 114, 126
'Capitalist Realism' 166
Caravaggio, Michelangelo da 8, 16, 189,
 205
Carillo Puerto, Felipe 94–95
Carolus-Duran, Charles 17
Carrà, Carlo 55, 57, 60–61, 65, 67; *52*
Carroll, Lewis 133
Casanova, Laurent 114–15
Casorati, Felice 63–64, 74; *53*
Cassatt, Mary 41, 45–47; *30, 36*
Caulfield, Patrick 168; *150*
Celmins, Vija 181–83; *162, 163*
Central Intelligence Agency, US 152
Cézanne, Paul 9, 11, 19, 39, 45, 46, 50, 56,
 63–64, 133, 137, 144, 173, 183; *9*
Chardin, Jean-Baptiste-Siméon 34
Chessman, Caryl 164
cinema 10, 98, 210; British documentary
 141; Italian neo-realist 108, 123, 146;
 Soviet 106, 118–19, 121, 151, 167–68
Clark, Kenneth 136–37
Clark, T. J. 11, 173
Clemente, Francesco 197
Close, Chuck 179–81, 183, 203–04; *159, 160*
Cocteau, Jean 56
Coldstream, William 137, 141–43, 173; *124*
Cold War 109, 114, 121, 123, 147, 197
Cominform 114
Comintern 84
Communist Party, Soviet 101, 114, 121,
 123; British 136; French 109–10,
 112–16; Italian 110, 123
Conceptual Art 200
Constable, John 141
Constructivism, Russian 68, 99–101
Corinth, Lovis 46–48; *38, 39*
Cottingham, Robert 169
Courbet, Gustave 8, 9, 11, 14, 16, 19, 29,
 134, 169–73, 200–01; *12*
Critical Realism 197; and framing 168; of
 interwar period 77; see also Dadaism:
 Berlin Dada; November Group
Crow, Thomas 164
Cubism 10, 38, 50–53, 125; and the 'call to
 order' 56; and interwar 'Realisms' 77
Curry, John Steuart 94

Dadaism 161; Berlin Dada 67–68;
 Neo-Dadaism 160
Dalí, Salvador 64; *56*
Darwin, Charles 14
Daumier, Honoré 91
David, Jacques-Louis 113
de Beauvoir, Simone 111, 126, 129
Debord, Guy 168
de Chirico, Giorgio 10, 57–63, 65, 71; *51*

de Francia, Peter 146–47; *130*
Degas, Edgar 17, 39–40, 45
de Gaulle, General Charles 110, 114
'Degenerate Art' exhibition (1937) 103
Deineka, Aleksandr 76, 100–101, 103, 121;
 89
de Kooning, Willem 179, 193
de la Fresnaye, Roger 56; *48*
Deleuze, Gilles 189
Della Francesca, Piero 63, 74
De Man, Paul 199
Demuth, Charles 74
Denis, Maurice 34, 36, 56
Dennison, George 89
Depression, the 97; see also Federal Art
 Project; New Deal; Wall Street Crash
Derain, André 56–59, 71, 73, 111; *49, 50*
Derrida, Jacques 159
Detroit Institute of Arts 95–97
de Vlaminck, Maurice 110–11
Diebenkorn, Richard 177
Dix, Otto 9, 65, 72, 81–82, 89, 115; *62, 70*
'Documenta 5' exhibition 169
Dos Passos, John 141
Dreyfus, Alfred 136
Drysdale, Russell 133; *115*
Duchamp, Marcel 53, 99–100, 161, 167,
 198; *46*
Dumas, Marlene 212–13; *190, 191*
Dunbar, Evelyn 136; *120*
Dyer, George 25

Eakins, Thomas 15–21, 24, 28, 53, 190; *5, 7,
 8, 45*
Eardley, Joan 147; *131*
Eight, the 24, 38, 40
Eisenstein, Sergei 106
Eluard, Paul 110, 113
Entartete Kunst, see 'Degenerate Art'
 exhibition
Estes, Richard 175–77, 179, 203; *155*
Euston Road School 142
Evans, Walker 90
Evergood, Philip 9, 80, 87–89; *79, 80*
existentialism, French 125–26, and ff.
Expressionism, German 104

Fairington, Mark 211; *189*
Fascism 55, 61, 84, 109
Fauvism 56
Federal Art Project (of Works Progress
 Administration) 84, 91
Feminist art history 45, 158
Filonov, Pavel 47
First World War 54–55, 80–81, 113, 116
Fischl, Eric 180
Fitzroy Group, the 37, 38
Flack, Audrey 204–05; *182*
Flaherty, Robert 31
Fontana, Lucio 164–66
Ford, Edsel 97
Ford, Henry 97
Ford Motor Company, River Rouge Plant
 76–77, 97; *66*
Foster, Hal 164, 177
Foucault, Michel 159
Fougeron, André 108, 110, 114–16, 118,
 125; *99, 107*
Fourteenth Street School 84–87
Frampton, Meredith 63, 137–39; *121*

fresco painting 10, 97
Freud, Lucian 11, 12, 148–49, 184–88, 190, 193; *132, 166, 167, 168*
Freud, Sigmund 55–56, 60, 107
Friedrich, Ernst 81
Fry, Roger 38, 137, 144
Futurism, Italian 31, 60; Russian 99

Gandhi, Mohandas Karamchand 94
Gauguin, Paul 15, 33, 34, 39, 46
genre painting 8, 12, 15, 32, 33, 84
Gerasimov, Aleksandr 103, 119
Gérôme, Jean-Léon 15, 16
Giacometti, Alberto 11, 109, 126–29, 131–33, 143, 152; *109, 110*
Giacometti, Annette 128–29
Giacometti, Diego 128
Gibson, J. J. 143
Gide, André 36
Giotto 60, 97
Glackens, William 24, 27
Godard, Jean-Luc 168
Golub, Leon 11, 197, 201–03; *181*
Gombrich, E. H. 142–43
Goodrich, Lloyd 17
Gore, Frederick Spencer 38–39; *27*
Goya, Francisco 9, 89, 91, 210
Greaves, Derrick 144; *127*
Greenberg, Clement 13, 98, 156, 159, 173, 198–99, 201
Gross, Dr Samuel 16; *5*
Grosz, George 9, 65, 67–68, 72, 99, 115; *58*
Gruber, Francis 11, 109, 111–12, 125–27, 149; *97, 108*
Guillaume, Paul 58–59
Guttuso, Renato 114, 121, 123–25, 146, 164; *96, 104, 106*

Hals, Frans 24, 208
Hamilton, Richard 142–43, 150, 168–69; *126, 151*
Harrison, Tom 141
Hartlaub, Gustav 68
Heartfield, John 67
Heidegger, Martin 159, 183
Hélion, Jean 11, 109, 126, 129–33; *111, 112, 117*
Henri, Robert 21–24, 28–29, 37–39, 79
Heron, Patrick 146
Herzfelde, Wieland 67
Hitler, Adolf 68
Höch, Hannah 67–68; *59*
Hockney, David 207–08; *185*
Hodler, Ferdinand 47–48; *41*
Hogarth, William 9, 89, 208
Homer, Winslow 15–16, 29–31; *17*
Hopper, Edward 21, 79–80, 155–59; *67, 68, 140*
Hopper, Jo 79
Hyperrealism 203; see also Baudrillard; Lyotard

Ibsen, Henrik 35, 46
illusion, pictorial 6–7, 9, 12, 142–43, 151, 199, 200
Immendorf, Jorg 197; *175*
Impressionism 14–15, 19, 32–33, 37, 41, 44, 45, 46, 50, 56, 107, 158
Isherwood, Christopher 141
Independent Group, the 142, 150

Ingres, Jean-Auguste Dominique 56, 142
intersubjectivity 9, 126

John, Augustus 42
John, Gwen 42–44; *34, 35*
John Reed Club 87
Johns, Jasper 156–62; *143*
Johnson, Jack 25
journalism 10

Kahlo, Frida 97; *87*
Kandinsky, Vassily 158
Katz, Alex 208; *186, 187*
Kent, Rockwell 21, 29–31; *18*
Khruschev, Nikita 121–23
Klee, Paul 143
Klimt, Gustav 48
Klinger, Max 59–60
Klossowski, Pierre 133
Knight, Laura 137, 140; *122, 123*
Kokoschka, Oskar 48
Kollwitz, Käthe 81, 83; *73*
Korzhev, Geli M. 120–21; *103*
Kossoff, Leon 144, 146, 193–94; *174*
Kundera, Milan 113

Labyrinthe 126
Lacan, Jacques 177, 184
Laktionov, Aleksandr 119; *102*
Laning, Edward 89
Lascaux, cave paintings at 133–35; *116*
Lawrence, Jacob 87, 91–92; *83*
Le Corbusier (Charles-Edouard Jeanneret) 55
Léger, Fernand 99–100, 105, 109, 112–13, 116–18, 146; *93, 98, 100*
Leibl, Wilhelm 104
Leiris, Michel 189
Lenin, Vladimir Ilyich 94, 98, 100–01
Leslie, Alfred 173–75
Levi, Carlo 123
Lhote, André 56, 73
Lichtenstein, Roy 162
life room, life painting 9, 137, 141–42
Loos, Adolf 48
L'Ouverture, Toussaint 91
Lozowick, Louis 84
Lucretius 212
Lueg, Konrad (Konrad Fischer) 166
Lukács, Georg 92, 121, 123, 125–26, 147
Luks, George 24, 27–28
Lunacharsky, Anatoly 100–01
Lyotard, Jean-François 168

Mackensen, Fritz 47
Madge, Charles 141
Magic realism 152
Magritte, René 11, 59; *1*
Mallarmé, Stéphane 33
Malraux, André 114, 125–26
Manet, Edouard 14, 15, 17, 19, 24, 32–34, 41, 156; *4, 21*
Marey, Etienne-Jules 52, 53
Marsh, Reginald 84, 87; *76*
Marxism 92, 100, 125, 168
Masses, The 27, 28
'Mass observation' 141
Matignon agreement (1936) 105
Matisse, Henri 9, 29, 198; *2*
Mayakovsky, Vladimir 118

McLean, Richard 169
Merleau-Ponty, Maurice 114, 126
Metaphysical School, the 54, 60–61, 65
Middleditch, Edward 144
Millet, Jean-François 47
Mimesis 7, 12
Minotaure 74
Modernism 9, 10, 13, 14
Modersohn-Becker, Paula 46–47, 50; *37*
Mondrian, Piet 125
Monet, Claude 33, 35
Monory, Jacques 167–68; *149*
Monroe, Marilyn 164
Morandi, Giorgio 9, 60–65, 183; *55, 164*
Moravia, Alberto 122
Morley, Malcolm 156–58, 177; *141*
Munch, Edvard 46, 47
Munich Secession 47
mural painting: in USA 92–99; for Mexican government 93; by Léger and Perriand 105
Murphy, Gerald 74
Music, Zoran 109
Mussolini, Benito 122
Muybridge, Edweard 28, 52, 149–51, 190

Nabis, the 33, 34, 35–36
Nagy, Imre 123
narration 9, 11, 211
Nazism 68; Nazi cultural policy 103–04, 106
Nazi–Soviet pact (1939) 84, 110
Neel, Alice 206–07, 208; *184*
Neizvestny, Ernst 147
Neo-Expressionism 159, 197
Neo-Romanticism (British) 12, 137
Neue Sachlichkeit (New Objectivity) 10, 12, 55, 67–68, 71, 82, 103
New Deal, the 84, 89, 94–95, 104
New Economic Policy (NEP), Soviet (1921) 100–03
New English Art Club, the 38
'New Images of Man' exhibition 152, 173, 201–02
'New realism', of Léger 105; Pop art as 'New Realism' 125, 164, 173; see also *Nouveau Réalisme*
'New Realists' exhibition 173
New School for Social Research, murals 92–95, 105
Nietzsche, Friedrich 60
Nochlin, Linda 11, 169–73
Nouveau Réalisme 161–62, 167
Novecento group 55, 61
November Group 67
November Revolution, the (German) 54, 67
Nussbaum, Felix 82, 91; *74*

Occupation, of France, see Second World War
O'Keeffe, Georgia 74; *64*
Orozco, José Clemente 91–95; *85*
Orton, Fred 160–61
OSt 100–01, 103
Ozenfant, Amédée 55

Paolozzi, Eduardo 150
Paris International Exhibition (1937) 103, 105–06
Pasmore, Victor 142; *125*

Pasolini, Pier Paolo 123
Pearlstein, Philip 173; *153*
Penck, A. R. 197
perception, theories of 126, 142–44
Perriand, Charlotte 105
perspective 32, 65
Pétain, Marshal Henri 110
photography 10–12, 25, 28, 70–71, 76–77, 141, 151, 155–56, 159, 162, 189–90, 201, 204–05; chronophotography 52–53; documentary photography 10, 89–90
Photorealism 7, 10, 12, 159, 167, 175, 177, 179, 205
Picasso, Pablo 50–53, 56, 58, 106–07, 109–10, 112, 116, 121, 123, 147, 164, 198; *43, 95*; Pictorial realism 12
Pignon, Edouard 110
Pimenov, Yuri 103; *90*
Pirandello, Luigi 63
Piscator, Erwin 72
Plastov, Arkadi 103, 118; *91, 101*
Pollock, Griselda 45
Pollock, Jackson 156, 160, 164, 198
Ponge, Francis 131, 133
Pop art 12, 155–56, 159–60, 162, 167–68, 175, 205; as 'new realism' 125, 164, 173; British 168; French 167; German 166
Popular Front 84, 104–05, 112, 114
Porter, Fairfield 152–54, 175; *136, 156*
Post-Impressionism 38
Precisionism 74
Pre-Raphaelites 141
Procter, Dod *54*
Productivism 99–100
psychoanalysis 46; and art history 158

Quinn, John 43

Ramsden, Mel, see Art & Language
Raphael 8, 14
rappel à l'ordre, see 'call to order'
'*Réalismes, Les*' exhibition 10, 54
'Realism Now' exhibition 169
Reality journal 155
Regionalism 84, 94
Rego, Paula 210–11; *188*
Rembrandt 16, 188, 190, 208
Renaissance, Renaissance art theory 7, 8, 9, 32, 44, 54, 56, 74, 159 (Italian fresco 10)
Restany, Pierre 161
Revue blanche, La 33, 36
Richter, Gerhard 10, 155, 164–68, 197, 199, 201, 203; *138, 147, 148*
Riis, Jacob 27, 28; *15*
Rivera, Diego 76, 94–95, 97; *86*
Rivers, Larry 208
Rodin, Auguste 9, 43
Rogers, Claude 142
Roldán, Luisa 205
Roosevelt, President Franklin D. 84, 94
Roosevelt, President Theodore 24
Rosenquist, James 156; *139*
Rothko, Mark 90–91; *82*
Royal Academy of Arts, London, the 38
Ruscha, Ed 177; *158*
Rush, William 19–21
Ruskin, John 141, 143
Ryangina, Serafima 106, 118; *94*
Ryman, Robert 180–81; *161*

Salon, salon painting 10–11, 14; see also academic tradition
Salon d'Automne 114–15
Salon des Refusés 14
Sarfatti, Margherita 55
Sargent, John Singer 17–19, 24; *6*
Sartre, Jean-Paul 109, 111, 114, 126–29
satire 9, 208–10
Schad, Christian 71; *60*
Schapiro, Meyer 88, 159
Schiele, Egon 48–50; *40, 42*
Schlichter, Rudolf 65–67; *57*
Schnabel, Julian 197
Schopenhauer, Arthur 60
Sciascia, Leonardo 123
Scorsese, Martin 25
Second World War 109; and British art 136–37; and Occupation of France 110–12, 133; and Soviet Union 121
Selz, Peter 152
Semiotics, art history and 158
Shahn, Ben 87, 90; *81*
Sheeler, Charles 74, 76–77; *65, 66*
Sherman, Cindy 204–05; *183*
Shinn, Everett 24, 27, 40; *29*
Sickert, Walter 37–38, 39, 40–41, 43, 144; *28, 31, 32*
Simmel, Georg 68
Siqueiros, David Alfaro 94, 97–98; *88*
Sironi, Mario 55
Skira, Albert 126
Slade School of Fine Art, London 137, 142–43, 144
Sloan, John 24, 27–28, 29, 162–64; *16*
Smith, Jack 144, 146
social history of art 12, 158; see also T. J. Clark; Nochlin; Schapiro
Social Realism 7, 10, 11, 12, 54, 82–84, 87, 90, 92, 126, 142, 146–47, 164, 206
Socialist Realism 10, 11, 54, 55, 92, 98–100, 105–08, 114, 118–19, 121, 147, 164
Society of American Artists, the 38
Soutine, Chaim 189; *170*
Soyer, Isaac 87
Soyer, Moses 87
Soyer, Raphael 84, 87, 92; *78*
spectatorship 12, 14, 21, 32 (perspective), 40–41
Spencer, Stanley 63, 80–82; *69, 72*
Spoerri, Daniel 161–62; *144*
Stalin, Josef 54, 94, 104, 108, 116, 121, 123
Steen, Jan 9
Steichen, Edward 28
Stieglitz, Alfred 28, 74
Stokes, Adrian 141
Strand, Paul 77
Strindberg, August 35, 46
superrealism 177
Surrealism 10–11, 54, 74, 126, 160, 168, 189
Sylvester, David 144
Symbolism, Symbolist movement 15, 33–34, 36, 46, 47, 50, 57
Szeemann, Harald 169

tactitlity 50, 144, 179, 190
Tansey, Mark 197–200; *177, 178*
Tarkovsky, Andrei 118
Taslitzky, Boris 109, 115

Tatlin, Vladimir 68, 99
Taylor, Paul 208
Thiebaud, Wayne 162, 175, 177; *145, 157*
Thoma, Hans 104
Tillich, Paul 152
Titian 14
Tonks, Henry 81; *71*
Tooker, George 152–53; *135*
Transcendental realism, of interwar period 77; see also 'call to order'; Metaphysical School
Trotsky, Leon 98, 100–01
'Twenty-Two Realists' exhibition 169, 179

Uccello 60
Uglow, Euan 173; *154*
Utopian realism, of interwar period 77; see also 'New realism', of Léger

Vallotton, Félix 33, 34–36, 37, 40–41; *24, 26*
Valori Plastici 55, 61, 67; *58*
van Gogh, Vincent 135, 159, 166–67, 183; *142*
Vasconcelos, José 93
Velázquez, Diego 9, 18, 21, 150–51, 159, 188; *11*
verism 68, 71
Vermeer, Jan 9, 190
Vertov, Dziga 141
Vichy France 110, 114
video art 11–12
Vietnam War 202
Viola, Bill 12, 211
VKhuTeMas 103
Volpedo, Giuseppe Pelliza da 123; *105*
vorticist movement 145
Vuillard, Edouard 33, 34, 37, 40, 43, 152; *22, 23*

Wall Street Crash 74, 92
Wanderers, the 10, 92, 100
Warhol, Andy 162–64, 167–68, 173, 203, 206–07; *146, 184*
Weimar Republic, Weimar culture 68, 72–73
Willing, Victor 211
Wollheim, Richard 125
Wood, Grant 84, 94; *75*
Worpswede, artists' community of 47
Wyeth, Andrew 154, 164; *137*

Ziegler, Adolf 103–04; *92*
Zola, Emile 36